"ONLY THE BEST"

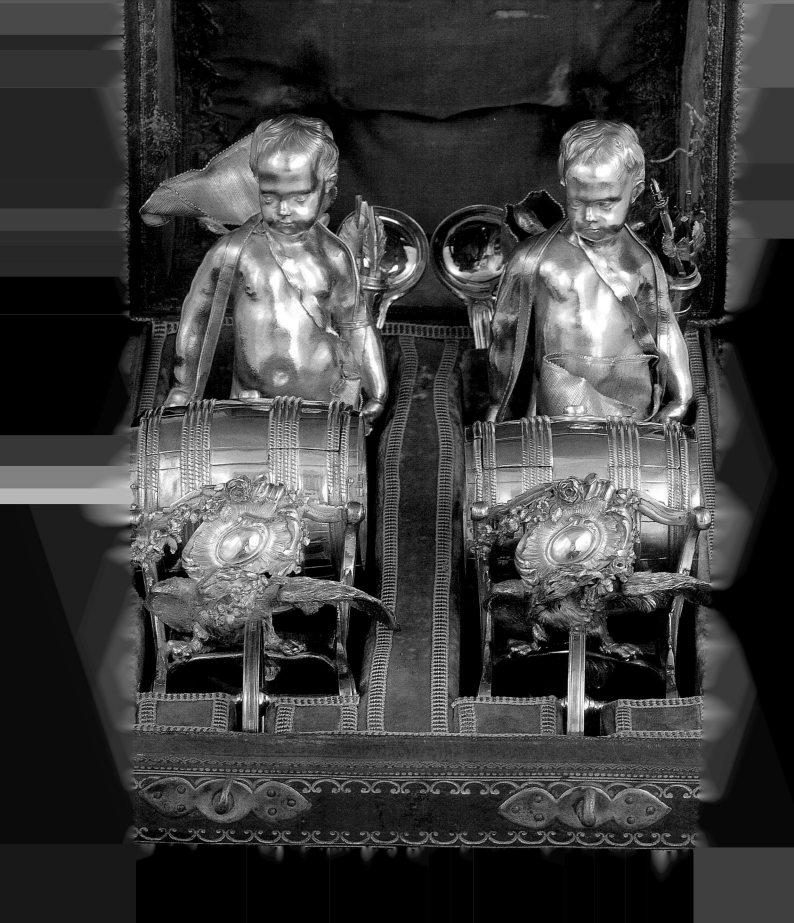

"ONLY THE BEST"

MASTERPIECES
OF THE
CALOUSTE GULBENKIAN MUSEUM,
LISBON

•

EDITED BY
KATHARINE BAETJER
AND
JAMES DAVID DRAPER

THE METROPOLITAN MUSEUM OF ART, NEW YORK

DISTRIBUTED BY HARRY N. ABRAMS, INC., NEW YORK

This publication is issued in conjunction with the exhibition
"'Only the Best': Masterpieces of the Calouste Gulbenkian Museum, Lisbon,"
held at The Metropolitan Museum of Art, New York, from November 16, 1999,
through February 27, 2000.

The exhibition is made possible by The Hagop Kevorkian Fund and The Kossak Family Foundation.

Additional support has been provided by Patti Cadby Birch.

The exhibition was organized in collaboration with the Calouste Gulbenkian Museum, Lisbon.

An indemnity has been granted by the Federal Council on the Arts and the Humanities.

The publication is made possible, in part, by the Roswell L. Gilpatric Fund for Publications.

Published by The Metropolitan Museum of Art, New York

John P. O'Neill, Editor in Chief
Jane Bobko, Editor
Miriam Berman, Designer
Merantine Hens, Production Manager

Translations from the Portuguese by Clifford Landers and Alexis Levitin

Photography by the Calouste Gulbenkian Museum, Lisbon

Separations by Professional Graphics, Rockford, Illinois
Printed by Julio Soto Impresor, S.A., Madrid
Bound by Encuadernación Ramos, S.A., Madrid
Printing and binding coordinated by Ediciones El Viso, S.A., Madrid

Jacket/Cover illustration: Édouard Manet (French, 1832–1883), *Boy Blowing Bubbles*, 1867.
Calouste Gulbenkian Museum, Lisbon (cat. no. 65)

Frontispiece: Antoine-Sébastien Durand (French, master 1740, recorded 1785), *Pair of Mustard Barrels*, 1751–52.
Calouste Gulbenkian Museum, Lisbon (cat. no. 54)

Library of Congress Cataloging-in-Publication Data

Only the best : masterpieces of the Calouste Gulbenkian Museum, Lisbon / edited by Katharine Baetjer
and James David Draper.
 p. cm.
 Catalog of an exhibition held at the Metropolitan Museum of Art, New York, from
Nov. 16, 1999, through Feb. 27, 2000.
 Includes bibliographical references.
 ISBN 0-87099-926-5 (hc. : alk. paper) — ISBN 0-87099-927-3 (pbk. : alk. paper) —
ISBN 0-8109-6546-1 (Abrams)
 1. Art—Portugal—Lisbon—Catalogs. 2. Museu Calouste Gulbenkian—Catalogs.
I. Baetjer, Katharine. II. Draper, James David. III. Metropolitan Museum of Art (New York, N.Y.)

N3231.M76 A63 1999
707'.4'7471 21—dc21 99-044794

Contents

PRESIDENT AND CHAIRMAN'S FOREWORD
Victor de Sá Machado, President and Chairman, Calouste Gulbenkian Foundation ... VI

DIRECTOR'S FOREWORD
João Castel-Branco Pereira, Director, Calouste Gulbenkian Museum ... VII

DIRECTOR'S FOREWORD
Philippe de Montebello, Director, The Metropolitan Museum of Art ... VIII

CONTRIBUTORS TO THE CATALOGUE ... IX

ACKNOWLEDGMENTS ... X

NOTE TO THE READER ... XI

CALOUSTE GULBENKIAN: THE COLLECTOR AS CREATOR
João Castel-Branco Pereira ... 3

A HOME FOR OUR "FRIENDS OF A LIFETIME"
Nuno Vassallo e Silva ... 11

CATALOGUE

ROMAN, ISLAMIC, ARMENIAN, EGYPTIAN, AND CHINESE ART ... 18
Mário de Castro Hipólito, Maria Helena Trindade Lopes,
Maria Antónia Pinto de Matos, Maria Queiroz Ribeiro

MEDIEVAL AND RENAISSANCE ART ... 32
Manuela Fidalgo, Maria Rosa Figueiredo, Luísa Sampaio

ISLAMIC ART ... 53
Maria Fernanda Passos Leite, Maria Queiroz Ribeiro

OLD MASTER PAINTINGS ... 89
Luísa Sampaio

EIGHTEENTH-CENTURY DECORATIVE ARTS ... 109
Isabel Pereira Coutinho, Maria Fernanda Passos Leite

FRENCH SCULPTURE ... 128
Maria Rosa Figueiredo

NINETEENTH-CENTURY PAINTING ... 134
Luísa Sampaio

LACQUER, LALIQUE, AND MODERN BINDINGS ... 148
Isabel Pereira Coutinho, Manuela Fidalgo, Maria Fernanda Passos Leite

SELECTED BIBLIOGRAPHY ... 163

President and Chairman's Foreword

The Calouste Gulbenkian Foundation, which has its headquarters in Lisbon, is one of the largest foundations in Europe. A Portuguese institution, the Gulbenkian Foundation was created by Calouste Sarkis Gulbenkian, the wealthy Armenian promoter of and pioneer in the Middle Eastern oil industry widely known as Mr. Five Percent—for the 5-percent share of stock he received in oil-industry negotiations. Gulbenkian came to Lisbon during World War II after the Nazis took Paris, and he made the Portuguese capital his home for the last years of his life.

The creation of the foundation was Gulbenkian's way of expressing his gratitude for the welcome he was given in Portugal, and it was a lasting tribute to the faith he had in the integrity and the ability of the Portuguese to do justice to his magnificent bequest.

The foundation has been very active, both in Portugal and in other parts of the world, in each of the four areas—charitable, educational, artistic, and scientific—that were set out in its statutes. Particularly worthy of mention is the foundation's large cultural complex that includes the Gulbenkian Museum, which is dedicated exclusively to the collection of Calouste Gulbenkian. The collection assembled by Gulbenkian over many years with sensitivity and refinement, intelligence and passion, is recognized today as one of the most remarkable private collections in the world. We are proud and honored to show pieces from this collection at an institution of such enormous prestige as The Metropolitan Museum of Art.

In making this exhibition possible, the Calouste Gulbenkian Foundation is fulfilling what was surely one of its founder's wishes: to share with people all over the world the extraordinary beauty of the pieces he was so fortunate to collect.

Victor de Sá Machado, President and Chairman
Calouste Gulbenkian Foundation

DIRECTOR'S FOREWORD

This exhibition is exceptional. Since the opening of the Calouste Gulbenkian Museum in Lisbon in 1969, many of the most important pieces shown here have not traveled internationally for an extended period. The temporary closing of the Gulbenkian Museum for extensive renovations made the loan of these works possible. Only works too fragile to travel or that overlap ones in The Metropolitan Museum of Art were excluded from consideration.

This exhibition in one of the world's preeminent museums is not strictly in keeping with Calouste Gulbenkian's characteristic discretion. Gulbenkian acquired his pieces in negotiations wrapped in secrecy, employing subtle diplomacy in correspondence either with dealers or with the owners of works that aroused his interest. Only a few privileged friends and close acquaintances were able to view the collection when invited to Gulbenkian's residence on the Avenue d'Iéna in Paris. Gulbenkian never refused to lend his artworks, however. He was aware that his collection should be seen. During his lifetime he donated important pieces to the National Museum of Ancient Art in Lisbon, and in his will he created a foundation whose main purpose is to house and display to the public his complete collection. We believe, therefore, that Calouste Gulbenkian's wishes have indeed been realized in the present exhibition. Its appearance at The Metropolitan Museum of Art honors us deeply.

In organizing the exhibition I was fortunate to receive the enthusiastic support of the director of The Metropolitan Museum of Art, Philippe de Montebello, and the collaboration of curators Katharine Baetjer and James David Draper, as well as the assistance of Harold Holzer, vice president for communications. Among the team at the Gulbenkian Museum, I would like to single out Deputy Director Nuno Vassallo e Silva; curators Maria Fernanda Passos Leite, Maria Rosa Figueiredo, Isabel Pereira Coutinho, Manuela Fidalgo, Maria Queiroz Ribeiro, and Mário de Castro Hipólito; Assistant Curator Luísa Sampaio; photographers Margarida Ramalho, Catarina Gomes Ferreira, and Carlos Azevedo; Lucinda Peixoto, in charge of the Photography Archives; Rui Xavier and Maria Scarpa of the conservation staff; my assistant, Alexandra Lopes de Almeida; and the Communications Service, represented by Deputy Director Wilton Fonseca. I would also like to thank the outside specialists who collaborated with us: Maria Antónia Pinto de Matos, Maria Helena Trindade Lopes, and conservators Constança Pinheiro da Fonseca and Sara Fragoso.

João Castel-Branco Pereira, Director
Calouste Gulbenkian Museum

DIRECTOR'S FOREWORD

A visit to the Calouste Gulbenkian Museum is a profoundly satisfying experience. During my own first pilgrimage to the museum, virtually every object struck me as having great quality and force. The collector's standards were indeed so high that in titling the exhibition we have appropriated Mr. Gulbenkian's phrase "only the best," not as a boast, but as a realistic assessment of the merits of each piece he gathered. It was with unconcealable interest that I learned that a selection of the Gulbenkian Museum's collections would be available for loan this winter, owing to renovations taking place there. With its tranquil and well-ordered galleries and grounds, the museum is always a delight, and the campaign of improvements now going on will no doubt make it more so than ever.

On behalf of the Metropolitan Museum, I express heartfelt thanks to Victor de Sá Machado and to José Blanco and the other trustees of the Calouste Gulbenkian Foundation for their initiative and willingness to share these extraordinary works, many of them without peer. João Castel-Branco Pereira, the museum's director, has expedited the project, and he receives our warm thanks, as do those members of his administration who have worked selflessly on the exhibition, notably Nuno Vassallo e Silva, deputy director; Maria Rosa Figueiredo, chief curator; and Alexandra Lopes de Almeida, assistant to the director. The catalogue has been written by the Gulbenkian Museum curators, each specializing in a given field, and is eloquent testimony to their expertise. For the exhibition's realization here, I have turned to two curators well-versed in the ins and outs of international exchanges, Katharine Baetjer, Curator, European Paintings, and James David Draper, Henry R. Kravis Curator, European Sculpture and Decorative Arts; this institution is indebted to them for taking on this ambitious project at relatively short notice. They join me in thanking all, in Lisbon as well as in New York, who have contributed to the exhibition's success.

The Metropolitan Museum is grateful for the generous support provided by The Hagop Kevorkian Fund and The Kossak Family Foundation toward the exhibition. Patti Cadby Birch has also helped to make this project possible, and we extend our sincere thanks for her assistance. We are indebted to the Roswell L. Gilpatric Fund for Publications for its support of the exhibition catalogue.

Philippe de Montebello, Director
The Metropolitan Museum of Art

CONTRIBUTORS TO THE CATALOGUE

João Castel-Branco Pereira

Nuno Vassallo e Silva

IPC Isabel Pereira Coutinho

MF Manuela Fidalgo

MRF Maria Rosa Figueiredo

MCH Mário de Castro Hipólito

MFPL Maria Fernanda Passos Leite

MHTL Maria Helena Trindade Lopes

MAPM Maria Antónia Pinto de Matos

MQR Maria Queiroz Ribeiro

LS Luísa Sampaio

ACKNOWLEDGMENTS

We express our gratitude to the trustees of the Calouste Gulbenkian Foundation and to the administrative and curatorial staff of the Calouste Gulbenkian Museum for receiving us so generously in Lisbon, and to the latter for their collaboration as well in all matters concerning the present exhibition—the selection, publication, and display of the works of art in their care.

We also wish to thank our colleagues at the Metropolitan Museum who have contributed their expertise: Dorothea Arnold, George Bisacca, Barbara Drake Boehm, Stefano Carboni, Julien Chapuis, Aileen K. Chuk, Helen C. Evans, Everett Fahy, Barbara B. Ford, Navina Haidar, Marsha Hill, Colta Ives, Marilyn Jenkins-Madina, Nobuko Kajitani, Margaret Lawson, Clare Le Corbeiller, Walter Liedtke, Charles T. Little, Joan R. Mertens, Olga Raggio, William Rieder, Perrin V. Stein, Richard E. Stone, Daniel Walker, and James C. Y. Watt. We also appreciate the advice of Dr. Carmen Arnold-Biucchi and Dr. Elena Stolyarik of the American Numismatic Society in New York.

For their stylish presentation of the Gulbenkian works of art in New York, we acknowledge our design team: Jeffrey L. Daly, Sue Koch, Michael Langley, and Zack Zanolli. Linda M. Sylling has overseen the installation with her customary prescience. The Editorial Department—Peter Antony, Merantine Hens, Ann Lucke, John P. O'Neill, and Gwen Roginsky—has seen the catalogue through with their usual skill, under exceptionally difficult time constraints. Thanks also to the designer of the catalogue, Miriam Berman, and particularly to the editor, Jane Bobko.

Katharine Baetjer
James David Draper

NOTE TO THE READER

Transliterations from Arabic and Persian follow a modified version of the Library of Congress system. The Hepburn system is used for the transliteration of Japanese.

Entries are signed with an author's initials. For full names, see Contributors to the Catalogue, p. ix.

The dimensions of works in this catalogue are given in centimeters followed by inches, the latter rounded off to the nearest eighth of an inch. Height precedes width, width precedes depth. Folios, where they can be identified, are labeled as *r* (recto) or *v* (verso). In books in Arabic, the recto is the left-hand page; the verso is the right-hand page.

"Only the Best"

CALOUSTE GULBENKIAN: THE COLLECTOR AS CREATOR

João Castel-Branco Pereira

In April 1942, in the midst of the Second World War, Calouste Sarkis Gulbenkian arrived in Lisbon. He was a wealthy businessman and renowned art collector, born on March 29, 1869, in Scutari (the present-day Üsküdar district of Istanbul) to a well-to-do Armenian family. At age seventy-three, he was seeking a peaceful place to live, and Portugal had remained neutral in the conflict that was engulfing the world. Gulbenkian spent the rest of his life in Lisbon's Hotel Aviz, the most luxurious in the city, and it was there, in 1955, that he died.

In his will, Gulbenkian specified that a foundation bearing his name was to be created in Portugal. The Calouste Gulbenkian Foundation came into being in 1956, through the efforts of José de Azeredo Perdigão, Gulbenkian's Portuguese lawyer, who served as its president until 1993. Among the foundation's many enterprises, only the museum was mentioned specifically in Gulbenkian's will. By his express wish, the Calouste Gulbenkian Museum is obligated to preserve under one roof the artworks in his collection. Because, however, the charter defines the mission of the foundation as philanthropic, educational, and scientific, as well as artistic, over the years its administrators have created other services that have greatly expanded its role in Portuguese culture and society. The Calouste Gulbenkian Foundation quickly earned international prestige and today ranks among the greatest of its kind in Europe.

Gulbenkian was educated at the local school in Scutari until, at age thirteen, he was sent to Marseille and later to London, where in 1887 he was awarded a diploma with distinction from the department of engineering and applied sciences of King's College. After visiting the Baku oil fields, he returned to Ottoman Turkey to run the Transcaucasia petroleum company. He published his recollections of this trip in a book entitled *La Transcaucasie et la Péninsule d'Apchéron* (1891), including not only information about the exploration of the oil fields but also comments on the archaeology of the area, the characteristics of its people, and the carpets made there. Gulbenkian's taste for oriental rugs would lead him to assemble a collection of Islamic carpets of extraordinary quality and rarity.

Some of the chapters from his book appeared in the *Revue des deux mondes,* also in 1891, under the title "Le pétrole, source d'énergie," while Gulbenkian was a representative of Royal Dutch-Shell and an adviser to the Ottoman Bank. His writings attracted the attention of the Turkish minister of mines, who asked Gulbenkian to prepare a report on the oil fields of the Ottoman empire, which encompassed Mesopotamia. After long negotiations on the eve of the First World War, the Turkish Petroleum Company was created, its stock divided among the Anglo-Persian Oil Company, Royal Dutch-Shell, and Deutsche Bank, with 5 percent going to the negotiator, Calouste Gulbenkian. When the Deutsche Bank share was reapportioned as a result of Germany's defeat

Opposite: Detail, cat. no. 44

Fig. 1. Calouste Gulbenkian (1869–1955) in his late twenties

in 1918, once again Gulbenkian intervened, transferring Germany's interest to France, a victor in the conflict. For the first time, France had access to sources of petroleum. In 1928, with Gulbenkian still at the center of complex negotiations, the stock of the Turkish Petroleum Company was redistributed with the skillful negotiator retaining his usual percentage. From this practice came the nickname Mr. Five Percent. Gulbenkian was thus assured a colossal fortune. He would use it to form one of the preeminent art collections of the first half of the twentieth century.

Gulbenkian had begun to collect in a systematic fashion at the end of the nineteenth century and continued to do so without pause until 1953. In 1943, Gulbenkian wrote to George Davey of M. Knoedler & Co., a dealer he trusted in the purchase of art objects: "By temperament I am not a scientific collector of periods or series, but just as with my pictures, I like to possess the finest specimens . . . I have not got many pieces but I want them to be of the highest quality." Gulbenkian took various artworks home before deciding on their purchase, and he donated or traded acquisitions if he became disenchanted with them. Thus his taste for quality was refined, and the collector could truly state that he was interested in "only the best." (The example par excellence of Gulbenkian's pursuit of supreme quality is his obsessive, nearly ten-year attempt—without success—to acquire the portrait of the condesa de Chinchón [private collection], the only Goya that interested him despite others that appeared on the market.)

In 1943, André Weil offered to serve as intermediary for the acquisition of one or two paintings that the Lewisohn family was willing to part with; he proposed a Manet and a Gauguin. It was Manet's *Boy Blowing Bubbles* (cat. no. 65) that primarily interested Gulbenkian, particularly after he received a telegram from Sir Kenneth Clark, at the time director of the National Gallery in

London, saying, "STRONGLY RECOMMEND MANET." On December 16, 1943, Weil sent the collector a telegram: "DEAL MANET DEFINITIVELY CONCLUDED PAINTING WELL IN INDIVIDUAL VAULT STOP WORKING GAUGUIN STOP . . ." The Gauguin, however, was not acquired. In 1954, Covington & Burling, in Washington, D.C., proposed the purchase of a Cézanne portrait depicting the painter's wife, but by this time the collector was already seriously ill. Could such a work entice a man who had written that Post-Impressionism did not interest him, that his preference was for the classical tradition? Possibly, for in his diary of a visit to Munich in 1933, Gulbenkian mentioned what he termed two excellent Cézannes—a landscape and a portrait—in the Neue Staatsgalerie and referred to van Gogh's *Sunflowers,* in the same museum, as a painting of the highest quality.

Among Gulbenkian's acquisitions, whether purchased as a group or individually, some stand out because of their obvious merit or because of the complex negotiations that surrounded them. Early in 1927, the bronze *Apollo* (cat. no. 61) by Houdon was acquired from the comtesse de Pastré in negotiations through her son and the intermediary Badin. Ownership of this beautiful Neoclassical statue, which was conceived as a pendant to the *Diana* that Houdon had sculpted ten years earlier, in 1780, must have awakened Gulbenkian's desire to reunite the two works. In 1928 he entered into negotiations with the Soviet government, through the organization known as the Antikvariat, to acquire works from the Hermitage in Leningrad. Gulbenkian sent his agent André Aucoc, a Parisian jeweler and goldsmith, to the Hermitage to report on the paintings that struck him as both in the best condition and of the highest quality. Aucoc reported on decorative arts and sculpture as well, using the notations A and B to indicate relative quality. Although he considered the Hermitage's *Diana* "a superb marble," Aucoc assigned it to category B. Gulbenkian, shrugging off his emissary's opinion, acquired this masterpiece of French sculpture in 1930.

Aucoc provided Gulbenkian with a long list of recommendations, including works by van Eyck, Botticelli, Giorgione, Rubens, van Dyck, Rembrandt, Claude Lorrain, and Watteau. From this list Gulbenkian selected forty paintings, asking Aucoc to examine them closely for any sign of retouching and to report on their artistic merit. He also requested photographs of eighteenth-century French and antique sculpture, as well as information on eighteenth-century French furniture and Greek coins (Greek coins were one of Gulbenkian's great passions, and he amassed an outstanding collection. He also acquired a set of eleven Roman medallions purportedly discovered in Aboukir, Egypt [cat. nos. 1, 2].)

From the initial contact with the Antikvariat came twenty-four superlative examples of French silver- and goldsmiths' work, two paintings by Hubert Robert depicting the gardens at Versailles (one is cat. no. 45), an Annunciation by Dirk Bouts, and a Riesener desk. Gulbenkian's second Hermitage purchase included fifteen silver pieces, seven by François-Thomas Germain (including cat. nos. 55–57). The third purchase consisted of Houdon's *Diana* and five paintings—two of them Rembrandts, one by Ter Borch, and one each by Lancret and Watteau. The Watteau is the famous *Mezzetin,* which went to Wildenstein & Co. and was subsequently sold to The Metropolitan Museum of Art. Gulbenkian kept only Rembrandt's *Pallas Athena* and the *Diana.*

His final acquisition from the Hermitage, in 1930, was Rembrandt's *Portrait of an Old Man* (1645), one of the greatest works in the Gulbenkian Museum. It happened that among the pictures he most coveted, Gulbenkian was unable to acquire Giorgione's *Judith.*

Some of the treasures of the Gulbenkian collection once belonged to members of the Rothschild family and were acquired after 1919 through dealers, at auction, or directly from the owners. These include *Mrs. Lowndes-Stone* by Gainsborough (cat. no. 50) and two medal cabinets by Cressent (one is cat. no. 51). Other acquisitions resulted from conversations in 1943 between Gulbenkian and Baron Henri de Rothschild, who was then in Portugal while his property remained in England, where the baron had been classified as an enemy alien. In these negotiations, Gulbenkian had recourse to the opinion of Kenneth Clark, who strongly urged the purchase of several paintings. Gulbenkian eventually acquired from Baron de Rothschild an exceptional pastel by Quentin de La Tour, two Lépiciés, and a Nattier—all portraits—as well as a fantastic jasper ewer mounted in gold (cat. no. 52).

In the 1920s, Gulbenkian had acquired a house on the Avenue d'Iéna in Paris, which he completely remodeled and where he began to assemble many of the major pieces that formed his collection. Whether by gift, exchange, or as partial payment, Gulbenkian also transferred title to works in which he had lost interest. In 1928, for example, he gave as a wedding gift a Turner watercolor he had purchased in 1914; in 1930 he ceded to Wildenstein the painting *Le Canal* by Hubert Robert, a Pigalle terracotta, and a Louis XIV table that he had acquired in 1917, 1921, and 1922, respectively; in 1948 he traded a painting by Fantin-Latour, *Pears, Apples, and Flowers;* in 1950, he offered two Fantin-Latours, *Hollyhocks* and *Oranges, Strawberries, and Flowers,* as partial payment for the Durand silver *cloche* (cat. no. 53); and, finally, he made countless gifts of Near and Middle Eastern textiles and tiles and of Persian and, especially, Turkish ceramics.

Gulbenkian was also interested in public collections and contributed to museum purchases. In 1921 the director of the Musée du Louvre, Paris, thanked him for a large contribution toward the acquisition of Islamic ceramics. Following his purchase of the sixteenth-century Flemish tapestry *Vertumnus and Pomona* from the Kunsthistorisches Museum, Vienna, Gulbenkian made a generous donation toward the museum's acquisition of a magnificent twelfth-century chalice. In 1949 he presented to the Portuguese embassy in Paris a marble torso of Apollo that he had acquired in 1917. This Greek sculpture dates from the second half of the fifth century B.C. His most magnanimous gesture, however, occurred between 1949 and 1952, with the gift of an extremely important nucleus of works to the National Museum of Ancient Art in Lisbon. Even if his primary, hidden motive may have been to obtain a certain piece of eighteenth-century goldsmith's work (which was impossible because Portuguese law forbade the transfer to private individuals of goods belonging to state museums), Gulbenkian's donation was a gesture in recognition of the hospitality that he had enjoyed in Portugal and that, as he put it then, he had never felt anywhere else.

In 1939 Gulbenkian bought in London a portrait by Reynolds of General William Keppel that was immediately delivered to the National Gallery for exhibition. In 1948 he wrote the restorer Dr. Martin de Wild asking to be informed of the condition of that painting, since he intended to

Fig. 2. Calouste Gulbenkian near the end of his life

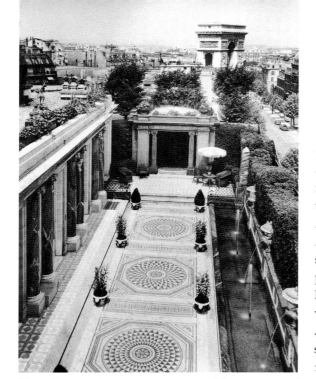

Fig. 3. Terrace, Avenue d'Iéna, Paris

present it to the National Museum in Lisbon. The gift reflected Gulbenkian's admiration for, as well as a deep friendship with, Dr. João Couto, the museum's director. In 1950 Gulbenkian presented Gustave Courbet's *Man with a Pipe*. In 1951 he donated van Dyck's *Lucas Vorsterman the Elder*; the *Presumed Portrait of Monsieur de Noirmont* by Largillierre; Courbet's *Snow*; *Pasture by the Marsh* by Jules Dupré; and a Fantin-Latour, *Roses*. During the same year, he offered sculptures such as an Egyptian lion from the Ptolemaic period and a *Danaïde* by Rodin, plus *Saint Catherine* by Lucas Cranach the Elder, *Interior of a Temple* by Hubert Robert, and *Eleanor of Austria* by Joos van Cleve. The last possessed added historical interest because Eleanor of Austria was the third wife of the Portuguese king Manuel I (r. 1495–1521); she was remarried in 1530 to Francis I (r. 1515–47) of France. Finally, in 1952, Gulbenkian donated another Reynolds, another Hubert Robert, a Hoppner, a writing desk by Riesener, and *Mariana of Austria*, attributed by some critics to the atelier of Velázquez and by Sánchez Cantón, a specialist on the painter, to the master's own hand.

Gulbenkian also gave the National Museum a collection of tiles, principally Iznik ware but also of Syrian and Persian origin, that, in combination with the examples in the Gulbenkian Museum, constitute an invaluable basis for comparative study with the tiles of Portugal, the European country that over the last five hundred years has made the greatest and most varied use of this decorative art form.

Gulbenkian defined himself as an eclectic collector, though one always zealous to ensure the quality of his selections. Passion for the object, he said, was a basic criterion in the creation of his collection. This element of affection may explain the expansion of Gulbenkian's Islamic holdings, possibly out of recollection of his origins. His European education directed him toward the painting, sculpture, and decorative arts of the great masters. The objects he brought together—whether a carpet from India, a ceramic from Iznik, a cabinet by Cressent, silver by François-Thomas Germain, a jewel by Lalique, or notable Greek coins—are affirmations of his personality and a life spent amid luxury.

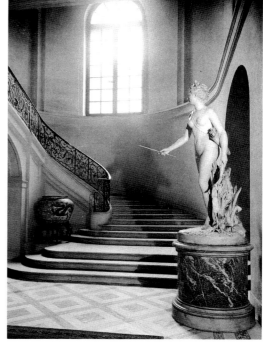

Fig. 4. Houdon's Diana, *Avenue d'Iéna, Paris*

A love of nature is displayed in the delicate floral decoration of the Iznik wares (cat. nos. 25–31), the Chinese porcelains (cat. no. 11), and the Japanese *inrō*, as well as in Lalique's fascinating jewels (cat. nos. 72, 73, 75, and 77). Nature eloquently reveals itself through landscape in the paintings of Jacob and Salomon van Ruisdael, Hubert Robert, Corot, and Turner.

A sensitivity to human form characterizes the Egyptian statue (cat. no. 8), the *Portrait of a Young Woman* by Ghirlandaio (cat. no. 19), the exquisite *Helena Fourment* by Rubens (cat. no. 42), the *Diana* by Houdon, the *Crouching Flora* by Carpeaux (cat. no. 62), and the portrait *Madame Monet* by Renoir. It is sustained in Bugiardini's attention to the materials of a young woman's clothing, in the showy attire of the *Duc de Richelieu* by Nattier, in Gainsborough's *Mrs. Lowndes-Stone* (cat. no. 50), and even in the baroque pearl belonging to a Lalique jewel.

It could be said that the Islamic textiles, the peopled landscapes of Lancret (cat. no. 43) and Fragonard (cat. no. 44), the French furnishings and silver, Lalique's works, and paintings such as *Reading* by Fantin-Latour (cat. no. 67) and *Henri Michel-Lévy* by Degas (cat. no. 66) all point to a subtle appreciation of mystery on Gulbenkian's part and an intense inner life. All in all, the way in which Calouste Gulbenkian conceived his collection of works of art, applying to it rigorous criteria of selection and projecting onto it his own intimate universe, reveals the collector as creator.

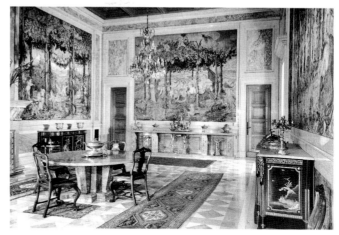

Fig. 5. Dining room, Avenue d'Iéna, Paris

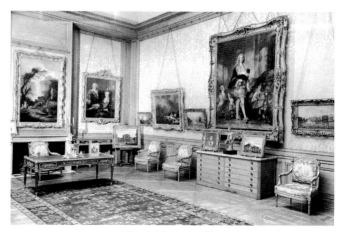

Fig. 6. Picture gallery, Avenue d'Iéna, Paris

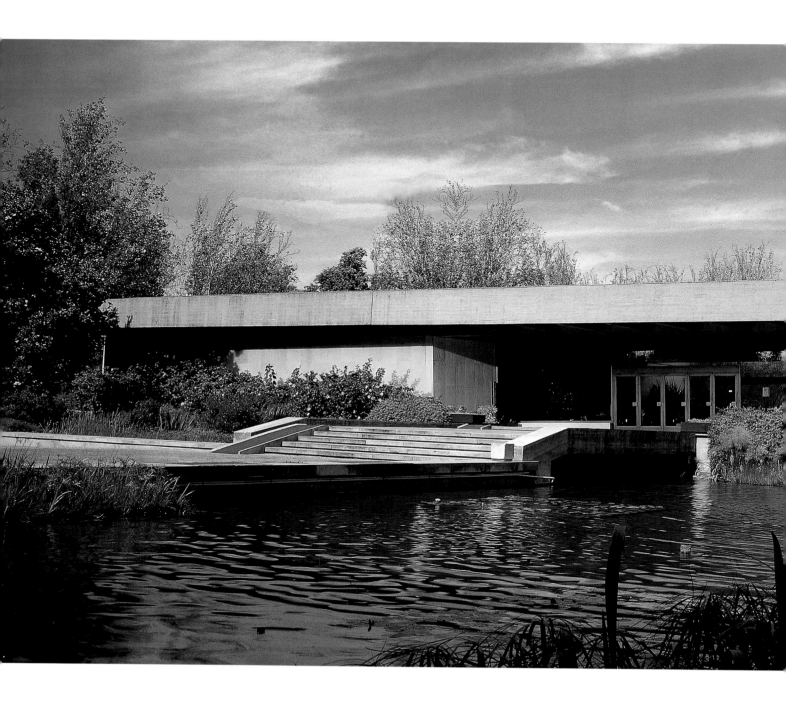

Fig. 7. Entrance to the Calouste Gulbenkian Museum, Lisbon

A Home for Our "Friends of a Lifetime"

Nuno Vassallo e Silva

The construction of the Calouste Gulbenkian Museum represents the realization of a dream that had been taking shape in the collector's mind since the eve of the Second World War. In the late 1930s Gulbenkian showed an interest in London as the site for an institution that would exhibit and preserve his collection, for he had recently lent some of his major paintings to the National Gallery and his Egyptian antiquities to the British Museum. Gulbenkian was motivated by more than a natural satisfaction with the public's admiration of his loans. By the end of the 1930s, the nucleus of the collection was in place, especially following the important acquisitions from the Soviet Union, although major works would continue to be incorporated—among them the Jameson collection of Greek coins—and his holdings would be enhanced.

In 1938, following an agreement with the trustees of the National Gallery, Gulbenkian commissioned the New York architect William Adams Delano to draw up plans for a museum to be situated behind the National Gallery. The project advanced rapidly (the scale model and blueprints were approved) but was suspended in 1940 following the outbreak of the war and then totally abandoned. In 1942, the English government declared Gulbenkian a "technical enemy" for having served as an economic adviser to the Iranian legation under the Vichy government, a classification that was rescinded the following year after Gulbenkian contested the charge, citing his diplomatic status. In 1947, he was approached by Sir Philip Hendy, the new director of the National Gallery, with an eye to placing paintings from the collection on exhibition again. Gulbenkian declined, however, insisting on presenting his collection in its entirety in a single building. Another factor in his decision was that two years earlier Sir Kenneth Clark, in whom he had complete confidence and who had been at his side during development of the plans for the new museum, had resigned.

The failed negotiations between Gulbenkian and the National Gallery trustees afforded an opening to the director of the Victoria and Albert Museum, Sir Leigh Ashton, who in 1947 proposed a new site, across from the Victoria and Albert Museum, for the future Gulbenkian Museum. The proposal was rejected by Gulbenkian, who by then had received a request from the National Gallery of Art, in Washington, D.C., to exhibit all the works housed in London, as well as a visit in Lisbon from the curator, John Walker. In 1948 the Egyptian antiquities were shipped from the British Museum to the United States, followed in 1950 by the paintings from the National Gallery.

American cities were considered. In Washington, the curator and the director of the National Gallery, David E. Finley, suggested a site on the Mall. The museum would be housed in a wing of a foundation to be created expressly to oversee the construction and maintenance. Gulbenkian turned down this proposal as well. In 1953, Gulbenkian received Francis Henry Taylor, director of The Metropolitan Museum of Art. He discussed with Taylor his desire to preserve his collection intact and as an independent entity, and inquired about the terms of various bequests to the New York museum, specifically that of Benjamin Altman. When on June 18, 1953, Gulbenkian wrote his will, he finally decided that his entire collection—referred to in 1947 as his "friends of a lifetime"—would come to Lisbon.

◆

A year after Gulbenkian's death in 1955, in keeping with his will, a foundation bearing his name was established. A new museum was to be constructed from the ground up, in Santa Gertrudes Park, not far from the Hotel Aviz. While proposals for construction of the museum and the foundation headquarters were being studied, a large palace in Oeiras, near Lisbon, was acquired. The Pombal Palace, dating from the second half of the eighteenth century, had been designed by Carlos Mardel and had belonged to the famous marquês de Pombal (1699–1782), chief minister to the Portuguese king José I (r. 1750–77). The palace was immediately prepared to receive the artworks coming from London, Washington, and Paris. Maria José de Mendonça of the National Museum in Lisbon supervised the transport and conservation of the works of art and implemented the first steps toward their permanent installation.

In October 1959, the first shipment arrived from London: several precious manuscripts, Turner's *Quilleboeuf, Mouth of the Seine,* a group of eighteen Renaissance medals, Chinese porcelains, and a pair of silver tureens by Antoine Boullier from the Soltikov Service. The works on loan to the

National Gallery of Art in Washington, recalled in 1960, were exhibited in Paris, at the Gulbenkian residence on the Avenue d'Iéna. The French government raised various obstacles to the removal from French soil of priceless items of historical importance, such as works from the royal palaces at Versailles and Fontainebleau, as well as sculptures by Houdon, that were in the residence. The transfer to Lisbon of the collection in its entirety was finally made possible only through a determined legal and diplomatic effort by the administration of the Gulbenkian Foundation in conjunction with the Portuguese minister of foreign affairs and the ambassador to Paris, Marcello Mathias. It may have helped that the Portuguese government conferred upon André Malraux, then the French minister of culture, the Grand Order of Santiago de Espada. The final shipment arrived in Portugal on June 16, 1960, and for the first time, albeit under a temporary roof, the more than 5,000 works acquired during his lifetime by Calouste Gulbenkian were brought together as the collector had dreamed.

In order to make the Gulbenkian collection better known to the Portuguese public, several exhibitions were held in the early 1960s. The National Museum of Ancient Art showed "Paintings from the Calouste Gulbenkian Collection" in 1961, in which the paintings recently arrived from Washington were brought together with those from the French capital, followed in 1963 by "Art of the Islamic East." In Oporto, at the Soares dos Reis National Museum, the exhibition "French Art from Watteau to Renoir" was presented in 1964. These exhibitions were experiments that would considerably influence the presentation of the collection at the future Calouste Gulbenkian Museum.

Upon completion of the remodeling of the Pombal Palace, close to three hundred works were placed on permanent exhibition there on July 20, 1965, the tenth anniversary of Gulbenkian's death. In 1969 the collection left the Pombal Palace for Lisbon, where on October 3 the Calouste Gulbenkian Museum and the headquarters of the Calouste Gulbenkian Foundation opened in Santa Gertrudes Park. Maria Teresa Gomes Ferreira became the museum's first director.

◆

The Calouste Gulbenkian Museum is a noteworthy example of Portuguese architecture of the 1960s. The building that houses both the museum and the foundation was jointly designed by architects Alberto Pessoa, Pedro Cid, and Ruy de Athouguia. Theirs was the winning plan in a competition in which three proposals were presented, each very different in its treatment of volume and space, yet each closely conforming to the concern of the new museum's administrators that the edifice possess a somber dignity in a unified architectural setting.

Rather than compete with the works of art that it houses, the building affirms its stature as another work of art. Of striking formal purity, the exterior is a massive rectangular parallelepiped resting on one of its longer sides (fig. 7). The facings are concrete and granite in restrained chromatic equilibrium. Laid out in a rectangular format, the permanent exhibition galleries are organized around two internal gardens (fig. 8). With the exception of the Egyptian and Greco-Roman galleries, where visitors begin their tour, and the Lalique Room, at the end, all the galleries also overlook Gulbenkian Park, designed by the landscape architects Gonçalo Ribeiro Telles and António Viana Barreto. This relationship between art and nature is one of the museum's distinguishing features and can be felt with greatest impact in the long gallery dedicated to Islamic art, probably the most striking in the building. The adjoining internal garden, along with the gallery's Mamluk glass, evokes the luxuriant vision of the Garden of Paradise that so greatly influenced Islamic art.

The museum is planned around each of the objects brought together by Calouste Gulbenkian. In addition, it boasts on its lower floor a library, a temporary exhibition space, a small auditorium, a shop, and a cafeteria. In areas closed to the public are technical and administrative services and conservation workshops. On an underground floor, the reserves of the collection are stored.

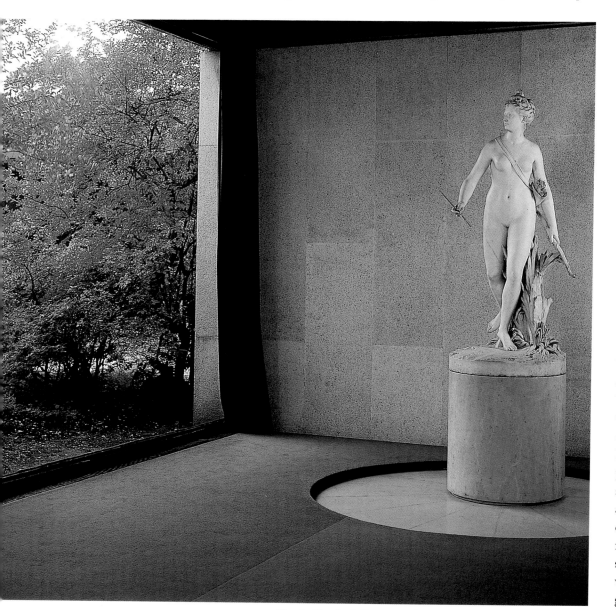

Fig. 8. Houdon's Diana, *Calouste Gulbenkian Museum, Lisbon*

In the great hall at the entrance to the museum, on the north wall, is an inscription taken from a letter that Calouste Gulbenkian wrote to John Walker on February 10, 1953. I can find no more fitting way to conclude this essay than to quote this inscription:

> I fully realise that it is high time that I should come to a decision with regard to the future of my collections. You know also how deeply attached I am to them all, in fact, it is without the slightest exaggeration that I consider them as "my children" and their future welfare is one of my dominant anxieties. They represent fifty or sixty years of my life and I have collected them, at times with immense difficulties, and always and exclusively guided by my own taste and judgment! Of course, as all collectors do, I have sought advice, but I do feel they are mine, after my own heart and soul!!

Calouste Gulbenkian,
Collector

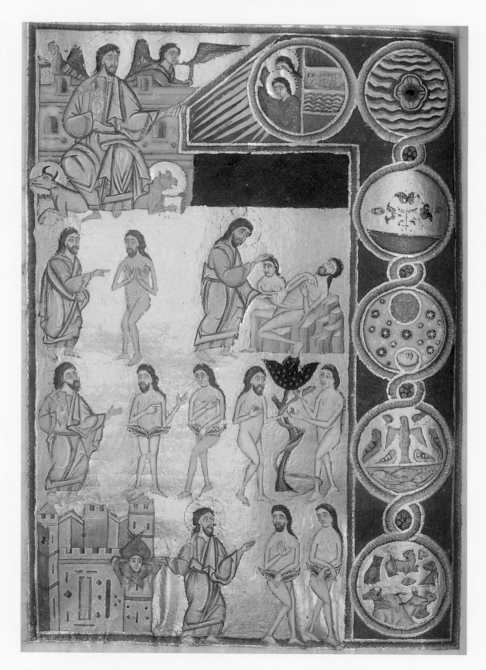

Roman · Islamic · Armenian · Egyptian · Chinese

1

ABOUKIR MEDALLION

BUST OF CARACALLA
(ob.)

MARINE CENTAUR CARRYING
A NEREID ON HIS BACK
(rev.)

Roman, 3rd century A.D.
Gold
Diam. 5.7 cm (2¼ in.), 69.36 g
Inv. no. 2433

OBVERSE:
Laureate bust of Caracalla facing
left with cuirass; he holds a spear
over his shoulder in his right
hand and a shield in his left

REVERSE:
Nereid mounted on a marine
centaur swimming to the left;
the centaur, his trunk and head in
three-quarter view, gazes to the
right, holding a trident in
his right hand and a fish in his
left; the nereid, nude above the
waist, turns toward the right;
her right arm is partially hidden
by the centaur and she rests
her left arm in her lap; dolphins
ride the waves

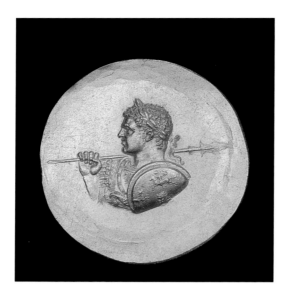
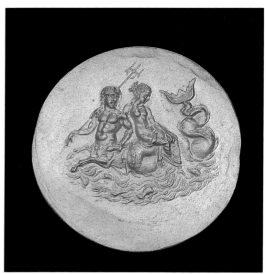

The Gulbenkian Museum owns eleven medallions from the find made about 1902, presumably in Aboukir, on the outskirts of Alexandria, in Egypt. The treasure included twenty medallions, approximately six hundred Roman aurei, and eighteen or nineteen ingots, all of gold. Three similar pieces found at Tarsus, in the Cilicia region (present-day Turkey), in the 1860s were acquired by Napoleon III, deposited in the Cabinet des Médailles of the Bibliothèque Impériale (now the Bibliothèque Nationale), Paris, and published in 1868. By contrast, when the Aboukir medallions became known, they immediately engendered controversy. The extraordinary character of the pieces, their number, uncertainties about the circumstances of the find, and reservations concerning the middlemen offering them for sale raised suspicion. The acquisition of five Aboukir medallions by the Königliche Münzkabinett, Berlin, led to the publication in 1906 of a monograph by Heinrich Dressel, the director of the Münzkabinett.[1] Dressel championed the Aboukir medallions' authenticity. The controversy, which lasted for more than half a century and divided academic authorities and commercial numismatic dealers, has today been resolved in favor of the medallions, in part thanks to the discovery of another two pieces identical in technique and with a recognized provenance.

The earliest scholarship, of which Dressel's is representative, regarded the medallions as prizes (*Niketeria*) that were struck in A.D. 242 when Emperor Gordian III (r. A.D. 238–44) attended Olympic games held at Beroea (present-day Veroia), Macedonia, on his way to military campaigns in Syria. The inscription ΟΛΥΜΠΙΑΔΟC on another of the Gulbenkian medallions was interpreted as a reference to the years A.D. 242–43. Recent reappraisals have described the medallions as extravagant manifestations of the deeply entrenched preoccupation of Roman emperors with Alexander the Great. Cornelius Vermeule attributes the medallions specifically to the reign of Severus Alexander, in the 230s A.D. He emphasizes the connections that both Caracalla (r. A.D. 211–17) and Severus Alexander (r. A.D. 222–35) drew between their military

1. Heinrich Dressel, *Fünf Goldmedaillons aus dem Funde von Abukir* (Berlin, 1906).

2. Cornelius Vermeule, "Alexander the Great, the Emperor Severus Alexander and the Aboukir Medallions," *Revue suisse numismatique* 61 (1982), pp. 61–71.

3. Adriano Savio, "Intorno ai medaglioni talismanici di Tarso e di Aboukir," *Rivista italiana di numismatica e scienze affini* 96 (1994–95), pp. 73–100.

Ex coll.
Found at Aboukir (?), near Alexandria, about 1902; Dr. Eddé, Alexandria; Pierpont Morgan Library, New York (bought from the Morgan Library in 1949)

engagements in Syria and the earlier exploits of Alexander the Great and his Seleucid successors. Vermeule suggests, moreover, that the medallions were struck in Macedonia or Thrace, in a center like Perinthus (present-day Ereğli, Turkey) that had a tradition of producing coins of large size.[2] Most recently the amuletic character of the Tarsus and Aboukir medallions has been emphasized, reviving a hypothesis offered in the initial publication of 1868 concerning the three medallions from Tarsus.[3]

At all events, the iconography and mythology of Alexander the Great are central to these consummate works of Roman art. The reverse of this medallion, with the marine centaur and nereid, may identify Olympias, Alexander's mother, with Thetis, the mother of Achilles. Caracalla would thus be associated with Alexander-Achilles. Similarly, the hunt on the reverse of catalogue number 2 might be intended to evoke the hero Meleager and the hunt of the Calydonian boar.

M C H

2

ABOUKIR MEDALLION

HEAD OF ALEXANDER
THE GREAT
(ob.)

ALEXANDER KILLING A
BOAR CHASED BY TWO DOGS
(rev.)

Roman, 3rd century A.D.
Gold
Diam. 5.4 cm (2⅛ in.), 96.3 g
Inv. no. 2428

OBVERSE:
Diademed head of Alexander the Great facing left, his gaze directed upward, with the horn of the Egyptian god Amun

REVERSE:
Alexander the Great standing and facing right, attacking with a spear a boar chased by two dogs; to the extreme right, a tree; inscribed in Greek, to the left and above, ΒΑCΙΛΕVC ΑΛΕΞΑΝΔΡΟC (King Alexander)

Ex coll.
Found at Aboukir (?), near Alexandria, about 1902; Madame Sinadino, Alexandria; Pierpont Morgan Library, New York (bought from the Morgan Library in 1949)

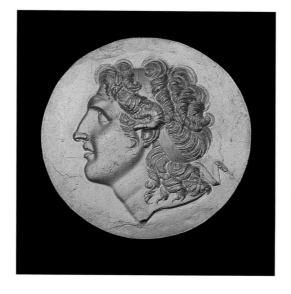
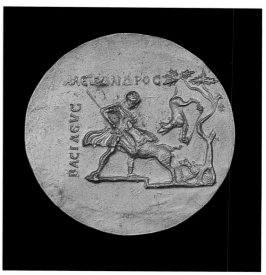

Numismatic portraiture of Alexander the Great was a posthumous phenomenon, the creation of the king's former generals who had divided among themselves vast regions of his empire. The image of Alexander on this medallion derives directly from a numismatic portrait adopted by one of his successors, Lysimachus (r. 323–281 B.C.), who ruled in Thrace. The rendering on the medallion includes realistic details such as the *anastole,* the prominent lock of hair rising above the forehead, while the upward gaze, the free-floating ends of the diadem, the deep orbital cavity, and the slightly open mouth convey Alexander's deification.

M C H

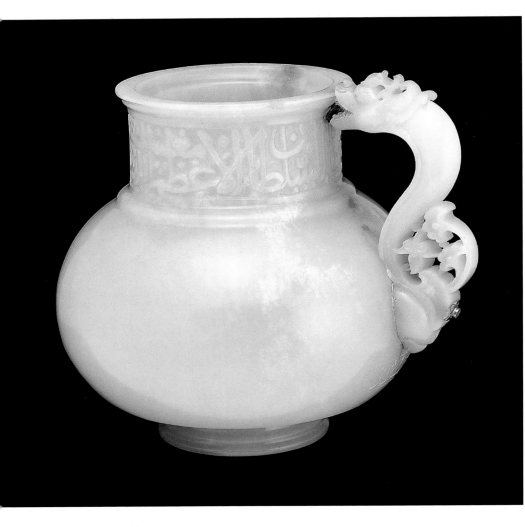

3

JAR

Eastern Iranian (Samarqand),
ca. 1447–49
White jade (nephrite)
H. 14.5 cm (5¾ in.),
maximum diam. 16 cm (6¼ in.)
Inv. no. 328

Central and eastern Asia and Iran were part of the vast empire constructed by Timur (Tamerlane; 1336–1405) between 1365 and 1402. This territory was later divided into regions governed by members of Timur's family, who maintained his tradition of patronage. Ulūgh Beg (1394–1449), son of Shāhrukh (1377–1447) and grandson of Timur, was the governor of Turkestan, Transoxiana, and the capital at Samarqand from 1409, and reigning prince from 1447 to 1449. He was also an eminent scientist and astronomer and a patron of the arts and sciences. For four decades Ulūgh Beg dedicated himself to astronomy and architecture, constructing in Samarqand in 1424 one of the finest observatories in the East; his architectural projects included the madrasas in Samarqand and Bukhara, which were prominent institutions of learning.

This jade jar is a masterpiece of Timurid decorative art and testifies to Ulūgh Beg's taste for exquisite objects made from precious materials. Jade, which both the Mongols and Turkic peoples considered a noble stone with talismanic powers, was mined in the Kunlun Shan (present-day Xinjiang Province, China) to the east of Samarqand. Pieces carved in jade appeared in the West only after the Timurid period, though in China there had been a long-established tradition of jade carving.

The jar, or *mashraba* (drinking vessel), is distinguished from the eleven or so other jade pieces executed for Ulūgh Beg principally by its dimensions (it is larger than any other such Timurid jade), as well as by its whitish color, its accomplished execution, and the quality of its finish. The form of the jar matches that of Timurid metal prototypes, but the dragon-shaped handle culminating in a floral ornament is of Chinese inspiration. The similarity between the treatment of the dragon's head here and its treatment on other Timurid jade pieces, such as a goblet in the British Museum, London (1961.2–13, 1), suggests that the pieces were all produced in Ulūgh Beg's Samarqand workshop in the first half of the fifteenth century. The dragon is a recurrent motif in Timurid metalwork, jade, jewelry, ceramics, and the arts of the book.

1. Stephen Markel, "Fit for an Emperor: Inscribed Works of Decorative Art Acquired by the Great Mughals," *Orientations* 21, no. 8 (August 1990), pp. 22–25.

Ex coll.
Bought probably before 1896

The Arabic relief inscription in *thuluth* calligraphy on the neck of the jar includes, along with the name and title Ulūgh Beg Kūrgān, the phrase "that the rule of the king and sultan be eternal." Ulūgh Beg used the title *kūrgān* (a Mongol term meaning "son-in-law" and first adopted by Timur) after 1417 and until his death in 1449. The dating may perhaps be further refined, since the inscription seems to be dedicated to the reigning sultan. Ulūgh Beg held the rank of sultan only from 1447 to 1449.

This jar eventually became part of the Timurid treasure held in India, as is attested by two other inscriptions added at a later date.[1] The name and titles of the Mughal emperor Jahāngīr are carved in *ta'līq* script along the rim, with the date 1613. Ownership of the jar passed to Jahāngīr's son Shāh Jahān, whose name and titles appear below the handle. This inscription, dated 1646, refers to Shāh Jahān as the "master of the second fortunate conjunction of the stars." The Mughal emperors in general, and Shāh Jahān in particular, compared themselves to their Timurid predecessors in order to justify their dynastic ambitions. Shāh Jahān chose his epithet in imitation of Timur, whose title was "master of the conjunction." M Q R

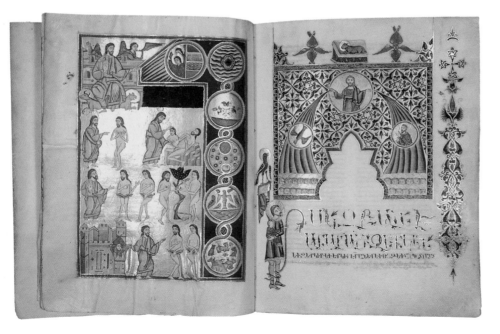

4
BIBLE

Constantinople, 1623
Parchment
22.4 × 16.5 cm (8⅞ × 6½ in.)
Inv. no. L. A. 152

The seventeenth century in the Armenian communities in Constantinople, the Crimea, and Isfahan saw a renaissance in the art of manuscript illumination. For the first time wealthy Armenians ordered Bibles extensively illuminated with images inspired by earlier Armenian manuscript traditions and European printed books.[1] According to the principal colophon, this Bible was commissioned in Constantinople by Khodja Nazar, a member of an important family in Isfahan, and completed in 1623; the copyist was named Hakob. During the fighting in the early seventeenth century between Iran and the Turks, Shāh 'Abbās I (r. 1588–1629) relocated

to Iran, in 1603, a portion of the eastern Armenian population. The Armenians were settled in a quarter of Isfahan that they called New Julfa, in memory of their native city. Workshops of copyists and illuminators soon appeared in New Julfa. Elaborate manuscripts like this were commissioned from the more established Armenian scriptoria in Constantinople. When the Bibles arrived in New Julfa, they quickly became models for other works, such as the similarly illuminated New Julfa Bible of 1645 now owned by the Armenian Patriarchate, Jerusalem (no. 1933).[2]

This Bible consists of 609 folios, 30 miniatures, illuminated canon tables and headpieces, and numerous illuminated ornaments. The text, in Armenian, is in two columns of forty-seven lines each, written in minuscule script called *bolorgir*. The title of each book of the Bible appears in the lower margin of the page below an elaborate headpiece. The initial letters of each chapter and verse are in gilded capitals, and the *nomine sacra* is in gilded lowercase letters.

The frontispiece to the Old Testament depicts the six days of the Creation (in six medallions) and the Creation of Man, Eve Taken from Adam's Rib, the Warning concerning the Forbidden Fruit, the Temptation of the Serpent, and the Expulsion from Eden. The headpiece of the Book of Genesis on the facing page refers to the Apocalypse, with the Lamb of God flanked by seraphim. Below, Christ Pantokrator appears in the central medallion. The rays emanating from His hands enclose the Holy Spirit in a medallion to the lower left and Moses in a medallion to the lower right, before descending upon twelve haloed heads on each side, which probably represent the twenty-four elders of the Apocalypse. The initial letter of the chapter is formed by a man with a halo grasping a child to his breast with his left arm. In his raised right hand he holds a gilded book upon which a haloed eagle perches, the symbol of John the Evangelist. The outer margin is decorated with intertwined palms crowned by a cross.

The remaining miniatures in this Bible represent Old Testament figures, the Evangelists, and other New Testament saints. Numerous decorative compositions confer great richness on this manuscript, a characteristic example of the works executed in Constantinople in the seventeenth century.[3]

<div style="text-align: right">M Q R</div>

1. Helen C. Evans and Sylvie L. Merian, "The Final Centuries: Armenian Manuscripts of the Diaspora," in *Treasures in Heaven: Armenian Illuminated Manuscripts*, ed. Thomas F. Mathews and Roger S. Wieck, exh. cat., The Pierpont Morgan Library (Princeton, 1994), p. 112.

2. Sirarpie Der Nersessian, *Armenian Art*, trans. Sheila Bourne and Angela O'Shea (London, 1978), p. 233 and pp. 234–35, colorpls.

3. Sirarpie Der Nersessian, study of the manuscript, 1968, Calouste Gulbenkian Museum, Lisbon.

EX COLL.
Sir Malcolm MacGregor of MacGregor (until 1926; sale, Sotheby's, London, November 15–18, 1926, no. 552, bought through Quaritch)

5

BOWL

Turkish (Kütahya),
18th century
Underglaze-painted
composite body
Diam. 16 cm (6¼ in.)
Inv. no. 927

The production of ceramics in urban centers such as Kütahya, in Anatolia, where Armenians settled toward the end of the fourteenth century, is to a large degree the result of the Ottoman appreciation for fine ceramics and of the declining quality of the work being produced elsewhere in Turkey—for instance, in Iznik.[1] Ceramic production in Kütahya, which developed in the seventeenth century, reached its height in the mid-eighteenth; work of lesser quality continued to be made through the nineteenth century.[2]

It is not widely known that in the sixteenth century Armenians were producing some ceramics—as is proven by the ewer and water bottle with Armenian inscriptions, from 1510 and 1529,

now in the British Museum, London.[3] A considerable number of Christian Armenian craftsmen, who had contributed to the flourishing of Iznik ceramics in the fifteenth and sixteenth centuries, moved to the Anatolian interior, settling principally in Kütahya. Kütahya's role is documented in seventeenth-century sources, including a 1608 decree by Sultan Ahmed I (r. 1603–17) charging Kütahya with supplying sodium borate to Iznik. According to the Ottoman chronicler Evliya Çelebi, almost half the artisans in Kütahya in the second half of the seventeenth century were potters.[4] These circumstances help to explain why in the eighteenth century Kütahya replaced Iznik as the center of ceramic production in the Ottoman empire.

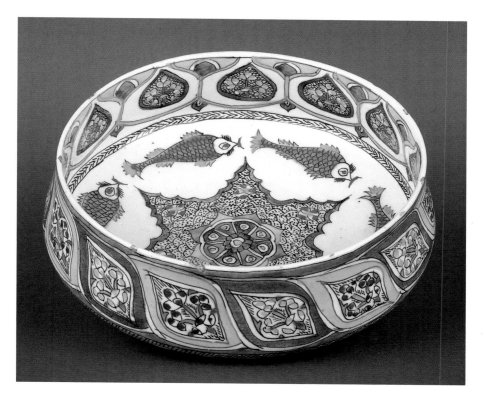

Kütahya ceramics are characterized by a siliceous paste without engobe, by an alkaline-lead glaze, and by a varied palette in which yellows and greens, sometimes slightly acid in tone, predominate. Although the technique and decoration of Kütahya ceramics were inspired by Iznik wares, their originality resides in their use of yellow (achieved through a secret process originating in Greater Armenia) and in their relatively abundant religious motifs. In both public and private collections there are candelabra, pilgrim's flasks, bowls decorated with figures of the apostles, and other objects with the monogram of Christ or stylized seraphim intended for religious use. In addition, tiles covered the walls of the cathedral and other churches in the New Julfa quarter of Isfahan and of the cathedral of Saint James in Jerusalem. At its zenith the Kütahya ceramics industry also served a Muslim clientele.[5]

This bowl is decorated in green, yellow, and aubergine against a white ground. Its central element is a large rosette in the form of a six-pointed star, around which fish move in a circle. The bowl may have been meant for secular use. Fish, however, were a symbol of the early Christian church, and bowls decorated on the interior with fish are known to have been used for the distribution of the Eucharist to the faithful.

M Q R

1. Jean-Michel Thierry, *Armenian Art*, trans. Célestine Dars (New York, 1989), pp. 316–17.

2. Ibid.

3. They were first identified as Armenian works in John Carswell and C.J.F. Dowsett, *Kütahya Tiles and Pottery from the Armenian Cathedral of St. James, Jerusalem* (Oxford, 1972), vol. 1, pp. 78–79, pls. 21a, b, vol. 2, pp. 4–6, when in the Godman collection, England. The argument is repeated in John Carswell, *Iznik Pottery* (London, 1998), pp. 45–50, where the works are identified as now in the British Museum.

4. Carswell and Dowsett, *Kütahya Tiles*, vol. 2, pp. 6–8.

5. Thierry, *Armenian Art*, pp. 316–17.

BIBLIOGRAPHY
Ribeiro, Maria Queiroz. *Louças Iznik/Iznik Pottery*. Lisbon, 1996.

EX COLL.
Kevork L. Essayan (until 1922; bought on February 4, 1922, through Indjoudjian)

6

RELIEF BLOCK FROM THE TOMB OF PRINCESS MERIT-ITES AND AKHTI-HETEP

Egyptian, Old Kingdom
(Dynasty IV; reign of Khufu
[Cheops], 2551–2528 B.C.)
Limestone with traces of paint
23 × 31.5 cm (9 × 12⅜ in.)
Inv. no. 159

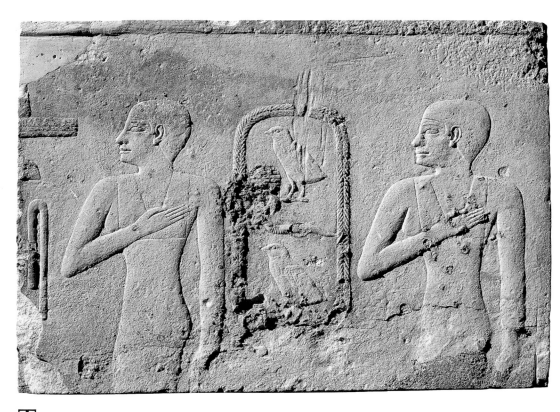

This limestone relief block with traces of green pigment formed part of the western wall of the offering chamber in the Giza mastaba (G7650) of Princess Merit-ites (who seems to have been a daughter of the pharaoh Khufu) and her husband, Akhti-hetep. The mastaba was located to the east of the Great Pyramid of Khufu, in the cemetery he had laid out for the tombs of his children.

Two daughters of Merit-ites and Akhti-hetep fold the right arm across the chest in a gesture of respect for the parent, once depicted to the left, whom they approach. The large partial hieroglyphs at the left form part of the name of the first woman, which is certainly Hetepheres. The lower part of the name of the second woman is missing. Her name is compounded with her grandfather Khufu's name, which is written in a large cartouche with a finely plaited rope border.

The relief is very low and the surface scarcely modeled. The women have short, caplike hair, large eyes slightly rounded in the socket, strong noses and chins, and broad, sensitive mouths. They wear tight sheaths with deep V necks. Youthful high breasts, which would actually have been covered by the dress straps, are revealed in the composite frontal-and-profile view conventional in Egyptian reliefs. The smooth, unmodeled bodies and the fresh, serene, barely individualized countenances represent the ideal of human beauty in the middle of the fourth dynasty.

M H T L

BIBLIOGRAPHY
Assam, Maria Helena. *Colecção Calouste Gulbenkian: Arte egípcia.* Lisbon, 1991, p. 34, no. 2, and pp. 18, 30–31, and 35–37, colorpls.
EX COLL.
Rev. William MacGregor (until 1922; his sale, Sotheby's, London, July 8, 1922, no. 1567)

7
TORSO OF KING PEDUBAST

Egyptian, Third Intermediate period (Dynasty XXIII; reign of Pedubast, 818–793 B.C.)
Bronze with gold and copper inlay
H. 26 cm (10¼ in.)
Inv. no. 52

The complete bronze statue of King Pedubast, a pharaoh of the twenty-third dynasty, showed the king striding with left leg forward. The statue was certainly intended for a temple, and the king may have held out small jars of wine or some other offering to the gods.

On the king's abdomen are traces of divine figures inlaid with gold wire. The ornate belt and apron preserve a rich encrustation of gold and copper in a feather pattern. A panther head tops the apron and a uraeus frieze lines the bottom. The elements of this costume combine to emphasize the king's divinity. Traces of gilding over the kilt complete the rich impression.

The inscriptions on the belt and down the front of the apron identify the king. The cartouche on the belt reads: Usermaatre-Chosen-of-Amun, Pedubast-Son-of-Bastet, Beloved-of-Amun. Written vertically on the apron is: King of Upper and Lower Egypt, Lord of the Two Lands, Usermaatre-Chosen-of-Amun, Son of Re, Lord of Appearances, Pedubast-Beloved-of-Amun.

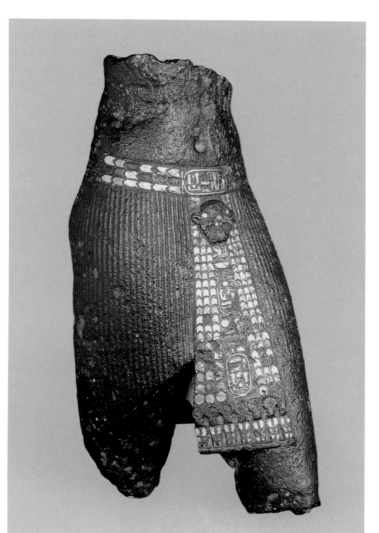

During the Third Intermediate period (1070–712 B.C.), a number of large, complex, and ornately decorated bronzes of royalty and high temple officials were produced. These spectacular works attest to the vitality and artistic confidence of an era characterized by many small kingdoms and by political ferment.

M H T L

BIBLIOGRAPHY
Assam, Maria Helena. *Colecção Calouste Gulbenkian: Arte egípcia.* Lisbon, 1991, p. 64, no. 16, and p. 65, colorpl.

EX COLL.
Count Gregory Stroganov, Rome; bought from Frederik Muller, Amsterdam, December 13, 1921, no. 612, through Duveen

8

STATUE OF THE COURTIER BES

Egyptian, Saite period
(Dynasty XXVI; reign of Psamtik I,
664–610 B.C.)
Compact limestone
H. 32.2 cm (12⅝ in.)
Inv. no. 158

This statue of Bes, "Count and Prince, Companion of His Majesty," is sculpted with great clarity and precision in fine-grained compact limestone similar to marble. On a rectangular plinth, Bes squats with his bent right leg lying flat, the foot tucked behind the heel of the other leg, which is bent but raised. His left hand lies open on his left knee, while his right hand grasps the edge of his kilt. This casual, natural pose was popular during the Old Kingdom (ca. 2649–2150 B.C.), the early part of the New Kingdom (ca. 1550–1070 B.C.), and again among the officials who served Psamtik I. Bes wears a smoothly curved bag wig. His youthful, slightly rounded face with tilted eyes and a faint smile prefigures the style that came to dominate the twenty-sixth dynasty, and the stylized elegance of his face is in pleasing contrast to his somewhat heavy body and limbs. His bare torso is attentively modeled, with prominent clavicles and a deep depression down the center of his chest. Small flowerlike nipples ornament his chest.

The prenomen and nomen of Psamtik I, the king Bes served, appear in cartouches on the upper right arm and the skirt. A long inscription beginning on the back pillar and ending on the upper side of the pedestal gives Bes's chief titles: Member of the Elite, High Official, Representative of the Subjects in Every Matter, Royal Acquaintance in the Nursery. The inscription also describes a royal offering by Harendotes of Khemmis on behalf of Bes and records a prayer—to the gods of the place called the Fields of Horus—for a good and eternal life for Bes, who "has not committed any sacrilege or raised his voice untowardly in the silence of the temple."

This dignified portrayal demonstrates a purity and harmony of form characteristic of the so-called Saite renaissance.　　　　M H T L

BIBLIOGRAPHY

Assam, Maria Helena. *Colecção Calouste Gulbenkian: Arte egípcia.* Lisbon, 1991, p. 80, no. 24, and pp. 81–83, colorpls.

EX COLL.

Rev. William MacGregor (until 1922; his sale, Sotheby's, London, July 8, 1922, no. 1628)

9

HEAD OF AN OLD MAN

Egyptian, Ptolemaic period
(ca. 200 B.C.)
Green schist
H. 9.5 cm (3¾ in.)
Inv. no. 46

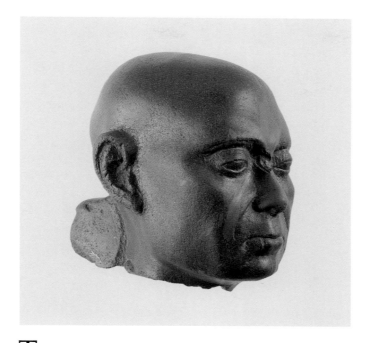

This old man's skull is beautifully modeled, with the bone and its ridges perceptible beneath the smoothly stretched skin of the cranium and the high forehead. The looser flesh of the face creates a topography of pouches and furrows. The eyes gaze out beneath heavy lids. The nose is somewhat small, with strongly arched nostrils. In the expanse created by the square jaw and the large area between the nose and upper lip, the mouth is tight, thin-lipped, perhaps a bit hard.

In Egyptian art older men, secure in their experience and power, were emblematic of a successful life. During the Late (ca. 712–332 B.C.) and Ptolemaic (332–30 B.C.) periods particular attention was given to depictions of aged men, resulting in many remarkable characterizations. This head of an old man is one of a group of highly individualized sculptures of men of experience datable to the Ptolemaic period.

M H T L

BIBLIOGRAPHY
Assam, Maria Helena. *Colecção Calouste Gulbenkian: Arte egípcia.* Lisbon, 1991, p. 100, no. 35, colorpl.

EX COLL.
Dr. Daniel-Marie Fouquet, Cairo (until 1922; his sale, Paris, June 19–20, 1922, no. 19, bought through Graat)

10

STEM CUP

Chinese (Jiangxi Province),
Yuan dynasty (1279–1368),
early 14th century
Glazed porcelain
H. 10 cm (3⅞ in.),
diam. 9.5 cm (3¾ in.)
Inv. no. 2372

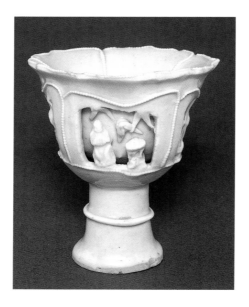

This exquisite cup is of a fine white, partially translucent porcelain with a glaze called *qingbai* (blue white) or *yingqing* (shadow blue), a more recent term. The rim is indented with five continuous bracket designs. The hollow stem thickens toward the base and has a partially glazed interior; the body is slightly orange where it was exposed to the air in the kiln immediately after firing. The outside of the cup is decorated with four recessed openwork panels in which scholars appear among bamboo. The panels are framed by a fine string of pearls in relief, a motif that is repeated on the rim and in the interior, where five strings of pearls meet in a central rosette reminiscent of a flower's corolla. The stem is circled by a band in relief.

Fine stoneware and translucent porcelains featuring little or no decoration and with a translucent light blue glaze were made in Jingdezhen, in Jiangxi Province, and must have been broadly utilized during the Song dynasty (960–1279), though they have not yet been identified in contemporaneous Chinese literature. While other wares produced under the Song were named after the places where they were manufactured, these wares were referred to by the descriptive term *qingbai*.[1] *Qingbai* wares are usually the first to merit the designation porcelain, defined in the West as a material that is hard, vitrified, resonant to percussion, and of a translucent white.[2]

This cup is part of a group of *qingbai* porcelains decorated with strings of pearls that were made from the end of the thirteenth to the middle of the fourteenth century for export. Besides various Buddhist figures ornamented with pearls, the group includes the famous Gaignières-Fonthill vase, with its molded floral panels and strings of pearls. This vase, thought to date from about 1300 and documented as the oldest Chinese porcelain to reach Europe, today is in the National Museum of Ireland, Dublin.[3] A similar vase is in the British Museum, London.[4] The same pearls and panels with flowers in relief occur on a wine jar *(guan)* from the early fourteenth century. Decorated in cobalt blue and copper red underglaze, the wine jar is in the collection of the Percival David Foundation, London (PDF B661).[5] This cup is also comparable in form and decoration to a white example, from the Zhengde era (1506–21) of the Ming dynasty, in the Vernon Wethered collection.[6]

M A P M

1. Regina Krahl, *Chinese Ceramics from the Meiyintang Collection* (London, 1994), vol. 1, p. 312.

2. Jason C. Kuo, ed., *Born of Earth and Fire: Chinese Ceramics from the Scheinman Collection*, exh. cat., Baltimore Museum of Art (College Park, Md., 1992), p. 94, no. 74, colorpl.

3. Arthur Lane, "The Gaignières-Fonthill Vase: A Chinese Porcelain of about 1300," *Burlington Magazine* 103, no. 697 (April 1961), pp. 124–32.

4. S. J. Vainker, *Chinese Pottery and Porcelain: From Prehistory to the Present* (London, 1991), p. 143.

5. *Imperial Taste: Chinese Ceramics from the Percival David Foundation*, exh. cat., Los Angeles County Museum of Art (San Francisco and London, 1989), p. 56, fig. 29.

6. R. L. Hobson, *The Wares of the Ming Dynasty* (New York, 1978), p. 92 and pl. 27, fig. 3.

BIBLIOGRAPHY
Jenyns, Soame. *Ming Pottery and Porcelain* (London, 1953), p. 23, pl. 3A.

EX COLL.
Henry Brown (until 1947; his sale, Sotheby's, London, March 25, 1947, no. 21, bought through Knoedler)

11

PLATE

Chinese (Jiangxi Province),
Ming dynasty (1368–1644),
early 15th century
Porcelain with underglaze
blue decoration
H. 7 cm (2¾ in.),
diam. 40.3 cm (15⅞ in.)
Inv. no. 2374

This large, deep plate was inspired by metal plates from the Near East.[1] It exemplifies one of the characteristic forms of fourteenth-century Chinese porcelain, which persisted, with some variations, into the fifteenth. The naturalistic decoration is painted in a skillfully variegated deep cobalt blue underglaze. In the center, bordered by a double circle, is a single curving branch of leaves and peonies—two blown, another opening, and still another in bud. On the cavetto there is a continuous scroll of flowers and lotus leaves, motifs that have long been part of the Chinese decorative repertoire. The peony, the queen of flowers, gained tremendous popularity in China during the Tang dynasty (618–907) and was later regarded as a symbol of riches and nobility; the lotus flower, symbol of purity, was venerated since the introduction of Buddhism in China. On the rim, the eight alternating sprays of fruit and flowers include the pomegranate, peach, persimmon, chrysanthemum, camellia, and gardenia; their style is characteristic of the fifteenth century. The outside features a stylized lotus scroll. The unglazed base turned a light pink during firing.

It is difficult to date precisely blue-and-white porcelain produced in the early fifteenth century, of which this plate is an excellent example.[2] Articles from the Yongle (1403–24) and Xuande (1425–36) periods of the Ming dynasty are not easy to distinguish, though Yongle porcelain rarely bore the *nianhao*, or reign mark, which in the Xuande era began to appear regularly on official wares. Under the Xuande emperor, there was an official interest in production from Jingdezhen, which is reflected in the more uniform style and the high quality of workmanship. These features can already be observed in this plate.

Plates like this one were exported to the Islamic market. Two with this shape and design, from the Ardabīl Shrine, are now in the Iran Bastan Museum, Tehran.[3] Two others are in the Topkapı Sarayı Museum, Istanbul.[4]

M A P M

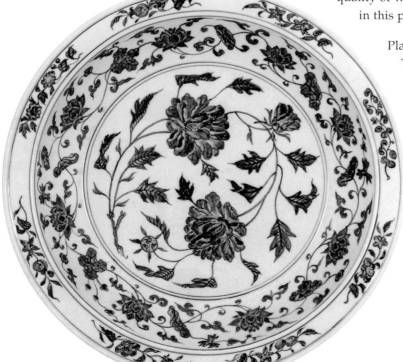

1. Regina Krahl, *Chinese Ceramics in the Topkapi Saray Museum, Istanbul*, vol. 2 (London, 1986), pp. 483–84.

2. Ibid., p. 486.

3. John Alexander Pope, *Chinese Porcelains from the Ardebil Shrine* (Washington, D.C., 1956), pl. 32, no. 29.65.

4. Krahl, *Chinese Ceramics*, vol. 2, p. 511, no. 598.

EX COLL.
 H. F. Parfitt (until 1946; his sale, Sotheby's, London, February 8, 1946, no. 37, bought through Knoedler)

MEDIEVAL
AND
RENAISSANCE ART

This diptych tells the story of the life and Passion of Christ in seventeen episodes. The arrangement is chronological, starting at the upper left and ending at the lower right. The order, from left to right across the leaves, is as follows: Annunciation, Visitation, Nativity and Annunciation to the Shepherds; Adoration of the Magi, Massacre of the Innocents; Flight into Egypt, Circumcision and Presentation in the Temple; Resurrection of Lazarus, Entrance into Jerusalem; Washing of the Feet, Last Supper; Agony in the Garden, Kiss of Judas and Arrest of Christ; Flagellation, Way to Calvary; and Crucifixion and Entombment. The diptych omits events that followed Christ's death, as well as those that preceded His Incarnation and Passion—the sin of Adam and Eve and the Expulsion from Paradise—which are shown in other extant examples. The arrangement is relatively natural for the present day (more natural yet would be to read one leaf at a time, from top to bottom) but was unusual in the fourteenth century, when *ymages d'yvoire* demanded an almost codified reading similar to that required for illuminated manuscripts. Nonetheless, this "natural" organization occurs in several related diptychs, for example, one in the Walters Art Gallery, Baltimore (71–272). The same artists who painted miniatures in Books of Hours and antiphonaries underscored the whiteness of ivories by applying blue, red, and gold pigments. While the present example lacks any vestige of the original polychromy, the diptych is otherwise in a perfect state of preservation.

Ivory diptychs, triptychs, and tabernacles were, like Books of Hours, owned both by nobility connected to the court and by feudal lords so that, in their private chapels and oratories, they could meditate upon the suffering of Christ and the possibility of redemption through His death. (This was the period of the Black Death [1347–50] and of the Hundred Years' War [1337–1453].) The format of the majority of these ivories was similar to that of a book, able to be opened and closed at will and easily transported.

This ivory has a close affinity with a group attributed to the Master of the Diptych of the Passion; other examples are in the Minneapolis Institute of Arts; the Walters Art Gallery, Baltimore; the Musée du Petit Palais, Paris; and the British Museum, London. They are probably late products of a Paris workshop that functioned during the reigns of Charles V (1364–80) and Charles VI (1380–1422); they found inspiration in the monumental carvings of the cathedral of Mantes and of the Portail de la Calende of Rouen cathedral. In the Gulbenkian ivory, the scenes are organized beneath arcades featuring trefoils, floral ornaments, and decorated finials. Each tableau is set off from the one above by pearl-like borders. The pillow of the Virgin in the scene of the Nativity and the sarcophagus in the final scene are decorated with an incised or carved lozenge pattern.

M R F

BIBLIOGRAPHY
Koechlin, Raymond. *Les ivoires gothiques français.* Paris, 1924, vol. 2, no. 813 *bis*.

Ex coll.
S. E. Kennedy (until 1918; his sale, Christie's, London, March 20, 1918, no. 386, bought through Agnew)

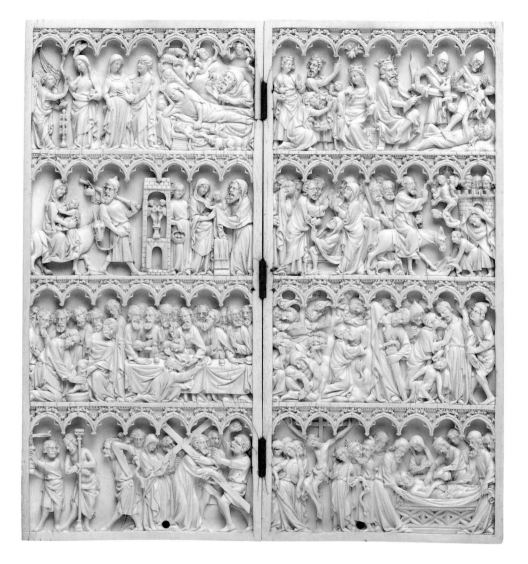

12

DIPTYCH WITH SCENES FROM THE
LIFE AND PASSION OF CHRIST

French, ca. 1375–1400
Ivory
26 × 23.5 cm (10¼ × 9¼ in.)
Inv. no. 133

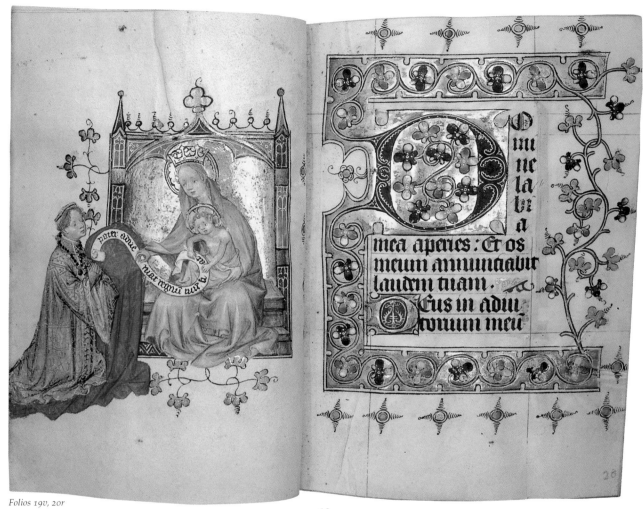

Folios 19v, 20r

13

HOURS OF MARGARET OF CLEVES

Netherlandish (probably Utrecht), ca. 1395–1400
Parchment
13.2 × 9.6 cm (5 ¼ × 3 ¾ in.)
Inv. no. L. A. 148

Margaret of Cleves (ca. 1375–1411) was the daughter of Adolph of Mark, count of Cleves (d. 1394), and Margaret of Berg (d. 1425). In 1394, she became the second wife of Albert, duke of Bavaria-Holland, and moved to his capital at The Hague. Thanks to Albert's patronage, The Hague had become an important cultural center with a notable production of illuminated manuscripts. Books of Hours, with prayers and texts for private devotion, were among the manuscripts commissioned by members of Duke Albert's court at The Hague. In the present Hours, containing 283 folios, an inscription added at the conclusion of the Office of the Dead records that the manuscript was to be preserved in Margaret of Cleves's memory at the Dominican convent of Schönensteinbach, in Upper Alsace.

Executed probably by a court painter at The Hague or by a professional illuminator in Utrecht, during the last years of the fourteenth century, Margaret of Cleves's Book of Hours contains five major sections: a calendar, the Hours of the Virgin, the Short Hours of the Holy Spirit, the Seven Penitential Psalms and Litany of the Saints, and the Office of the Dead. The illuminations are the most original element in the Lisbon manuscript and include eleven full-page miniatures whose subjects are enclosed in tabernacle-like frames. Some figures and objects are shown breaking or overlapping the frames. This compositional device, though not unique to the Hours of Margaret of Cleves, is exploited to great expressive effect and underscores the emotional impact of the scenes depicted.

The Hours of the Virgin is the only text that contains a cycle of miniatures rather than a single illustration. The cycle begins, on folio 19v, with an image of the patron before the enthroned Virgin and Child. Earlier works portrayed the donors either outside or fully within the space of the Virgin and Child. Here, however, Margaret—represented as a richly attired noblewoman— both kneels before the sacred space and inhabits it. She is also portrayed on the same scale as the Virgin. Parts of Mary's throne and mantle overlap the frame, as if Mary were coming forward and entering, in turn, the world of the donor. The reciprocity between the secular and divine realms is accentuated by the exchange of glances between the figures. As if in response to the prayer of the duchess, the Virgin and Child turn toward her and point to a scroll whose text is taken from the Lord's Prayer. The Child writes the word *fiat*, from *fiat voluntas tua* (Thy will be done).

The manuscript is bound in red velvet over wooden boards.

<div align="right">M F</div>

BIBLIOGRAPHY
Marrow, James H. *As Horas de Margarida de Cleves / The Hours of Margaret of Cleves*. Lisbon, 1995.

EX COLL.
Margaret of Cleves (d. 1411); Schönensteinbach convent, Upper Alsace (after 1411); Madame de Cauly (1879); Librairie Damascène Morgand, Paris (1890); Madame Poullier-Ketele (until 1924; her sale, J. & A. Le Roy Frères, Brussels, May 15–17, 1924, no. 8, bought through Henri Leclerc)

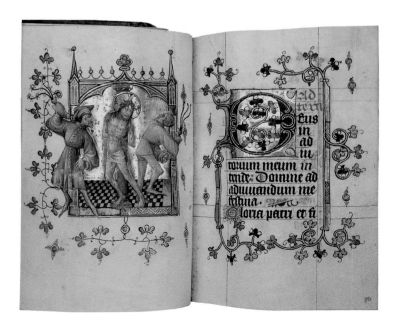

The Flagellation (fol. 79v); opening of terce, from the Hours of the Virgin (fol. 80r)

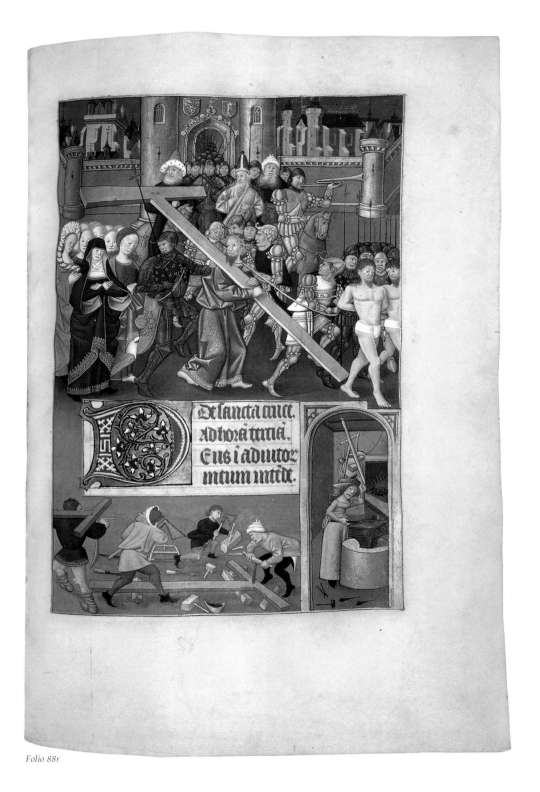

Folio 88r

14

BOOK OF HOURS

French, ca. 1450–60
Parchment
25 × 17 cm (9⅞ × 6¾ in.)
Inv. no. L. A. 135

The sumptuousness of this Book of Hours results from the profuse decoration of its folios, from small paintings in the margins to miniatures that fill entire pages. The manuscript was produced in the Loire region by an artist whose style closely resembles that of the Master of Jouvenel des Ursins, who was so designated after the recipient of his most important work, the *Mare historiarum* (ca. 1448–49) of Giovanni Colonna: Guillaume Jouvenel des Ursins, chancellor of France during the reigns of Charles VII (1422–61) and Louis XI (1461–83).[1] The miniaturist's virtuosity in the present case is evident from his use of harmonious coloring based on multihued tonalities. The contours of the figures and the fall of drapery are underscored by subtle gilded details. Other characteristics of this artist's style include the superimposition of planes in the creation of perspective, as well as detailed treatment of landscape and architectural backgrounds.

The texts that compose this Book of Hours are framed by margins filled with branches and arabesques highlighted in gold, where the artist has given free rein to his imagination, placing at their center small pictures that either portray fantastical beasts or illustrate the adjacent text.

The miniatures of the calendar, typically, represent the occupations of the months. In them, scenes of daily life in fifteenth-century France are presented with great freshness and luminosity—for example, the pruning of trees (March), the harvest (July), the gathering of fruit (August), the vintage (September), and the sowing of the fields (October) are juxtaposed with merrymaking (May), hunting (October), various ball games (February and July), and, finally, playing in the snow (December). The twelve signs of the zodiac appear prominently.

The miniature of the Way to Calvary, on folio 88r, is one of the illustrations of the Hours of the Cross. Crowned with thorns, Christ carries to Golgotha the Cross on which he will be crucified, preceded by the two thieves who have also been condemned. In the foreground of the densely populated scene, Christ turns to gaze sadly at his mother, who accompanies him supported by Holy Women. Two smaller miniatures accentuate, by their pragmatic content, the cruelty of this scene. In the first miniature, workers in a great bustle are constructing the Cross, while in the second, a woman with a wicked look is fashioning the nails that will shortly be put to use.

On folio 151v, preceding the Suffrages of the Saints, the Holy Trinity appears surrounded by angels and, in the corners, by the symbols of the four Evangelists. A smaller miniature at the bottom shows a female saint praying.

Although the owner of this Book of Hours is unknown, below the miniature on folio 147r portraying the Virgin and Child there is an image of a woman in prayer that undoubtedly represents the book's patron. The volume contains 173 folios and is bound in blue velvet. M F

Folio 151v

1. François Avril and Nicole Reynaud, *Les manuscrits à peintures en France, 1440–1520,* exh. cat., Bibliothèque Nationale (Paris, 1993), pp. 109–10.

Ex coll.
 H. Bordes [ex-libris]; Frédéric Engel-Gros, Château de Ripaille, Thonon, Savoy (until 1921; his sale, Georges Petit, Paris, June 2, 1921, no. 3, bought through Henri Leclerc)

15

HOURS OF
ALFONSO I D'ESTE

Italian (Ferrara), ca. 1506–7
Parchment
27 × 18.5 cm (10⅝ × 7¼ in.)
Inv. no. L. A. 149

Folio 14r

Among the twenty-five European illuminated books in the Gulbenkian collection, the Hours of Alfonso I d'Este is perhaps the manuscript with the most troubled history. Produced at the beginning of the sixteenth century for Alfonso I d'Este (1476–1534), third duke of Ferrara, Modena, and Reggio, the volume was kept in the Este library in Modena until 1859. It was then taken by Duke Francis V to Vienna, where it remained until the deposition of Emperor Charles I in 1918 and the fall of the Austro-Hungarian Empire. When the Hours of Alfonso I d'Este entered the Gulbenkian collection, it was lacking fourteen full-page miniatures separated at an unknown date. These miniatures had been bought from an antique-book dealer by Bishop Strossmayer, and today are in the Strossmayer Gallery, Zagreb. The Zagreb miniatures are large and borders have been excised.

The Hours of Alfonso I d'Este retains nineteen splendid illuminated pages attributed to Matteo da Milano, who worked in Ferrara from the end of the fifteenth century until about 1512. The most spectacular examples of Matteo's artistry are the exuberant margins that border the opening pages of the offices, combining Flemish, German, and northern Italian elements with decorative motifs typical of Renaissance classicism. Using gold stippling and brilliant colors on gilded or black grounds, Matteo represented pearls, cameos, and precious gems amid flowers, fruit, beasts, and fanciful grotesques. Heraldic emblems and devices of the patron, most set inside medallions, complete the decoration.[1]

On folio 14r, the opening of the Gospel of Saint John, the initial I is embellished with the bust of the saint at prayer. Small medallions in the side margins give Alfonso's name and his ducal title (Dux Ferrariae III), while the upper and lower margins contain emblems alluding to the warfare that was so prevalent during his rule. A grenade with flames escaping from three openings symbolizes the might of his artillery. Seven arrows bound with a ribbon are emblematic of Alfonso's cunning and capacity for rapid intervention, and of the strength of the alliance upon which his victories depended.

The inventiveness of the painter is especially evident in the small miniature that decorates the initial letter of the opening of the Office of the Dead, on folio 94r. Death—a skeleton in women's attire, with a garland of flowers and a necklace of pearls—gazes at herself in a mirror. Her reflection is an image of mankind's irreversible destiny.

In its present state, the volume contains 179 folios. The eighteenth-century red calfskin binding is decorated with gilt interlaces and floral motifs. M F

1. Paola di Pietro Lombardi, "Le imprese Estensi come ritratto emblematico del principe," in *La corte di Ferrara*, vol. 1 of *Gli Estensi*, exh. cat., Biblioteca Estense Universitaria (Modena, 1997), pp. 183–231.

BIBLIOGRAPHY
Toniolo, Federica. "A proposito del Libro d'Ore di Alfonso I," *Miniatura* 2 (1989), pp. 149–51, illus.

EX COLL.
Alfonso I d'Este (d. 1534); by family descent to Francis V of Austria-Este, Modena and Vienna (1846–d. 1875); by family descent to Charles I, emperor of Austria, Vienna and Funchal, Madeira (1916–d. 1922); bought from J. Bourdariat, Paris, on May 2, 1924

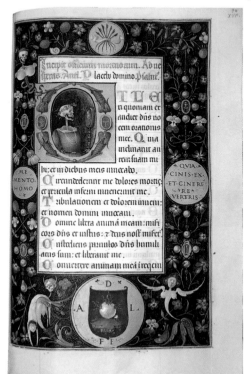

Folio 94r

16

MATTEO DE' PASTI
(Italian, active 1441–67/68)

ISOTTA DEGLI ATTI,
WIFE OF SIGISMONDO PANDOLFO MALATESTA
(ob.)

ELEPHANT
(rev.)

Rimini, 1446
Bronze
Diam. 8.4 cm (3¼ in.)

Inscribed on obverse:
ISOTE.ARMINENSI.FORMA.ET.VIRTVTE.ITALIE.DECORI.
(For Isotta de Rimini, ornament of Italy through her beauty and
virtue); on reverse: *OPVS.MATHEI.DE.PASTIS.V[ERONENSIS]*
(The work of Matteo de' Pasti of Verona); *M.CCCC.XLVI.*

Inv. no. 2419

Isotta degli Atti (1432/33–1474) came from a noble family in Rimini that had grown wealthy through the wool business. She was the great love of Sigismondo Pandolfo Malatesta (1417–1468), the lord of Rimini, condottiere, and patron of the arts, who fell in love with her in 1445/46, when she was barely thirteen. Although he took her as his lover at that time, he did not marry her until ten years later, after the death of his second wife, Polissena Sforza. Isotta's beauty and virtues were sung by the humanist poets Basinio and Porcellio in their *Isottaei,* and her talents were recognized even by Pope Pius II, a staunch enemy of Sigismondo. Long before she officially became the lady of Rimini, Pope Nicholas V authorized Isotta, through a bull dated September 12, 1447, to undertake construction of the Chapel of the Angels in the church of Saint Francis in Rimini, in preparation for the eventual installation of her tomb.

It is generally conceded that the date 1446 borne by the medal does not correspond to the date when it was pro-

duced but is, rather, a symbolic date commemorating the beginning of Sigismondo's relationship with Isotta. Fourteen forty-six was a year replete with successes for Sigismondo, who, besides winning Isotta, consolidated his public power and inaugurated his new castle. Thus the date 1446 came to be written on almost all the monuments of his reign, including the most notable, the Tempio Malatestiano, a church dedicated to Saint Francis of Assisi but in the form of a pagan temple, which was designed by Leon Battista Alberti with elaborate interior carvings by Agostino di Duccio under Matteo de' Pasti's supervision.

The commemorative medal with the profile of the person honored on the obverse and a scene or symbol related to that figure on the reverse was still a novelty when Sigismondo decided to commission Matteo de' Pasti, painter of miniatures, architect, sculptor, and medalist, with the making of this one. Matteo had begun his career as an illuminator, first in Venice, then in the service of Piero de' Medici, and later in Verona, the place of his birth. He is documented in Rimini in 1449, working for Sigismondo Malatesta and going on to become one of the artists in whom Sigismondo showed the greatest confidence. As a medalist Matteo de' Pasti closely followed the example of Pisanello (about 1395–1455), who had retrieved the art of commemorative medals from antiquity, reinventing it and placing it at the service of his contemporaries.

The elephant chosen for the reverse was one of Sigismondo's preferred motifs from classical antiquity, and he used it as a device on a number of his undertakings. The inscription at the entrance of the Biblioteca Malatestiana at Cesena—*Elephas Indus culices non timet* (The elephant of India does not fear mosquitoes)—is a symbolic expression of the power of the Malatesta line. Pasini explains the elephant's presence on medals representing Isotta as a sign of her contribution to Sigismondo's fame and power.[1]

The roses and rosebushes that appear on both sides of the medal are obviously symbolic of the great passion to which this work bears witness. A rose with four petals is also an element of the Malatesta coat of arms.

The great number of medals representing Isotta that have survived testifies to the wide diffusion Sigismondo intended to give the image of his third wife and is proof not only of his love—they celebrate Isotta's beauty, virtue, and intelligence—but also of the splendor and éclat of his court. Sigismondo deposited large quantities of medals, representing both Isotta and himself, in the foundations or within the walls of the edifices he built, in order to perpetuate his and Isotta's fame and to guarantee their immortality—a custom derived from Roman antiquity.

A second medal of Isotta by Matteo de' Pasti in the Gulbenkian collection shows her at an older age, probably about 1453, by which time she was formally a member of the Malatesta family.

M R F

1. Pier Giorgio Pasini, "Matteo de' Pasti: Problems of Style and Chronology," in *Italian Medals,* vol. 21 of *Studies in the History of Art* (Washington, D.C., 1987), pp. 143–59.

BIBLIOGRAPHY
Ferreira, Maria Teresa Gomes, and Maria Isabel Pereira Coutinho. *Colecção Calouste Gulbenkian: Medalhas do renascimento.* Lisbon, 1979, n.p., no. 9, illus.

EX COLL.
Bought probably before 1896

17

Probably by Niccolò di Forzore Spinelli, called Niccolò Fiorentino
(Italian, Florentine, 1430–1514)

Filippo Strozzi
(ob.)

Eagle and Coat of Arms
(rev.)

ca. 1489
Bronze
Diam. 9 cm (3½ in.)

Inscribed on obverse: *PHILIPPVS•STROZA*

Inv. no. 2399

Filippo Strozzi (1428–1491) belonged to a family of Florentine bankers almost as important as the Medici. The Strozzi, their fortune having been confiscated, were banished from the city for political reasons in 1434. To Filippo belongs the credit for restoring the family's fortunes (by starting a bank in Naples), reasserting the family's power (by returning to Florence in 1466), and initiating construction of a monumental palace on Florence's via Tornabuoni. Among those engaged in building this famous palace was Benedetto da Maiano (1442–1497), who also sculpted for it the celebrated marble bust of Filippo that is today in the Musée du Louvre, Paris. The similarity between that portrait and the one on this medal led an earlier generation of scholars to attribute the medal to Benedetto da Maiano.[1] Hill classified the medal as "in the manner of Niccolò Fiorentino."[2]

The medalist Niccolò di Forzore Spinelli, called Niccolò Fiorentino, was one of the most faithful portrayers of leading Italian figures of the Renaissance. He gave scant attention, however, to the reverses of his medals, which are often slack and without formal conviction. This medal, if by him, is his best. Obverse and reverse are exceptionally strong. The obverse shows the patrician aged yet vigorous, wrinkled yet confident and supremely dignified. On the reverse, an eagle spreads its wings as it settles on a tree stump to which a shield bearing the Strozzi arms (incorporating three crescent moons) is tied. This scene set in a landscape of pine trees, the field semé with plumes shed by the eagle, is a proud armorial announcement of Filippo's puissance. The medal was doubtless produced for the raising of his palace: the contemporary diarist Luca Landucci speaks of the burial of "certain medals" in the palace's foundations on August 6, 1489, and they must have included specimens with this composition.[3]

M R F

1. Julius Friedlaender, *Die italienischen Schaumünzen des fünfzehnten Jahrhunderts (1430–1530)* (Berlin, 1882), p. 141, no. 1.

2. George Francis Hill, *A Corpus of Italian Medals of the Renaissance before Cellini* (London, 1930), no. 1018.

3. Luca Landucci, *A Florentine Diary from 1450 to 1516,* trans. Alice de Rosen Jervis (London, 1927), p. 48.

Bibliography
Ferreira, Maria Teresa Gomes, and Maria Isabel Pereira Coutinho. *Colecção Calouste Gulbenkian. Medalhas do renascimento.* Lisbon, 1979, n.p., no. 22, illus.

Ex coll.
E. Gutman; bought from Kurt Walter Bachstitz, The Hague, on March 23, 1925

18

STEFAN LOCHNER
(German, ca. 1400–1451)

PRESENTATION IN
THE TEMPLE
(ob.)

STIGMATIZATION OF
SAINT FRANCIS
(rev.)

Cologne, 1445
Tempera and oil(?) on oak
35.5 × 22.5 cm (14 × 8⅞ in.)

Dated top of *Presentation: 1445*

Inv. no. 272

Painted on both sides, this panel was originally the right wing of a tripartite altarpiece dedicated to the Incarnation and Passion of Christ. When open, the triptych showed scenes from Christ's infancy: the left wing, with the Nativity, is in the Alte Pinakothek, Munich, while the central panel, probably an Adoration of the Magi, has been lost. When closed, the altarpiece juxtaposed the Crucifixion (reverse of the Nativity) with the Stigmatization of Saint Francis (reverse of the present panel). The triptych was completed in 1445. Lochner painted a larger version of this subject two years later that is now in the Hessisches Landesmuseum, Darmstadt.

The *Presentation in the Temple,* framed by a diaphragm arch, takes place in a vaulted chamber, with the figures standing around an altar. According to the law of Moses, who is depicted in the window at the back of the scene, every Jewish couple must consecrate—or present—their first-born son to God, in memory of Israel's deliverance from Egypt, and so Mary and Joseph brought the Christ Child to the temple. Joseph holds a basket with two turtledoves, the offering of the poor. The prophetess Anna folds her hands in prayer. Described in the Gospels as an eighty-four-year-old woman, she has a wrinkled face that contrasts with the Virgin's youthful countenance. The playful gesture of the Christ Child in the arms of the priest Simeon softens the solemnity of the group.

Lochner was the most illustrious painter in fifteenth-century Cologne. The diaphanous canopy that casts a shadow on the rear wall of the room evinces his keen awareness of the potential of light as a space-creating device. Lavishing attention on detail, Lochner distinguishes velvet from fur, gems from pearls, and marble from other types of stone. His figures, clad in heavy, angular draperies, have a strong volumetric presence. Lochner's adoption of these formal means reveals his knowledge of works by the Netherlandish artists Jan van Eyck (before 1395–1441) and Rogier van der Weyden (1399–1464), as does his use of the diaphragm arch, a principle of spatial organization favored by Rogier. At the same time, Lochner remains indebted to the Cologne painting tradition, especially in his rich, vibrant palette, his abundant use of gold, his facial types, and his formal elegance, which recall the *Weicher Stil* (soft or beautiful style) of the early fifteenth century. The appeal of Lochner's art, of which the *Presentation* is an exquisite example, results from his synthesis of these two traditions.

The back of the *Presentation* depicts, in a less elaborate style, Saint Francis receiving the stigmata from Christ, who appears as a seraph on the Cross. The steep rocky landscape is an allusion to La Verna, the mountain where the miracle purportedly occurred. The *Stigmatization of Saint Francis* has sometimes been attributed to Lochner's workshop, but the picture is now generally ascribed to Lochner himself. It is not uncommon for the scenes on the exterior of an altarpiece to exhibit a more rapid execution than the scenes on the inside, and Lochner's work is no exception.

L S

BIBLIOGRAPHY

Zehnder, Frank Günter, ed. *Stefan Lochner: Meister zu Köln. Herkunft–Werke–Wirkung.* Exh. cat., Wallraf-Richartz-Museum. Cologne, 1993, pp. 326–27, no. 47, colorpls.

EX COLL.

Bettendorf, Aachen, by 1817–18; John Rushout, second Baron Northwick, Thirlestaine House, Gloucestershire (by 1858–d. 1859; his estate sale, Phillips, Thirlestaine House, August 9, 1859, no. 919, as by Meister Wilhelm, to Redfern); James Jones, Lechlade Manor, Gloucestershire (until 1921; his estate sale, Knight, Frank & Rutley, Lechlade Manor, June 24, 1921, no. 955, as by Meister Wilhelm); bought from Duveen, London, on August 22, 1921

Reverse

19

DOMENICO
GHIRLANDAIO
(Italian, Florentine,
1449–1494)

PORTRAIT OF A
YOUNG WOMAN

ca. 1485
Tempera on wood
44 × 32 cm (17 3/8 × 12 5/8 in.)
Inv. no. 282

One of Domenico Ghirlandaio's most important commissions was for the fresco decoration of the Sassetti Chapel, in the Florentine church of Santa Trinita, with scenes from the life of Saint Francis of Assisi. The fifth and principal scene, which dates from 1484–85 and occupies the back wall of the chapel, represents the miracle of Saint Francis Raising the Dead Child. The sitter for the Gulbenkian picture is reminiscent of the young women at the left in the fresco, onlookers who are thought to be the five daughters of the chapel's patron, Francesco Sassetti (1421–1490), a financial adviser to Lorenzo the Magnificent.[1] A closely related half-length of a perhaps slightly older woman is in the collection of the Metropolitan Museum.[2] It, too, can be dated to about 1485. Unfortunately, however, neither portrait can be specifically identified as one of the sisters represented in the fresco.

A third painting of a girl, which is of precisely the same size and format as that in the Gulbenkian, belongs to the National Gallery, London.[3] The inferior quality of the London portrait suggests an attribution to Ghirlandaio's workshop rather than to the master himself. Despite the correspondence in size, the Lisbon and London portraits cannot be pendants, as the London work is related stylistically to the frescoes commissioned from Ghirlandaio to decorate the Tornabuoni Chapel in the church of Santa Maria Novella and was probably painted some five years later, in about 1490.

The young woman here is dressed in the Florentine fashion of her day, in a tight-fitting bodice laced at the front and with sleeves of a contrasting color. She wears a short string of coral beads around her neck. Typically, her hair is parted at the center and drawn tightly back and bound, but with loose locks framing her face. Her torso is frontal with shoulders well back, while her wide-open eyes impart a frank, ingenuous look. The figure is set forward in the picture space against a dark solid background, engaging the attention of the observer. Despite the smooth decorative contours and, doubtless, a degree of idealization, the young woman displays a fresh naturalism and individuality that are characteristic of Ghirlandaio's distinguished work in this genre.

L S

1. Ronald G. Kecks, *Domenico Ghirlandaio* (Florence, 1998), pp. 132–35, colorpls., and p. 137.

2. Federico Zeri, with the assistance of Elizabeth E. Gardner, *Italian Paintings: A Catalogue of the Collection of The Metropolitan Museum of Art*, [vol. 1], *Florentine School* (New York, 1971), p. 136, illus., and p. 137, acc. no. 32.100.71, illus.

3. *National Gallery Illustrated General Catalogue*, 2nd rev. ed. (London, 1986), p. 228, acc. no. 1230, illus.

BIBLIOGRAPHY
European Paintings from the Gulbenkian Collection. Exh. cat., National Gallery of Art. Washington, D.C., 1950, p. 36, no. 13 (text by Fern Rusk Shapley), and p. 37, illus.

EX COLL.
Count Savonelli, Rome (until 1860); Georges Spiridon (1860–d. 1887); Joseph Spiridon, Paris (1887–1929; his sale, Cassirer & Helbing, Berlin, May 31, 1929, no. 29); bought from Arthur Julius Goldschmidt in June 1929, through Duveen

Islamic Art

21

BOWL

Iranian (Rayy or Kāshān),
late 12th–
early 13th century
Overglaze-painted
composite body
H. 8 cm (3⅛ in.),
diam. 18 cm (7⅛ in.)
Inv. no. 935

In the golden age of Iranian ceramic production at the end of the twelfth century and the beginning of the thirteenth, pottery of high quality and technical, stylistic, and thematic variety was created. The final stage in this Seljuq-period evolution in ceramic making consisted of polychromatic decoration. Attempting to increase ceramics' chromatic range, Iranian potters developed two types of ware: so-called *mīnāī* (enameled) and *lājvardīna* (lapis lazuli).

Mīnāī decoration—known also as *haft-rang* (seven colors), the description that best fits the technique—was the first to be tried. As many as seven basic colors were used: green, blue, brown, black, red, gold, and white, and different tones thereof. (On some occasions yellow was used instead of gold.) The pieces were fired twice, first at elevated temperatures for glazing and for the more stable colors, then at a temperature below 600° C to set the more fragile pigments and the gold. By exploiting different melting points, the running or mixing of colors was avoided. In the thirteenth century, *mīnāī* provided a starting point for the *lājvardīna* method in which successive layers of gold leaf were applied over the glaze on a blue (or, sometimes, white) ground.

Mīnāī ceramics, considered valuable luxury objects, were without doubt the crowning glory of the twelfth- and thirteenth-century craftsmen of Kāshān, one of the most important artistic centers of medieval Iran. Other manufacturing centers, such as Rayy, Saveh, and Natanz, were also dedicated to *mīnāī* work. The existence of a piece that combines the *mīnāī* technique with Rayy-style luster painting appears to remove any doubt about Rayy's significance as a locus of *mīnāī* pottery.[1] (Not all manufacturing centers have been identified, and the provenance of some pieces awaits scientific confirmation. Such is the case with this bowl, which, according to available documentation, was excavated at Rayy.)

Mīnāī decoration appears to have favored figurative scenes over geometric or pseudovegetal compositions. The subjects depicted include views of court or scenes from epic literature, inspired by the miniatures found in manuscripts of the period. This footed bowl with an octagonal lobed rim takes its visual inspiration from Chinese porcelain. The court scene represented on the inside shows a young prince seated on a high-backed throne and surrounded by four horsemen alternating with pairs of confronted falcons. The horsemen hold polo mallets—polo was one of the favorite pastimes of the Iranian court. On the exterior is a calligraphic inscription wherein the bowl's owner is wished a long life and power. M Q R

1. *Islamische Kunst: Meisterwerke aus dem Metropolitan Museum of Art, New York/The Arts of Islam: Masterpieces from The Metropolitan Museum of Art, New York*, exh. cat., Museum für Islamische Kunst (Berlin, 1981), p. 92, no. 31 (text by Marilyn Jenkins).

BIBLIOGRAPHY
Mota, Maria Manuela. *Louças seljúcidas.* Lisbon, 1988, pp. 86–87, no. 23, colorpls. and illus.

EX COLL.
Bought from Kevorkian on August 19, 1912

22

BOWL

Iranian (Rayy),
late 12th–
early 13th century
Overglaze-painted
composite body
H. 8 cm (3⅛ in.),
diam. 20 cm (7⅞ in.)
Inv. no. 932

At the beginning of the eleventh century, under the dominion of the Seljuq Turks from Central Asia, Iranian ceramic production developed in unprecedented fashion in such urban centers as Rayy and Kāshān. When the power of the Seljuqs (1038–1194) declined, the Iranian area continued to be ruled by Turkic atabegs related to the Seljuqs. Thus the pottery produced in Iran from the second half of the twelfth century to the first quarter of the thirteenth century, after which the Ilkhanid Mongols arrived from the East and destroyed Iran's urban centers, is designated as Seljuq.

One of the technical innovations that revolutionized medieval Iranian pottery was the production of a ceramic body made of pulverized quartz, potash, and very fine white clay found near Kāshān. The glaze, of similar composition, adhered easily to the body during high-temperature firing. In addition, improvement in the quality of glazing through the utilization of fusing agents made possible painting on top of a transparent glaze. This hitherto impractical technique probably was first successfully attempted in Kāshān about 1200.

In their effort to rival Chinese porcelain, which was highly esteemed in the Middle East, Iranian potters succeeded in creating a composite body with characteristics akin to those of porcelain. A treatise written in 1301 by Abū al-Qāsim, a member of a Kāshān family of potters, describes in detail the manufacturing processes for various types of medieval ceramics.

This footed bowl, decorated in the *mīnāī* technique, bears a symmetrically arranged pseudo-vegetal design very similar to that of a bowl in The Metropolitan Museum of Art (27.13.8).[1] The complex composition on the interior of the bowl consists of interlocking arabesques and stylized vegetal motifs. The symmetrical arabesques, the light blue and the turquoise beneath the glaze and the dark red and the black over the matte glaze, radiate from a central medallion with six pineconelike motifs.

The colors over the glaze were applied to the already-fired piece in the manner of enamels—the same method as was used to produce Syrian enameled glasswork in the Mamluk period (see cat. nos. 23, 24)—then set in a second firing at low temperature. Objects created by this technique became known as *mīnāī*, the Persian word for "enameled."

On the inside rim of this bowl there is an inscription in flowery Kufic script. On the exterior is a turquoise blue inscription in *naskhī* script.
 M Q R

1. *Islamische Kunst: Meisterwerke aus dem Metropolitan Museum of Art, New York / The Arts of Islam: Masterpieces from The Metropolitan Museum of Art, New York,* exh. cat., Museum für Islamische Kunst (Berlin, 1981), p. 92, no. 31 (text by Marilyn Jenkins), and p. 93, illus.

BIBLIOGRAPHY
Mota, Maria Manuela. *Louças seljúcidas.* Lisbon, 1988, pp. 82–83, no. 21, colorpls. and illus.

EX COLL.
Arthur Sambon (until 1914; his sale, Georges Petit, Paris, May 25–28, 1914, no. 159)

23
MOSQUE LANTERN

Syrian or Egyptian, 14th century
Free-blown, tooled,
enameled, and gilt glass
H. 31 cm (12¼ in.)
Inv. no. 1033

Enameled-and-gilt-glass mosque lanterns from the Mamluk period (1250–1517) follow certain formal conventions, with some variation in structure and decorative vocabulary. The wide body, covered with inscriptions in *thuluth* script concerning the individual who commissioned the piece or with floral decoration, contains six suspension rings for chains. The verse from the Qur'an (24:35) dealing with Divine Light usually appears, in whole or in part, on the flared neck.

Mamluk taste favored calligraphic and vegetal decoration, which are recurrent elements in the enameled-and-gilt glasswork made in Syria or Egypt. Figurative compositions were replaced by arabesques, geometric ornament, and passages of *thuluth* script often interrupted by emblems of the emirs in office. The use of emblems expanded in the Syrian and Egyptian lands in the first half of the thirteenth century. It has been suggested that certain emblems are related to *furūsiyya*, the military training exercises of the Mamluks, which included horse races. Mamluks who were part of the imperial guard (*khaṣṣakiyya*) and constituted the reserve of officers for the sultan in power either chose or had attributed to them, according to their capabilities and the exercise for which they displayed the most aptitude, the characteristic symbol of that exercise. The emblems related to the *furūsiyya* appear almost exclusively in the first century of Mamluk rule. Mamluk emblems appeared regularly (with countless variations) in architecture as well and were subject to rigorous rules. Although questions about them remain, Mamluk emblems are a fundamental tool in dating works of art.

One of the rarer emblems shows a horse carrying on its back a structure that resembles a tent. This emblem and a dedication to ʿAli ibn Baktamur appear on this mosque lantern. The inscription on the neck and body of the lantern reads: "This is one of the objects made for the mausoleum of the late emir Ala al-Din ʿAli, son of His Excellency Saif al-Din Baktamur, the Chamberlain [al-ḥajīb], may God protect him with His Mercy." On the neck, the inscription is interrupted by a medallion divided into three fields; the upper and lower fields are white, while the central field features a horse with a palanquin on its back, on a scarlet ground. The palanquin, or probably a ceremonial cubicle, suggests a small, red leather tent in the form of a cupola (*qubba*) that served in remote times to transport a sacred object on the back of a camel. It later became a symbol of authority, splendor, and power, coming to represent the authority of the sultan himself. This emblem appears on coins, objects, and even in architectural decoration.

The British Museum, London, owns a copy of this lantern (1902.11–18.1) from the collection of Baron Gustave de Rothschild, signed and dated by Philippe-Joseph Brocard and made for the 1867 Exposition Universelle in Paris. M Q R

BIBLIOGRAPHY
Oriental Islamic Art: Collection of the Calouste Gulbenkian Foundation/L'art de l'orient islamique: Collection de la Fondation Calouste Gulbenkian Exh. cat., Museu Nacional de Arte Antiga. Lisbon, 1963, n.p., no. 5 (text by Ernst Kühnel), illus.

EX COLL.
Philip Sassoon (until 1919, bought on November 8, 1919, through Duveen)

24

CYLINDRICAL LANTERN

Syrian or Egyptian, 14th century
Free-blown, tooled, enameled,
and gilt glass
H. 27.5 cm (10⅞ in.)
Inv. no. 2377

During the Mamluk period (1250–1517), Egypt and Syria were ruled by a dynasty that arose from a class of military slaves; until the Ottomans defeated the Mamluks, they experienced times of particular economic prosperity and cultural splendor. The glass industry, which had existed in Syria, Egypt, Iran, and the Mesopotamian region even before the Arab conquest, reached its apogee in Syria and Egypt at the end of the thirteenth century and during the fourteenth century. About 1400 Timur (Tamerlane; 1336–1405) sacked Damascus and Aleppo, which were important glass-producing centers, and, according to the account of the Spanish ambassador to Timur's court, Ruy González de Clavijo, relocated the master glassmakers and enamelers to Samarqand, in central Asia—though no glass production from Samarqand is known.[1]

The technique of enameled-and-gilt glass for which the Syrian glassmakers were famous is considered one of Islam's principal contributions to the art of glass. This technique, possibly tried for the first time in the twelfth century in Raqqa, in Syria, developed over subsequent centuries. Syrian glassmakers at the end of the Ayyubid dynasty (1169–1260) introduced an innovation consisting of enameled-and-gilt decoration set by heat. After fusing the colored-glass paste applied to the surface of the finished piece, it was possible to utilize many different colors. Repeatedly, the object was slowly reheated at the door of the furnace until fusion occurred. For gilding, however, it was necessary to return the piece to the oven, at a low temperature.

This cylindrical lantern is decorated in blue, red, green, yellow, and white enamel, with red outlines. It has two sections separated by a prominent ring about 17 centimeters (6¾ inches) from the base, probably intended to support the object, which would be fitted into a metal holder and hung from a chain.

In the lower section is an inscription from the sura *al-Isrāʾ* (The Night Journey) of the Qurʾan: "And say: All praises be to the Almighty, Who has not begotten a son, and Who has no partner in His Dominion, nor has He need of protection from humiliation. Praise Him for His Greatness and Glory" (17:111). The final two words of the verse have been omitted, probably for lack of space. The absence of a verse from the Sura of Light (chapter 24 of the Qurʾan, concerning Divine Light) is exceptional among known mosque lanterns. The inscription in *thuluth* script is framed by two bands with peony medallions alternating with triangular arabesque designs.

In the upper section, a small inscription serves not to identify the individual who commissioned the piece but to repeat in full or abbreviated form the honorific formulas "the sultan, the learned, the ruler, the learned" in *naskhī* script. The inscription includes diacritical signs in unexpected places, as is common in *naskhī* inscriptions where the letters are compressed.[2]

M Q R

1. Ruy González de Clavijo, *Embassy to Tamerlane, 1403–1406,* trans. Guy Le Strange (London, 1928), pp. 287–88.

2. The two inscriptions were deciphered by Noha Sadek, Lille, France.

BIBLIOGRAPHY
Oriental Islamic Art: Collection of the Calouste Gulbenkian Foundation / L'art de l'orient islamique: Collection de la Fondation Calouste Gulbenkian. Exh. cat., Museu Nacional de Arte. Antiga. Lisbon, 1963, n.p., no. 4 (text by Ernst Kühnel), illus.

EX COLL.
Eumorfopoulos (until 1940; Eumorfopoulos sale, Sotheby's, London, June 5–6, 1940, no. 95, bought through Giraud-Badin)

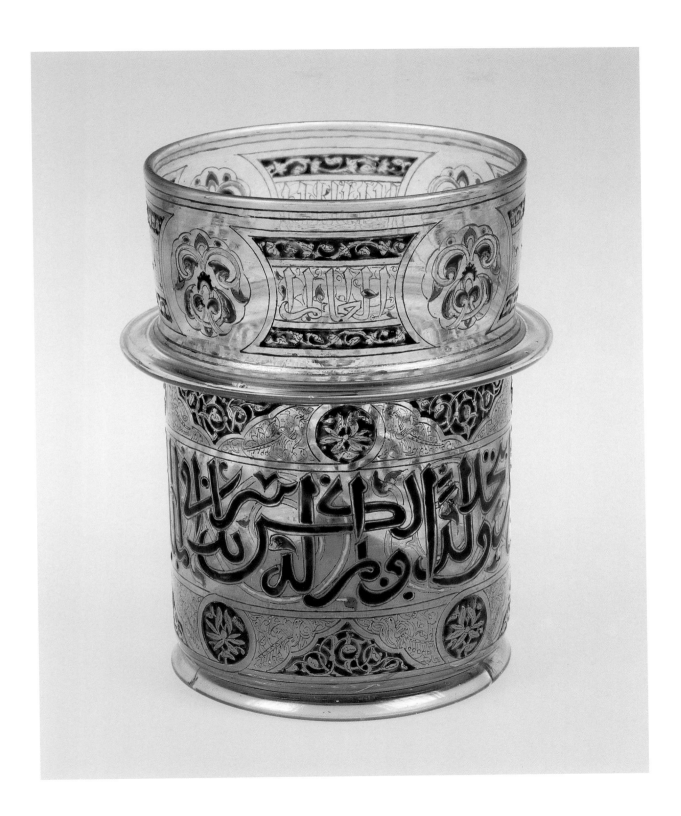

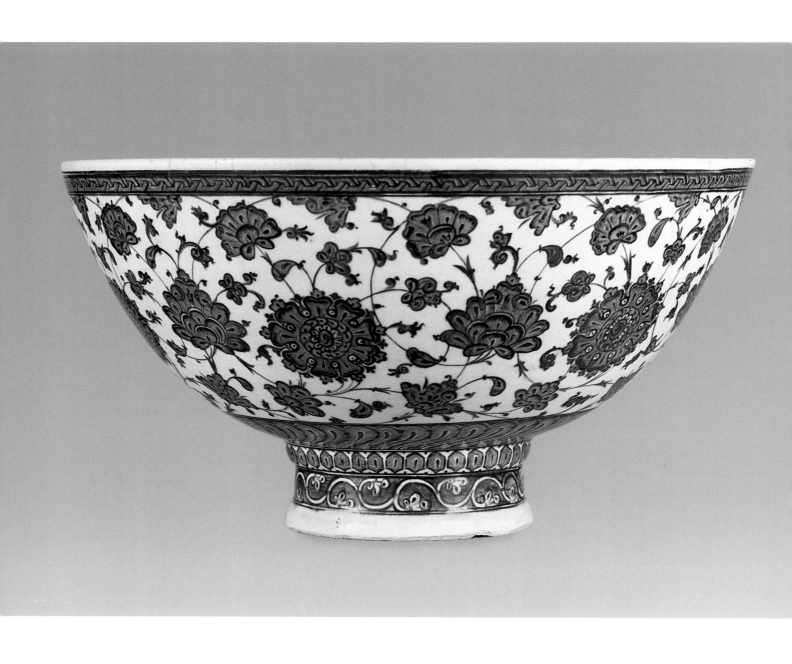

25
FOOTED BOWL

Turkish (Iznik), ca. 1510
Underglaze-painted
composite body
H. 22 cm (8⅝ in.),
diam. 42 cm (16½ in.)
Inv. no. 211

From the end of the fifteenth century until the end of the sixteenth, the Iznik workshops experienced a period of great vitality and importance thanks to the patronage of the Ottoman court. The pastes employed in the manufacture of Iznik pottery have a high silica content. White slip is used as a base for the decoration to which a shiny alkaline glaze is applied in turn, giving Iznik ceramics the appearance of porcelain. The principal characteristics of blue-and-white ceramics produced in the Iznik workshops between 1510 and 1520 are the use of a medium blue enhanced by a darker blue, the alternation of white-on-blue and blue-on-white decoration, and the presence of *rumi* and *hatayi* motifs. *Rumi* are arabesques on a white ground with alternating panels in white on blue (based on half-leaf forms); *hatayi* are festoons of stylized flowers of Chinese inspiration.

This early-sixteenth-century blue-and-white bowl is one of the most noteworthy creations of the Iznik workshops. The quality of its craftsmanship and the refinement of its decoration suggest that this especially large piece was intended for the Ottoman court, for use in ritual ablutions. Its uniqueness lies in its form, innovative for the period, its proportions, and the decoration in tones of blue and white; no other example is known prior to 1550. (A second bowl of this type in the Gulbenkian collection dates from the 1620s.) There are relatively few bowls of such proportions in existence.

The bowl features an original combination of motifs current at the time. The exterior has a *hatayi*-type decoration, in blue on a white ground. Inside, in blue on white, six multilobed panels in a radial composition filled with *rumi* motifs surround a central medallion. The *rumi* motifs that fill the panels are in white on blue. The central medallion is decorated with a knot and cloud scrolls (of Chinese influence)—a composition that, by comparison with other pieces, suggests the work of a single atelier or even a single craftsman. Knots of different types joined with cloud scrolls appear in a variety of compositions attributed to the Master of Knots in this period. Bowls in the Victoria and Albert Museum (1981–1910), London, and in the Musée du Louvre (7880–92), Paris, display compositions of this type on their interior and belong to the same group.

M Q R

BIBLIOGRAPHY
Atasoy, Nurhan, and Julian Raby.
Iznik: The Pottery of Ottoman Turkey.
London, 1989, no. 292, colorpl.

Ribeiro, Maria Queiroz. *Louças
Iznik/Iznik Pottery.* Lisbon, 1996,
p. 93, no. 1, and pp. 92–93, colorpls.

EX COLL.
Brouwer, Nice; bought from Pollak,
Paris, on February 22, 1929

26

DISH

Turkish (Iznik), ca. 1545
Underglaze-painted
composite body
Diam. 35.5 cm (14 in.)
Inv. no. 818

BIBLIOGRAPHY
Atasoy, Nurhan, and Julian Raby.
Iznik: The Pottery of Ottoman Turkey.
London, 1989, no. 341, colorpl.

Ribeiro, Maria Queiroz. *Louças
Iznik/Iznik Pottery.* Lisbon, 1996,
p. 107, no. 8, and pp. 106–7, colorpls.

EX COLL.
Bought from L. Hirsch, London, on
November 4, 1919

As they abandoned the *rumi-hatayi* style (see cat. no. 25) elaborated at the Ottoman court, the ceramics workshops at Iznik took the first steps toward the exuberant and naturalistic style that would mark the second half of the sixteenth century. Beginning in the 1530s, craftsmen freed themselves from the blue-and-white schema and broadened the array of colors.

In breaking with tradition, the potters ventured new approaches. New plant-inspired forms arose; they resembled pomegranates or artichokes and were usually filled with a scale pattern. Green was introduced into the palette. More unified schemes of decoration were another innovation of the 1530s, allowing the craftsman greater liberty. The various surfaces of a dish (bottom, cavetto, and rim) began to be decorated as if they were a single surface. (This innovation continued into the following decade in more schematized versions. Beginning in the 1540s, however, exuberant compositions that do not differentiate among surfaces disappeared with the introduction of violet into the palette. The older color scheme of blue and turquoise persisted.)

This spectacular dish with a lightly scalloped rim is blue, green, and turquoise on a white ground. Two large, scaly artichokes supported by thick stalks and overlaid with curving leaves filled with plum (or prunus) blossoms dominate the surface. These imposing, nearly symmetrical vegetal motifs frame a stylized fleuron inspired by the lotus flowers that occupy the bottom, cavetto, and rim. On the underside of the dish are alternating rosettes and small flowers.

M Q R

27
CYLINDRICAL
TANKARD

Turkish (Iznik), ca. 1575
Underglaze-painted
composite body
H. 22 cm (8⅝ in.),
diam. 11.3 cm (4½ in.)
Inv. no. 777

The sixteenth century marks the peak of Ottoman Turkish imperial power and civilization, the result both of political and economic factors and of the impact of strong personalities such as Sultan Süleyman the Magnificent (r. 1520–66), who was a great patron of the arts.

In the second half of the sixteenth century (about 1557), when ceramics production at Iznik reached maturity, the celebrated red known as Armenian bole was introduced into the palette. The thickness of this pigment, with a ferrous-oxide base, causes motifs painted in it to appear in slight relief underneath the transparent and brilliant glaze. The naturalistic floral motifs that decorate both dishwares and tiles in this period are painted in intense blue, red, and emerald green, in exuberant compositions from the Turkish repertoire. (Technical and decorative similarities in tiles and dishwares imply that the same craftsmen dedicated themselves to the production of both. Decorative compositions were transferred from tile panels to dishwares, a consequence, perhaps, of the greater importance of tile production for much of the sixteenth century.) Iznik craftsmen now devoted themselves primarily to the manufacture and decoration of ceramic tiles for use as revetments on religious and civic buildings. This growing demand resulted in the adoption of standardized decorative motifs, a limiting of artists' creativity that is evident in this tankard, or *hanap*. The composition, nonetheless, is full of movement and lightness, with the flowered stems adapted to the shape of the piece.

The tankard is based on a European-inspired model popular in Ottoman Turkey in the second half of the sixteenth century. Cylindrical tankards with angular handles may have been devised from European prototypes in wood, leather, or even metal and were surely intended either for traders and diplomats who lived in Turkey or for the foreign market. The naturalistic composition of curving groups of elongated red tulips, hyacinths, and blue narcissus is bordered at the lip and base with a curving frieze of half palmettes. Originating in eastern Asia, where it enjoys a long history, the tulip was introduced into Europe by the Turks in the sixteenth century. Tulips, in an almost endless variety, were a constant in Ottoman decorative art, especially dishwares and tiles, until the end of the sixteenth century. M Q R

BIBLIOGRAPHY
Atasoy, Nurhan, and Julian Raby. *Iznik: The Pottery of Ottoman Turkey.* London, 1989, no. 705, colorpl.

Ribeiro, Maria Queiroz. *Louças Iznik/Iznik Pottery.* Lisbon, 1996, p. 173, no. 46, and pp. 172–73, colorpls.

EX COLL.
Jeuniette (until 1919; Jeuniette sale, Manzi-Joyant, Paris, March 26–29, 1919, no. 96, bought through Stora)

28

PLATE

Turkish (Iznik), ca. 1575
Underglaze-painted
composite body
Diam. 20.3 cm (8 in.)
Inv. no. 2250

Coat-of-arms pottery produced by Iznik craftsmen is extremely rare. Surviving pieces destined for the domestic market, whether for the Ottoman court or for a more diverse clientele, display no heraldic insignia of any kind. Iznik ceramics were also exported to Europe, however, mainly to the Italian cities that dominated maritime commerce in the Mediterranean basin. An interest in and a taste for Iznik ceramics grew among Europeans, and exports increased, not only to Italy but also to France, Germany, Austria, and England. Commissions for goods, for which there are records dating from 1570, were placed and imitations began to appear. Neither the quantity nor the type of pieces manufactured for the foreign market has been sufficiently documented, but the available evidence suggests that the number of pieces produced for export was significant.

Although mediocre by Ottoman standards, export china was superior in quality to that made by European imitators. This pottery was so esteemed for its exuberant decoration and rich use of color that it, like Chinese porcelain, was sometimes enhanced with silver or gold-plated mounts, a task carried out in Europe. A tankard in the Gulbenkian collection (inv. no. 812) has a mount of engraved and tooled silver of European origin, probably executed in this period.[1]

The plate shown here displays a European coat of arms identical to that on other plates dispersed among various museums (the British Museum, London; the Ashmolean Museum, Oxford; and the Musée National de Céramique, Sèvres, among others) and must have belonged

Underside

1. Maria Queiroz Ribeiro, *Louças Iznik/ Iznik Pottery* (Lisbon, 1996), p. 275, no. 103, and p. 274, colorpl.

2. Nurhan Atasoy and Julian Raby, *Iznik: The Pottery of Ottoman Turkey* (London, 1989), pp. 266–67, no. 752.

BIBLIOGRAPHY
 Atasoy, Nurhan, and Julian Raby. *Iznik: The Pottery of Ottoman Turkey.* London, 1989, no. 735, colorpl.

 Ribeiro, Maria Queiroz. *Louças Iznik/Iznik Pottery.* Lisbon, 1996, p. 177, no. 48, illus., and p. 176, colorpl.

EX COLL.
 Bought from A. Spero, London, on February 16, 1935

to a set commissioned from the workshops at Iznik. Besides a fragmentary dish found recently in excavations in Iznik, there are only nine known examples of plates carrying this coat of arms, whose identification has caused some controversy.

In the center of the plate is an ovoid shield divided into two bands by an oblique red stripe. A blue star appears on a white ground in the upper field and a white star appears on a blue ground in the lower field. Despite small errors stemming surely from the craftsman's lack of knowledge, this coat of arms has been attributed to the Spingarolli de Dessa family, of Dalmatia. Whether the service was commissioned from Iznik by the Spingarolli de Dessa family or was a gift from the Ottoman Turks to a family member with commercial ties to Turkey is unknown. It is certain, however, that there was commercial traffic between cities in Dalmatia and Turkey during this period. Even if commissions were infrequent, there exist two other plates, with different coats of arms, that were made for northern European clients.[2]

This plate, like seven of the nine others from the set, was inspired formally by the Italian *tondino* (a small dish) with a very wide, flat rim and minimal cavetto. Symmetrically arranged hyacinth branches, roses, tulips, and plum flowers blooming from a cluster of leaves surround the shield. On the underside, pairs of tulips alternate with rosettes. Although all the plates discovered thus far have an identical palette (greens, reds, and blues), their floral compositions vary.

M Q R

29
MOSQUE LANTERN

Turkish (Iznik), ca. 1580
Underglaze-painted
composite body
H. 29.5 cm (11⅝ in.)
Inv. no. 196

The earliest known ceramic mosque lanterns were found in the tomb of the Ottoman sultan Bayazid II (r. 1481–1512) and were perhaps commissioned just after his death. Throughout the sixteenth century, lantern decoration kept pace with the stylistic evolution in Iznik ceramics. Ceramic mosque lanterns were of relatively small dimensions at the beginning of the sixteenth century. These dimensions increased significantly over the years until the lanterns—such as those in the Istanbul mosque of Sokollu Mehmed Paşa (1505–1579), constructed in 1571–72—nearly doubled in height. Formally, the ceramic mosque lanterns were inspired by glass mosque lanterns and are roughly pear-shaped. The British Museum, London, owns a signed and dated lantern (87.5–16.1) that offers important documentation for Iznik manufacture. The small inscription at the base of the lantern gives the name of the decorator, the place of origin, and the date 1549.

The lantern shown here was executed during the reign (1574–95) of Murad III. Like other elongated ceramic lanterns of the period, it exhibits formal affinities with metal lanterns and is more elegant than its squatter glass predecessors. Stylized fleurs-de-lis and blue diamond-shaped lozenges outlined in red, on a white ground, cover the neck and body of the lantern. The lip is highlighted with a band of half plum flowers. On the upper part of the body are three suspension handles decorated in green.

Despite their religious associations, ceramic lanterns, many of which were found in tombs, were not used for lighting, as were glass lanterns. Suspended in series from chains above eye level, ceramic lanterns played an ornamental and symbolic role and were believed to enhance the acoustics of places of worship.

MQR

BIBLIOGRAPHY
Atasoy, Nurhan, and Julian Raby. *Iznik: The Pottery of Ottoman Turkey*. London, 1989, no. 738, colorpl.

Ribeiro, Maria Queiroz. *Louças Iznik/Iznik Pottery*. Lisbon, 1996, p. 193, no. 57, and p. 192, colorpl.

EX COLL.
Charles Testart (until 1924; his estate sale, Drouot, Paris, June 24–25, 1924, no. 68, bought through Duveen)

30
TILE FRIEZE

Turkish (Iznik), ca. 1573
Underglaze-painted
composite body
Each tile: 31 × 34 cm
(12¼ × 13⅜ in.)
Inv. no. 1602

The Ottoman Turkish empire expanded following the conquest of Constantinople in 1453. In the sixteenth century, the empire encompassed the Balkans and part of central Europe as well as the Black Sea basin, Anatolia, Syria, Palestine, Iraq, Arabia, Egypt, and the coastal areas of the Maghreb as far as the Moroccan border. Although subject to Iranian influence, Ottoman art acquired its own specific characteristics. In Ottoman architecture, revetments, consisting for the most part of square or rectangular tiles that suggest wall hangings, were the chief decoration. In the second half of the sixteenth century, manufacturing in Iznik was dominated by commissions for tiles for countless civic and religious buildings, in both Istanbul and other cities of the empire, planned during the age of Sultan Süleyman the Magnificent (r. 1520–66).

By the mid-sixteenth century, Ottoman craftsmen had mastered the technique of underglazing at the same time that a new pigment—a red known as Armenian bole—was introduced (see cat. no. 27). Simultaneously, a stylistic change—the integration of naturalistic floral decoration—also occurred in Iznik production. Both dishwares and tiles, and even textiles and book illustrations, adopted a decorative style in which tulips, hyacinths, carnations, roses, and other flowers are drawn with great realism, alongside other Chinese-influenced motifs such as the lotus flower, the chrysanthemum, and the peony.

The friezes that frame tile compositions serve as finishing touches or accentuate the shape of prayer niches. These four tiles were part of the interior frieze of the mihrab (prayer niche) in the Piyale Paşa mosque in Istanbul, completed about 1573. Here, the *hatayi* motifs (festoons of flowers of Chinese inspiration), stylized lotus flowers, and *saz* foliage (large, lanciform leaves) combine harmoniously with naturalistic roses and tulip buds. The dominant hue is cobalt blue. The design is formed by two intertwined, waving branches culminating in exuberant blooms. One of the branches shows budding flowers, lotus blooms, and *saz* leaves in green filled with small plum flowers. On the other branch rosebuds and tulips, as well as large compound fleurons of Chinese influence, appear.

M Q R

BIBLIOGRAPHY
Türkische Kunst und Kultur aus osmanischer Zeit. Exh. cat., Museum für Kunsthandwerk. 2nd ed. Recklinghausen, 1985, vol. 1, no. 2/75, illus.

EX COLL.
Bought probably before 1896

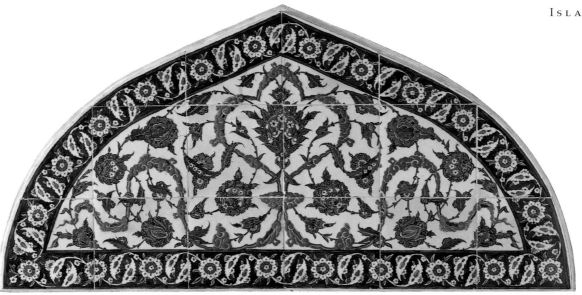

31

TILE TYMPANUM

Turkish (Iznik), ca. 1573
Underglaze-painted
composite body
70 × 136 cm (27 ½ × 53 ½ in.)
overall
Inv. no. 1598B

BIBLIOGRAPHY
Bernus-Taylor, Marthe, et al. *Soliman le Magnifique.* Exh. cat., Galeries Nationales du Grand Palais. Paris, 1990, pp. 139–40, no. 148, and p. 140, colorpl.

EX COLL.
Bought probably before 1896

Tile revetments for buildings lend themselves to adaptation, which is certainly the reason for their survival, their dominance in architectural decoration, and their relevance to the urban aesthetics of several Middle Eastern cities. Ottoman tile panels, which were chiefly interior decorations, were frequently removed from their original setting or destroyed along with the building or during renovation. This panel belongs to a set of almost a dozen that are nearly identical. (Two others are in the Gulbenkian collection—catalogue number 30 and another in the reserves—and the rest are dispersed among various European museums.) These tiles decorated an edifice ordered built by Piyale Paşa, commander of the Ottoman fleet and a favorite of Sultan Selim II (r. 1566–74). It is not certain, however, whether they all came from Piyale Paşa's mosque, or from his palace as well. The most widely held opinion is that the panels belonged to the mosque—which was designed, possibly by Sinan, about 1573—since all the tympanums disappeared from the windows and only the mihrab (prayer niche) tiles remained in any number. The mosque was restored in 1890, after an earthquake damaged the building, and it is possible that the tile tympanums were replaced by painted murals at this time. An official document dated 1909, from the Ministry of Religious Foundations to the Ministry of Public Works, also mentions the removal of panels from the Piyale Paşa mosque. There is an aesthetic kinship between this tympanum, panels in the Selim II mosque built by Sinan in Edirne (1569–75), and panels in the tomb of the same sultan in Istanbul (completed by Sinan in 1574–75).

Here, the main field is decorated in blue, turquoise, green, and red, with cloud scrolls forming a serpentine ribbon that encloses a lotus flower in a trilobate loop. From the central motif, spirals of slender boughs with leaves, flower buds, and *hatayi* motifs unfold. The appearance of this highly dynamic decorative schema on all the tympanums presupposes the use of an identical design, created in the ateliers of the imperial palace. Although the tiles were produced en masse, their technical quality was rarely affected.

M Q R

32
VOLUME OF THE ISKANDAR-SULṬĀN ANTHOLOGY

Iranian (Shīrāz), ca. 1410–11
Paper
27.4 × 17.2 cm (10¾ × 6¾ in.)
Inv. no. L. A. 161

Tʜɪs manuscript dedicated to Prince Iskandar ibn ʿUmar Shaikh ibn Timur (1384–1415) is without doubt one of the most beautiful examples of the art of the book from the Timurid period (1378–1506), when this art was highly prized and encouraged by important patrons. Iskandar-Sulṭān, grandson of Timur (Tamerlane; 1336–1405), was a leading supporter of the arts of the book at the beginning of the fifteenth century. Some seventy manuscripts, complete and incomplete, are associated with his patronage. Today they are scattered among various institutions in Istanbul, London, Dublin, Paris, Tehran, New York, and Lisbon.

The Anthology is in the early Timurid style with thirty-eight miniatures and fifteen full-page and half-page decorative illuminations and contains numerous poetic, literary, historical, and scientific texts in *nastaʿlīq* script. Horizontal lines of calligraphy take up the center of the folios, and diagonal lines fill the margins. The calligraphers were Maḥmūd ibn Aḥmad al-Ḥāfiẓ al-Ḥusainī and Ḥasan al-Ḥāfiẓ; the illuminators are unknown. The Anthology is in two volumes. The first volume, shown here, has 234 folios. Among the poetic texts collected in it are excerpts from the *Manṭiq al-tayr* (The Conference of the Birds), by Farīd al-Dīn ʿAṭṭār; the *Masnawī* (Couplets), by Jalāl al-Dīn Rūmī; the *Dahnāma,* by Awḥadī Maraghī; the *Gulistān* (The Rose Garden), by Saʿdī; the *Khamsa* (Quintet), by Niẓāmī; the *Shāhnāma* (The Book of Kings), by Abū al-Qāsim Firdausī; and the *Akbar al-afkār* (The Best Thoughts). The prose selections in the second volume include a historical text and a medical treatise. Restoration of this manuscript was carried out by the Turkish book artist Rikkat Kunt (1903–1986) following damage suffered in the flooding of the Pombal Palace, in Oeiras, in 1967; it was a painstaking labor based on the surviving pigments and on photographs taken prior to the flooding.

The full-page miniature on folio 66v is an illustration to the *Haft paikar* (Seven Portraits), the fourth poem in Niẓāmī's *Khamsa.* Although this Anthology's version of the *Khamsa* is its most extensive poetic text, the illustrations are limited, by contrast with the profusely illustrated versions of the work that appeared during the fifteenth century. The *Haft paikar,* one of the most popular of Niẓāmī's poems despite being among the most hermetic, deals with the formation of the ideal monarch through the narration of episodes from the life of a Sassanian king, Bahrām Gūr.

Here, the painter conflates two moments: Bahrām Gūr's youth and his kingship. In the palace at Khawarnaq, where he spends his youth, Bahrām Gūr discovers a room with painted murals representing seven beautiful women from different regions as well as a young man beside whom is an inscription referring to Bahrām Gūr, who will possess them all. This discovery is a premonition of a later event: the construction of pavilions to install seven princesses. After consolidating power in Iran, Bahrām recalls the portraits of the seven beauties and, after locating the women, brings them to his palace, where the marriages are celebrated. Every week, Bahrām Gūr meets with each of the princesses, who represent the various aspects of love. In the foreground of the miniature on folio 66v, Bahrām Gūr admires the pavilions with vaulted domes where the princesses are seated, represented as if they were painted murals. ᴍ ǫ ʀ

Bɪʙʟɪᴏɢʀᴀᴘʜʏ
Oriental Islamic Art: Collection of the Calouste Gulbenkian Foundation/ L'art de l'orient islamique: Collection de la Fondation Calouste Gulbenkian. Exh. cat., Museu Nacional de Arte Antiga. Lisbon, 1963, n.p., no. 117 (text by Basil Gray), colorpl.

Ex ᴄᴏʟʟ.
Yates Thompson; Baron Edmond de Rothschild, given by him to Mr. Gulbenkian

Folio 66v

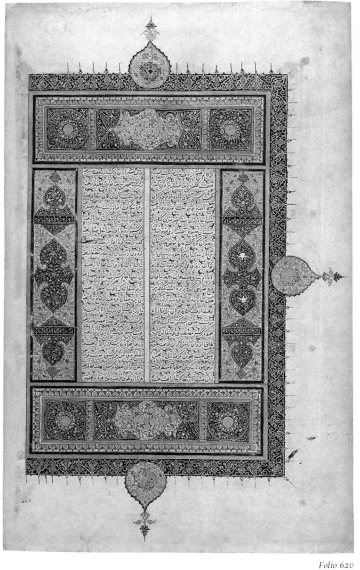

Folio 69r

Folio 62v

33

Double Frontispiece
of a Poetical Manuscript

Iranian (Shīrāz), ca. 1410
Paper
Each folio: 27.6 × 17.3 cm (10⅞ × 6⅞ in.)
Inv. nos. M. 62, M. 69

Calligraphy has been cultivated for centuries throughout the Islamic world and Arabic script, already in existence in pre-Islamic times, has been subject to continual transformation. The obligation of the faithful to read the Qur'an in the language in which it was revealed imposed the use of Arabic on the entire Muslim world. Both the Qur'an and classic works of Persian poetry and epic literature were copied and illuminated, bearing witness to the style and aesthetics of the schools that produced them. Although the art of calligraphy has its origin in the Qur'an, it was used in architecture and on objects as well, becoming more and more an art form in itself. It was also practiced by many rulers.

Calligraphy in Iran is based on a script known as *ta'līq*. It was developed about the thirteenth century by one of the most important calligraphers, Mīr 'Alī al-Tabrīzī. Eventually it evolved into *nasta'līq*, the script most commonly used. The Timurid period (1378–1506) was the golden age of the arts of the book in Iran. At the beginning of the fifteenth century, the leading centers were Shīrāz, Herāt, and Tabrīz.

The *kitābkhāna*, or palace workshop where the manuscripts were produced, employed copyists, illuminators, miniaturists, gilders, draftsmen of frames and outlines, stampers of gold and silver, appliers of lapis lazuli, and bookbinders. The basic decoration of a manuscript was done by the calligrapher, who often introduced variations in the type and format of the calligraphy. The illuminator gave the final touches. The main decorative areas were the title page, the frontispiece, and the opening of each chapter. The colophon, which was also decorated, generally contained the signature of the illuminator and of the calligrapher and indicated where the manuscript was produced and for whom it was intended.

This double-page frontispiece of a manuscript of poetry constitutes the *unwān*, or dedication. Two columns of text in *naskhī* script appear on each page, framed by profusely illuminated margins with panels of floral arabesques and three medallions, also illuminated. The painstaking calligraphy—in black ink inside *abrī* (outlined spaces resembling clouds)—displays exceptional quality. Stylistically, this *unwān* is closely linked to the Iskandar-Sulṭān Anthology (cat. no. 32). The naturalism characteristic of Shīrāz manuscript illumination during the early fifteenth century is evident in both.

<div style="text-align: right;">M Q R</div>

BIBLIOGRAPHY
Ettinghausen, Richard. *Persian Art: Calouste Gulbenkian Collection.* Lisbon, 1972, p. [5], no. 14, colorpl. and illus.
Oriental Islamic Art: Collection of the Calouste Gulbenkian Foundation / L'art de l'orient islamique: Collection de la Fondation Calouste Gulbenkian. Exh. cat., Museu Nacional de Arte Antiga. Lisbon, 1963, n.p., no. 116 (text by Basil Gray), illus.

EX COLL.
Bought probably before 1896

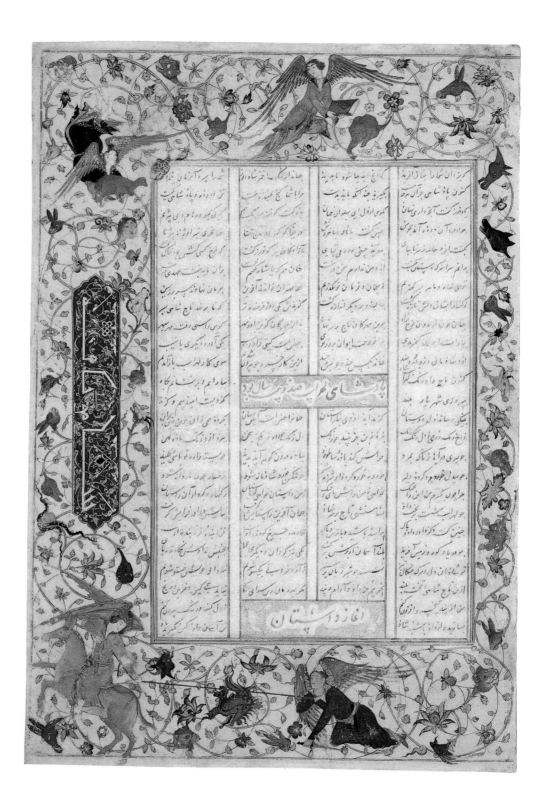

34

PAGE WITH ILLUMINATED MARGINS FROM A MANUSCRIPT OF THE SHĀHNĀMA

Eastern Iranian (Herāt),
mid-15th century
Paper
26.3 × 17.5 cm (10³⁄₈ × 6⁷⁄₈ in.)
Inv. no. M. 66A

The *Shāhnāma* (The Book of Kings), a tenth-century work in verse written by Abu'l Qāsim Firdausī, is Iran's most important epic poem. Its seven volumes tell the story of the kings of Iran and the struggles of pre-Islamic Iranian heroes, beginning with the mythical Gayumarth and ending with the downfall of the Sassanian dynasty. Based on oral tradition, the work combines historical events with legendary and fantastic episodes. Many complete manuscripts survive. In the Iranian tradition this heroic poem is considered more than literature; its conceptions of honor, ethics, and legitimacy make it a political treatise as well. Illustrated manuscripts of this history of the Iranian monarchy were much sought after and were commissioned by various dynasties in an attempt to legitimize their authority. The Timurid conquerors refined the text and even made dramatic alterations in the illuminations, as on this manuscript page (one of two in the Gulbenkian collection).

The unusual, subtly colored decoration on the page shown here has given rise to speculations about its source. It has been suggested that the figures indicate Western influence, perhaps Italian or Flemish.[1] Although undocumented, there probably was some European influence on Timurid art, transmitted by the flow of European travelers to Iran during the fifteenth century. Furthermore, following the establishment of diplomatic relations, there was commerce in this period between Herāt and the courts of Europe. It is unlikely, however, that European artists participated in the decoration of the margins of this page. Such a hypothesis is not credible if one compares a similar illuminated page from the *Khamsa* of Shāhrukh, dated 1431 and produced in Herāt (State Hermitage, Saint Petersburg, VR-1000).

Despite political instability, the long reign (1405–47) of Shāhrukh, with Herāt as the capital, enjoyed a brilliant creativity and a program of patronage that would serve as a model for Shāhrukh's successors. The arts of the book achieved a place of prominence, especially during the second and third decades of the fifteenth century.

This illuminated page, attributed to the Herāt school, features four long-winged angels amid interlaced swirls and vegetal decoration from which animal heads and human beings emerge. One of the angels holds a book, another carries a lamb, and the third, on horseback, seems to be dragging the fourth on a leash. The latter, with a somber expression, grasps the leash in one hand to avoid choking, while gripping a sword in the other. The exuberant decoration is not easy to interpret: there appears to be no relationship between the text and the margins. According to some scholars, the motifs have their roots in classical antiquity, specifically in Roman art. It has also been suggested that they are to be compared to Armenian manuscripts.

M Q R

1. *Oriental Islamic Art: Collection of the Calouste Gulbenkian Foundation/L'art de l'orient islamique: Collection de la Fondation Calouste Gulbenkian,* exh. cat., Museu Nacional de Arte Antiga (Lisbon, 1963), n.p., no. 121 (text by Basil Gray), illus.

BIBLIOGRAPHY
Hillenbrand, Robert. *Imperial Images in Persian Painting.* Exh. cat. Edinburgh: Scottish Arts Council Gallery, 1977, p. 92, no. 202, illus.

Lentz, Thomas W., and Glenn D. Lowry. *Timur and the Princely Vision: Persian Art and Culture in the Fifteenth Century.* Exh. cat., Los Angeles County Museum of Art, 1989, p. 128, no. 44A, colorpl.

EX COLL.
Bought probably before 1896

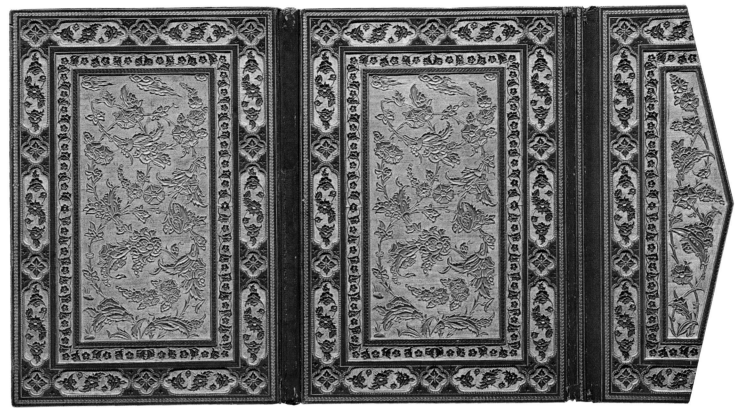

Front cover, back cover, and flap (exterior)

35
BINDING OF QIRĀN-I SAʾADAYN

Iranian (Tabrīz), ca. 1605
Carved, molded, and gilt leather
11.7 × 26.8 cm (4⅝ × 10½ in.)

Signed near flap:
Muḥammad Ṣāliḥ al-Tabrīzī

Inv. no. L. A. 187

This luxuriously bound manuscript of Amīr Khusrau Dihlāvī's *Qirān-i Saʾadayn (The Conjunction of Two Excellencies)* was copied by the famous calligrapher Sulṭān Muḥammad Nūr in 1515. It contains fifty-one illuminated pages, two *sarlauḥ*s (illuminated cartouches), and an *unwān* (dedication) that is illuminated but incomplete, its sides having been trimmed by the binder. The three signed miniatures are of later date in the style of the court of Shāh ʿAbbās I (r. 1588–1629). The first miniature has the full name of the painter, Nūr al-Dīn Muḥammad Muṣavvir, while the other two have only "Nūr." One page bears the impression of a seal—which has been painstakingly erased from the rest—identifying the manuscript as a religious donation (*waqf*) made in 1608 to the Safavid shrine of Ṣafī al-Dīn in Ardabīl. Shāh ʿAbbās I established not only the shrine but also its library, comprising more than 150 volumes, among them some ten manuscripts illuminated with miniatures attributed to the fifteenth-century court painter Bihzād and his school. Therefore, the miniatures and the binding of this manuscript were probably executed shortly before the donation date.

The technique used by Islamic bookbinders is different from that of their Western counterparts. In addition to an identical front and back cover, Islamic bindings have an envelope flap on the left side of the back cover; the flap, called a *lisān*, serves as a bookmark. Early

bookbinding practices were extremely simple. Gilding appeared about 1425, but only along the edges of the ornamentation. Gradually, gilding was more liberally applied and to the inside of the covers, as well.

The binding of this manuscript is important not only for artistic reasons but, above all, because it bears the craftsman's signature—a rarity on Islamic bindings. Muḥammad Ṣāliḥ al-Tabrīzī signed his work near the flap on the inside of the piece connecting the flap to the back cover. The signature attests to the work's origin in Tabrīz.

The exuberant decoration—large *saz* leaves and *hatayi* motifs (Chinese-inspired festoons)—recalls that of Iranian rugs from the beginning of the seventeenth century. The inside of the cover is decorated with gilt motifs against colored grounds to emphasize the composition—a practice that had become common at the end of the fifteenth century. On the outside, the cover, tooled and gilded, is similarly embellished.

M Q R

BIBLIOGRAPHY

Ettinghausen, Richard. *Persian Art: Calouste Gulbenkian Collection*. Lisbon, 1972, pp. [6–7], no. 19, colorpl.

Oriental Islamic Art: Collection of the Calouste Gulbenkian Foundation/ L'art de l'orient islamique: Collection de la Fondation Calouste Gulbenkian. Exh. cat., Museu Nacional de Arte Antiga. Lisbon, 1963, n.p., no. 191 (text by Basil Gray), illus.

EX COLL.

Claude Anet, Paris (until 1920; his sale, Sotheby's, London, June 4, 1920, no. 65, through Gudenian)

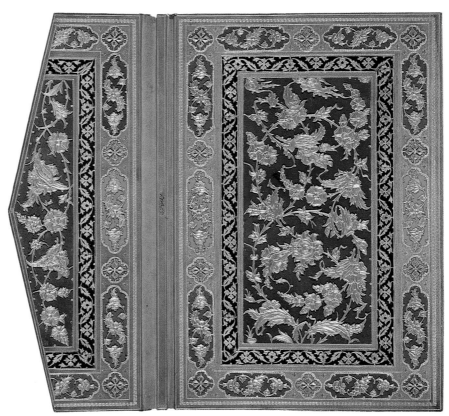

Flap and back cover (interior)

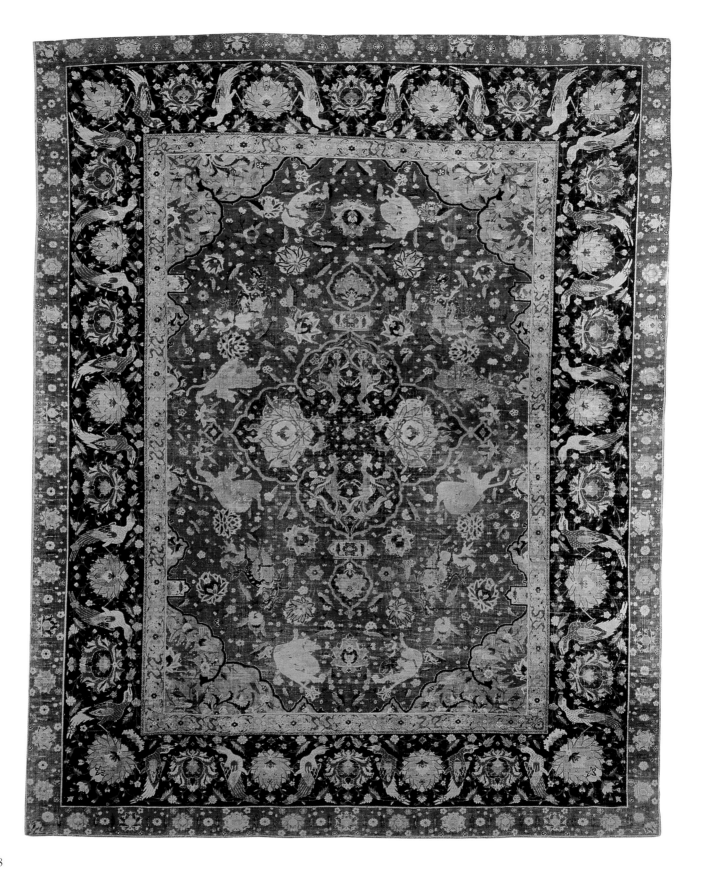

36
CARPET

Iranian (Kāshān),
mid-16th century
Silk
230 × 180 cm (90½ × 70⅞ in.)
Inv. no. T. 100

1. Arthur U. Dilley, *Oriental Rugs and Carpets* (New York and Philadelphia, 1959), p. 42.

2. Ibid., pp. 42–43.

3. Daniel Walker, "Silk Kashan Rugs," *Oriental Art* 41, no. 2 (Summer 1995), p. 2.

BIBLIOGRAPHY

Bode, Wilhelm von, and Ernst Kühnel. *Antique Rugs from the Near East.* Trans. Charles Grant Ellis. 4th ed. Berlin, 1958, p. 96, fig. 64.

Erdmann, Kurt. *Seven Hundred Years of Oriental Carpets.* Edited by Hanna Erdmann. Trans. May H. Beattie and Hildegard Herzog. London, 1970, p. 65, no. 68.

Ettinghausen, Richard. *Persian Art: Calouste Gulbenkian Collection.* Lisbon, 1972, pp. [7–8 and 12], no. 26, colorpl. and illus.

Pope, Arthur Upham, ed. *A Survey of Persian Art from Prehistoric Times to the Present.* London and New York, 1967, vol. 11, p. 1200.

EX COLL.

Wilhelm von Bode, Berlin; Kunstgewerbemuseum, Berlin; bought through Hans Stiebel, Amsterdam, in March 1936

Iranian silk carpets are considered the finest and most highly esteemed knotted carpets. During the sixteenth century, the city of Kāshān, in central Iran, was known as a major center of the silk trade and silk-textile production, but sources are silent about any carpet production. Beginning in 1600, however, Kāshān was mentioned for its fine carpets, and Shāh ʿAbbās I (r. 1588–1629) established a royal carpet and textile manufactory there.

ʿAbbās I was a great patron, as we are reminded by Arthur Dilley: "Appreciation and patronage of the fine arts was, with Shah Abbas, second nature. . . . the looms of Kashan, and new state manufactories established at Isphahan, produced precious silk carpets, brocades and velvets. The splendid garden pavilions were equipped with silk rugs."[1] Travelers' accounts from the early seventeenth century, as well as a documented foreign order of 1601, strongly imply that carpet weaving (though perhaps not in a royal factory) was already well established in Kāshān by 1600. Thomas Herbert, one of the Europeans who visited Iran under ʿAbbās I, left this account: "an officer led us into a little place having a pretty marble pond or tank in the centre; the rest spread with silk carpets. Thence we were led through a large delicate and odoriferous garden to a house of pleasure; the low room was round and spacious, the ground spread with silk carpets."[2] These words attest to silk carpets' importance in Iran in the decoration of imperial settings. There is also abundant documentation of the impact that such goods had in the West, where they were sent as gifts to European ambassadors, monarchs, and princes.

Similarities to the rugs described in the 1601 order, alongside the circumstantial evidence outlined above, led to the attribution of a group of twenty sixteenth-century silk carpets to Kāshān.[3] The carpet shown here is one of them, probably made during the reign of the great patron of the arts Shāh Ṭahmāsp I (r. 1524–76). Sixteen of the twenty Kāshān silk carpets are small and relatively homogeneous in composition and color. Twelve of these small carpets, inspired by the arts of the book, have a lobed central medallion and quarter medallions at the corners amid rich floral decoration (examples are in The Metropolitan Museum of Art; the Gobelins Museum, Paris; and museums in Munich, Vienna, and Coimbra); the other carpets are decorated with scenes of animals in combat distributed over the field (examples are in the Musée du Louvre, Paris, and in The Metropolitan Museum of Art). The carpet here, with extremely dense, very delicate knots, combines a central medallion and animals in combat distributed over the field. The refined design includes a central, lobed quatrefoil medallion with a blue ground and a phoenix and dragons in combat, alternating with two palmettes. The field, with a red ground, is filled with floral motifs and with lions, tigers, panthers, and antelopes. At the four corners, on a golden yellow ground, birds perch on delicate bushes. In the main border of moss green there are richly plumed pheasants alternating with palmettes and flowers, and in the minor borders, flowers and *chi* clouds of Chinese inspiration.

M F P L

37
PANEL

Indian(?), late 17th century
Velvet
127 × 161 cm (50 × 63⅜ in.)
Inv. no. 1422

The importance accorded fine fabrics—silks, brocades, or velvets such as this one—is a constant throughout the Islamic world. Kings and lords chose them for their raiment or used them in the decoration of their palaces, tents, or gardens, where, in combination with fine carpets, they created the decorative ambience in which the powerful and wealthy lived, as furniture was quite limited. In Muslim India during the more than three centuries of Mughal rule (1526–1857), as well as in Safavid Iran (1501–1736), the quantity of precious textiles represented in miniatures of the period and described in contemporaneous accounts, whether royal biographies or descriptions by foreign visitors, attests to the importance of silk fabrics. Unfortunately, given their fragility, relatively few silks have survived. An invaluable source for assessing the importance of such fabrics in Mughal India is the seventeenth-century *Padshahnama* (Chronicle of the King of the World) belonging to the Royal Library at Windsor Castle and recently exhibited at The Metropolitan Museum of Art.[1] It depicts in great detail the luxurious court of Shāh Jahān (r. 1628–58) and his immediate predecessors, where fabrics dominated the decoration and were presented as gifts of great value and prestige.

This velvet's extremely delicate pattern of roses, lotus flowers, lanciform foliage, and swirls often appears in seventeenth-century Islamic textiles. A fragment of identical design is in the David collection, Copenhagen (10/1989). Another example was recently sold in New York.[2] The first known reference to cloth of this type attributes its manufacture to an Iranian workshop in Yazd in the eighteenth century.[3] Later, such velvets were classified as probable products of Bukhara, from the seventeenth century.[4] Today, the manufacture of this piece is assigned, with high probability, to India at the end of the seventeenth century.　MFPL

1. See Milo Cleveland Beach and Ebba Koch, *King of the World: The "Padshahnama," An Imperial Mughal Manuscript from the Royal Library, Windsor Castle*, exh. cat., Arthur M. Sackler Gallery (London, 1997).

2. *Hali* 85 (March–April 1996), p. 141.

3. F. Sarre and F. R. Martin, eds., *Die Ausstellung von Meisterwerken Muhammedanischer Kunst, 1910* (Munich, 1912), pl. 205.

4. *Oriental Islamic Art: Collection of the Calouste Gulbenkian Foundation/L'art de l'orient islamique: Collection de la Fondation Calouste Gulbenkian*, exh. cat., Museu Nacional de Arte Antiga (Lisbon, 1963), n.p., no. 82, and Richard Ettinghausen, *Persian Art: Calouste Gulbenkian Collection* (Lisbon, 1972), n.p., no. 24.

EX COLL.
Bought at Sotheby's, London, July 27, 1921, through Gudenian

38
HANGING
Turkish (Bursa or Istanbul), 16th century
Velvet with silver and silver-gilt thread
192 × 132 cm (75⅝ × 52 in.)
Inv. no. 1384

In the Islamic art collection of the Gulbenkian Museum, a large group of ornate woven silks *(kemha)* and velvets *(çatma)* from Ottoman Turkey stands out. Their rich coloring, variety of patterns, and remarkable state of preservation testify to the richness and quality that these fabrics attained, especially from the fifteenth to the seventeenth century, in the major Ottoman textile-manufacturing centers—specifically, Bursa and Istanbul.[1] Most of the surviving textiles are, like those in the Gulbenkian collection, from the sixteenth and seventeenth centuries. Apart from their aesthetic quality, these fabrics contributed to the economic development of the Ottoman empire, as they were avidly sought in the West.

In general, Ottoman silks were intended for the attire of sultans and important personages. The largest collection of Ottoman silks, especially those used for caftans, is in the Topkapı Sarayı Museum, Istanbul; many of these are of imperial manufacture. Because of its weight and texture, velvet was better suited to the decoration of tents and palaces; it served as wall hangings and to cover divans, cushions, and the like. The patterns on Ottoman silks and velvets are usually geometric or floral in a variety of vibrant colors among which red, silver, and gold nearly always predominate. The impact of Ottoman textiles is copiously documented in accounts by European ambassadors and other travelers who visited the splendid Ottoman courts. These fabrics are also represented in numerous miniatures of the period.

This wall hanging of red velvet with blue highlights is decorated with large stylized carnations, resembling palms, on a ground of silver thread and with small tulips and bushes on a ground of gold thread.[2] Carnations and tulips are often found on Ottoman textiles and other art forms of the period. Here, two rectangular frames (only the inner frame interrupts the pattern) create a finishing touch. The hanging is made from two lengths joined by a central seam. M F P L

1. Marthe Bernus-Taylor, *Turquie: Au nom de la tulipe,* exh. cat., Centre Culturelle de Boulogne-Billancourt (Thonon-les-Bains, 1993), pp. 36–41, colorpls.

2. See Louise W. Mackie, *The Splendor of Turkish Weaving: An Exhibition of Silks and Carpets of the 13th–18th Centuries,* exh. cat., The Textile Museum (Washington, D.C., 1973), p. 26, no. 15, illus., for a similar velvet.

BIBLIOGRAPHY
Oriental Islamic Art: Collection of the Calouste Gulbenkian Foundation / L'art de l'orient islamique: Collection de la Fondation Calouste Gulbenkian. Exh. cat., Museu Nacional de Arte Antiga. Lisbon, 1963, n.p., no. 91, illus.

EX COLL.
Bought from Pollak, Paris, on November 13, 1926, through Bacri

39

Panel

Turkish (Bursa?),
mid-16th century
Silk with silver thread
134 × 80 cm (52¾ × 31½ in.)
Inv. no. 1419

In the sixteenth century Bursa was the most famous manufacturing center for ornate Ottoman silks, although Istanbul also produced them. Beginning in 1574, however, the use of gold and silver thread was forbidden in Bursa, and therefore textiles with metallic threads made after this date must be attributed to Istanbul.[1] Such products of imperial manufacture were for luxury apparel for sultans, princes, and important court dignitaries.

This wall hanging is one of a large number of Ottoman silks in the Gulbenkian collection. Its red ground is decorated with oval medallions containing pomegranates and various floral motifs in tones of blue and green with silver thread. The medallions are framed by intertwined cords. European-inspired (specifically, Italian) motifs, such as the lattice of intertwined cords, demonstrate the influence of Western production on that of Ottoman Turkey. Silks and velvets were imported by the Turks until the seventeenth century, principally from the republics of Venice and Genoa. A reciprocal influence can also be detected, which sometimes makes it difficult to distinguish Ottoman from European production.

M F P L

1. Louise W. Mackie, *The Splendor of Turkish Weaving: An Exhibition of Silks and Carpets of the 13th–18th Centuries,* exh. cat., The Textile Museum (Washington, D.C., 1973), p. 14.

Bibliography
Tecidos de Colecção Calouste Gulbenkian. Lisbon, 1978, no. 43.

Ex coll.
Besselièvre (until 1912; Besselièvre sale, Drouot, Paris, February 16–17, 1912, no. 63, through Stora)

40

HANGING

Turkish,
16th–17th century
Velvet with silver thread
172 × 64 cm (67 ¾ × 25 ¼ in.)
Inv. no. 1388B

Along with catalogue numbers 38 and 41, this hanging demonstrates the variety of patterns used to decorate Ottoman velvets. Its exceedingly well-executed decoration consists of two parallel columns of circular tangential medallions on a red velvet ground. The medallions enclose stylized tulips, carnations, and hyacinths, as well as three additional circular medallions that gradually diminish in size. The ground of the largest graduated medallion is filled with silver thread. The composition, simultaneously geometric and floral, perfectly exemplifies the decorative canons of sixteenth- and seventeenth-century Ottoman art. The pattern is so closely orchestrated that the effect achieved is truly spectacular.

When this velvet was acquired by Calouste Gulbenkian in 1925, its manufacture was attributed to Scutari (present-day Üsküdar). It was mounted, along with a companion piece, on a double-leaf screen in his residence.

M F P L

BIBLIOGRAPHY
Tecidos de Colecção Calouste Gulbenkian. Lisbon, 1978, no. 51.

EX COLL.
Count Vitali (until 1925; his sale, Paris, June 25, 1925, no. 338, bought through Isbirian)

41

HANGING

Turkish, 17th century(?)
Velvet with silver thread
108 × 87 cm (42½ × 34¼ in.)
Inv. no. 1385

As in the greater part of seventeenth-century Turkish production, so in a majority of the Ottoman velvets in the Gulbenkian collection, red is the dominant color, at times highlighted with gold or silver threads. The ornate velvet hanging shown here features less common colors—exquisite pastel hues of salmon and green amid the rare, predominant golden yellow. The stylized floral decoration (palms, tulips, and carnations around a small rosette) of this piece, occupying ogival compartments defined by a lattice of undulating bands, is found frequently in Turkish velvets and silks of the period. Here, however, the silver thread of the weft has a lower silver content than it has in catalogue numbers 38–40, which indicates that this textile probably was woven somewhat later.

Many of the motifs that appear on the velvets and silks of Ottoman Turkey also appear in other media, such as tiles and pottery, which demonstrates the uniformity of patterns in Ottoman decorative-arts production. M F P L

BIBLIOGRAPHY
 Tecidos de Colecção Calouste Gulbenkian. Lisbon, 1978, no. 50.

EX COLL.
 Bought from Isbirian, Paris, on January 26, 1929

OLD MASTER PAINTINGS

42

PETER PAUL RUBENS

(Flemish, 1577–1640)

HELENA FOURMENT

ca. 1630
Oil on wood
186 × 85 cm (73 ¼ × 33 ½ in.)
Inv. no. 959

1. R. S. Magurn, trans. and ed., *The Letters of Peter Paul Rubens* (Cambridge, Mass., 1955), p. 393. The final phrase was translated by the editor from Latin.

2. Hans Vlieghe, *Rubens Portraits of Identified Sitters Painted in Antwerp*, Corpus Rubenianum Ludwig Burchard, part 19, vol. 2 (New York, 1987), pp. 102, 109, and see also pp. 87–112, 165–67, and 169–72, and figs. 84–88, 92, 97, 103, 105–6, 109–10, 113, 115, and 193–95.

BIBLIOGRAPHY
European Paintings from the Gulbenkian Collection. Exh. cat., National Gallery of Art. Washington, D.C., 1950, p. 92, no. 40 (text by Fern Rusk Shapley), and p. 93, illus.

EX COLL.
Sir Robert Walpole, first earl of Orford, Houghton Hall, Norfolk (by 1743–d. 1745; sale, 1779); Catherine II, empress of Russia (1779–d. 1796); Russian imperial family (1796–1917); The Hermitage, Saint Petersburg [Leningrad] (1917–30); bought from the Antikvariat, Moscow, in March 1930

On December 6, 1630, Rubens, fifty-three and a widower, married the seventeen-year-old Helena Fourment (1614–1673), who was thirty-six years his junior. Of his decision to take a young wife he noted, "I made up my mind to marry again, since I was not yet inclined to live the abstinent life of the celibate, thinking that, if we must give the first place to continence, we may enjoy licit pleasures with thankfulness."[1] Helena was the daughter of Rubens's old friend Daniel Fourment, a wealthy silk and tapestry merchant of Antwerp. The connection between the two families dated back at least to 1619, when one of Fourment's sons married a sister of the painter's first wife, Isabella Brandt (1591–1626). Helena is most often identified as the subject of this portrait, Calouste Gulbenkian's favorite work of art and one of the acknowledged masterpieces of his collection.

Numerous images of exceptional quality assumed to date from the first years of their marriage document Rubens's loving relationship with his second wife.[2] Two of the earliest paintings show her in half-length, wearing a dark cap with white feathers (Alte Pinakothek, Munich), and in full-length, seated, and wearing a spray of orange blossoms suggestive of a marriage portrait (also in the Alte Pinakothek). Notable among the drawings are two half-lengths in which she seems to be wearing the same dress (Courtauld Institute, London, and Albertina, Vienna). In the Gulbenkian painting, as in the Vienna drawing, the sitter faces slightly to her right with both hands at her waist, right above left, fingers extended. The pose used for the painting is so similar that it may depend from the drawing. There is, however, some disparity in that Helena was a buxom blond with full cheeks and widely spaced eyes. The sitter who posed for the Gulbenkian portrait is slender with slightly sharper features.

Rubens also knew Helena's older sister Susanna Lunden (1599–1628), who, it has been suggested, might have been the model for the Gulbenkian picture. Susanna is almost certainly the subject of the famous half-length portrait called *Le châpeau de paille* (National Gallery, London). In *Le châpeau de paille*, Susanna—assuming that it is she—wears a costume much like that in the Gulbenkian portrait, a broad-brimmed hat trimmed with feathers, and a black dress with sleeves of a different color. She, too, faces a little to her right. However, the Susanna of the London portrait, which may date from about 1625, looks older than the Gulbenkian sitter, and her face is thinner. Her hair is coiffed differently, in a style that Helena is not known to have worn. The similarities of setting, pose, and costume draw attention to the differing physiognomies of the two sitters.

Although the composition is stately and the costume extremely formal, the portrait projects a tranquil intimacy. The young woman is surrounded by soft clouds, while the gentle landscape glows with early-evening light. The subtle gradations of color in the black satin skirt and the handling of the mauve ribbons, the delicate lace collar, and the soft flesh testify to the virtuosity of Rubens's technique.

L S

This *Fête galante* belonged to Frederick the Great of Prussia (r. 1740–86), an ardent admirer of Lancret and the eventual owner of no fewer than twenty-six of his pictures. In a 1739 letter to his sister that testified to his interest in contemporary French painting, Frederick described with enthusiasm the Watteaus and Lancrets that he had already assembled at Schloss Rheinsberg. He continued to acquire works by both artists until about 1750, when his interest shifted to earlier Italian and Dutch masters.

Probably painted in the early 1730s at the height of Lancret's career, this canvas is similar in style to *Dance between the Pavilion and the Fountain* of 1732 and *Quadrille before an Arbor*, ca. 1730–35 (both, Schloss Charlottenburg, Berlin), which are also from Frederick's collection.[1] Like the Gulbenkian painting, the *Quadrille* shows a statue on a pedestal, probably Bacchus, in the background. The title of the present picture is generic. Typically, such festive open-air scenes bring elegant figures together in animated gatherings. Subjects of the kind had been introduced into French painting by Claude Gillot (1673–1722) in whose atelier both Antoine Watteau (1684–1721) and Lancret trained. Watteau, Lancret, and, a little later, Jean-Baptiste Pater (1695–1736) specialized in the genre, which was inspired by the sixteenth-century Venetian painters Giorgione and Titian. In the early eighteenth century, the remote, idyllic *fête champêtre* of the Renaissance was gradually transformed into a vehicle for describing the courtship and dalliance of the contemporary French nobility. Because the theater was also a source of inspiration, the figures are often distributed and move about as if on the stage.

Lancret's contribution lies in the specificity with which he described the refined pleasures of society. He was sensitive to the decorative aspects of his compositions, reproducing the most up-to-date costumes with exactitude. His paintings seem to be an accurate reflection of contemporary taste and manners. Less poetic than Watteau's, his work, the fruit of direct observation, mirrors the occasionally superficial, sophisticated, pleasure-loving era in which he lived.

L S

43

NICOLAS LANCRET
(French, 1690–1743)

FÊTE GALANTE

Early 1730s
Oil on canvas
64.5 × 69.5 cm (25 3/8 × 27 3/8 in.)
Inv. no. 958

1. Mary Tavener Holmes, *Nicolas Lancret, 1690–1743*, exh. cat., The Frick Collection (New York, 1991), p. 31, colorpl. 3, and p. 46, colorpl. 4.

BIBLIOGRAPHY
European Paintings from the Gulbenkian Collection. Exh. cat., National Gallery of Art. Washington, D.C., 1950, p. 50, no. 20 (text by Fern Rusk Shapley), and p. 51, illus.

Wildenstein, Georges. *Lancret*. Paris, 1924, p. 93, no. 333, and fig. 94.

EX COLL.
Frederick II, king of Prussia (d. 1786); Prussian royal family (from 1786); Neues Palais, Potsdam (until 1930); bought from Hans Stiebel, Berlin, on January 9, 1930

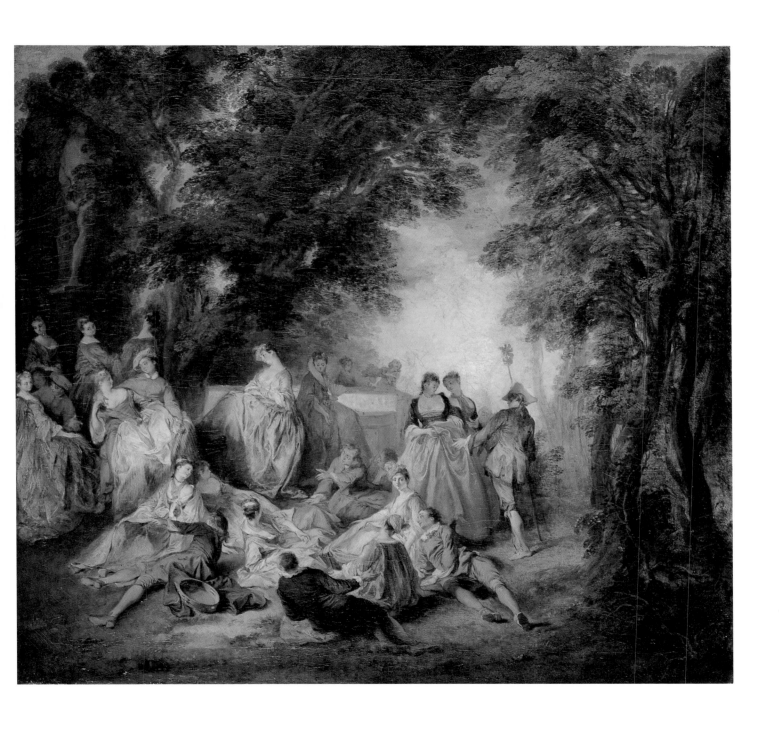

This painting, one of a pair, has as its pendant *Felling the Trees at Versailles: Le bosquet des Bains d'Apollon* (Calouste Gulbenkian Museum, Lisbon).[1] The Gulbenkian pictures either were undertaken by Robert as studies for two larger paintings (Musée National du Château de Versailles) or, more likely, are variants of slightly later date, perhaps made for the Russian market.[2] The nineteen-year-old Louis XVI (r. 1774–92) in consultation with the comte d'Angiviller, *directeur des bâtiments du roi*, determined in the summer of 1774 to replant the park at Versailles in the English taste. The trees were felled during the winters of 1774–75 and 1775–76. Mindful of encouraging painting in all genres, d'Angiviller suggested, and the king agreed, that Robert should document the picturesque if rather frightening spectacle of the work in progress. The Versailles canvases were exhibited to acclaim at the Salon of 1777, the Livret describing them as dating from "the years when the trees were cleared" and pointing out that they had been "ordered for the king."

The canvases commissioned by Louis XVI are roughly twice the size of those in the Gulbenkian collection. In the Versailles *Tapis Vert* Robert portrays Marie-Antoinette and the king himself, accompanied by d'Angiviller, in the foreground at right, while the Gulbenkian picture shows an elegant but anonymous group. Only the peasant leaning against the pedestal of the sculpture at left, the children on the seesaw, and the gentleman examining the sculpture at right appear in both versions. The point of view for the smaller picture is higher; the space is shallower; and there is more debris on the ground. All of the larger trees differ in various details.

At left center of both canvases is the classical group *Castor and Pollux* with the circular peristyle known as La Colonnade behind and the statue *Milo of Croton* by Pierre Puget (1620–1694) to the right. The setting is the entrance to the long avenue known as the Tapis Vert, with the Bassin d'Apollon directly in front and the Grand Canal vanishing into the distance. The painter's easy, fluid brushwork, reflecting the influence of Fragonard, shows itself in the sensitive handling of light, in the fresh atmosphere, and in the airiness of the architecture.

A designer of great renown, Robert was a keen proponent of the new English landscape style. Deeply influenced as well by the ruins of classical antiquity and the disordered nature he had encountered in Rome, he participated in a rebellion in French taste. The formal landscaping that André Le Nôtre (1613–1700) had created for Louis XIV at Versailles was by then more than one hundred years old. In 1778 Robert, having been named *dessinateur des jardins du roi*, began the more relaxed rearrangement of the Bains d'Apollon, incorporating the marble sculpture of the *Horses of Apollo* by the Marsy brothers, which is depicted in the pendant. L S

1. *European Paintings from the Gulbenkian Collection*, exh. cat., National Gallery of Art (Washington, D.C., 1950), p. 86, no. 37 (text by Fern Rusk Shapley), and p. 87, illus.

2. Jean de Cayeux, *Hubert Robert et les jardins* (Paris, 1987), pp. 15–19, 71–72.

BIBLIOGRAPHY
European Paintings from the Gulbenkian Collection. Exh. cat., National Gallery of Art. Washington, D.C., 1950, p. 84, no. 36 (text by Fern Rusk Shapley), and p. 85, illus.

EX COLL.
Count Tolstoy (until 1870); D. V. Grigorovich (1870); Alexander III, emperor of Russia, Anichkov Palace (1870–d. 1894); Russian imperial family (1894–1917); The Hermitage, Saint Petersburg [Leningrad] (1917–29); bought from the Antikvariat, Moscow, in April 1929

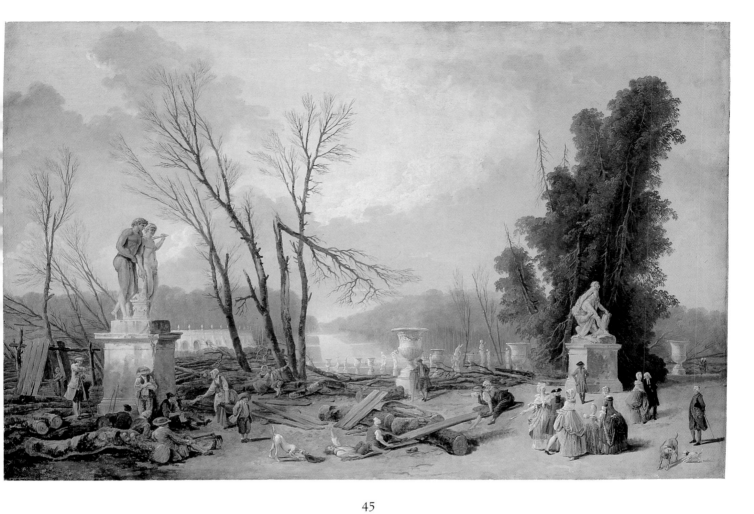

45

HUBERT ROBERT
(French, 1733–1808)

FELLING THE TREES AT VERSAILLES: LE TAPIS VERT

ca. 1775–77
Oil on canvas
67 × 102 cm (26⅜ × 40⅛ in.)
Inv. no. 626

46

ANTOINE WATTEAU
(French, 1684–1721)

THREE STUDIES OF A
WOMAN'S HEAD

ca. 1716–17
Black, red, and white chalk with stumping; framing lines in pen and brown ink
22.5 × 31 cm (8⅞ × 12¼ in.)
Inv. no. 2300

Watteau, according to his biographer and friend Edme-François Gersaint (1694–1750), took greater pleasure in drawing than in painting.[1] His restless, volatile character responded to the immediacy of drawing, which allowed him a livelier and more spontaneous expression than did other pictorial means. Thus, although Watteau was one of the most important painters of the early eighteenth century, contributing to the development of rococo style, especially with his creation of a new genre of painting, the *fête galante*, it is in his drawings that his direct response to the world around him is best revealed, and through them we gain a more intimate understanding of the evolution of his art.

From the time of his early association with Claude Gillot (1673–1722), Watteau never ceased drawing. The models that populated his works were encountered in the world around him. His notebooks also contained studies of landscapes, human figures, or decorative elements, many of which he apparently drew for his own pleasure without any particular purpose in mind, except, perhaps, to use them at a later date in a painting not yet conceived.

Three Studies of a Woman's Head, dated by Pierre Rosenberg and Louis-Antoine Prat to about 1716–17, is a splendid work of the artist's maturity, contemporaneous with the painting *Pèlerinage à l'île de Cythère* (Musée du Louvre, Paris), a masterpiece that enabled Watteau to be received as a member of the Académie Royale in 1717.

As was his practice, Watteau has here combined on a single sheet three studies of the same woman in a feathered hat and frilled collar, in different poses. The three sketches are harmoniously organized along a diagonal that begins at the upper left-hand corner, where the model faces forward with her head slightly tilted, and continues to the second study, where she appears in a three-quarter view, progressing finally to the lower right-hand corner, where she is seen from above, her eyes lowered. The mise-en-page creates a sense of movement that the gaze of the figure herself invites us to follow. The first study is elaborated against a darkened background, which lends it a palpable sense of volume, while the last shows a more summary treatment without, however, any loss of expressiveness. The charm of the sketches and their placement on the sheet are complemented by Watteau's skillful *trois-crayons* technique (red, black, and white chalk).

Various authors have tried, unsuccessfully, to identify the woman portrayed as an actress of the Comédie-Française, Mlle Duclos (b. 1665), and, moreover, to link the head on the left with that of the actress depicted in *Les habits sont italiens*. M F

1. Edme-François Gersaint, *Catalogue raisonné de bijoux, porcelaines, bronzes . . . de M. Angran, Vicomte de Fonspertuis* (sale, the first days of December 1747 and March 4, 1748), reprinted in Pierre Rosenberg, ed., *Vies anciennes de Watteau* (Paris, 1984), p. 44.

BIBLIOGRAPHY
Rosenberg, Pierre, and Louis-Antoine Prat. *Antoine Watteau, 1684–1721: Catalogue raisonné des dessins*. Milan, 1996, vol. 2, pp. 880–81, no. 523, colorpl.

47

PIERRE AVELINE

(French, 1702[?]–1760)

L'ENSEIGNE DE GERSAINT,
in *L'oeuvre d'Antoine Watteau,
Peintre du Roy en Son Academie
Roïale de Peinture et Sculpture. Gravé
d'après ses Tableaux et Desseins
originaux tirez du Cabinet du Roy &
des plus curieux de l'Europe, par les
soins de M. de Jullienne*

Etching with engraving,
after Antoine Watteau, third state

Paris, ca. 1735
51.9 × 83.7 cm (20³/₈ × 33 in.)
(platemark)
Inv. no. L. A. 124

Solitary and melancholic, with an anxious and unstable personality perhaps due to his precarious state of health, Antoine Watteau (1684–1721) nonetheless maintained until the end of his life a circle of friends who protected him and extended their hospitality. They also rendered homage after his premature death at the age of thirty-seven, by composing his biography and by disseminating knowledge of his art.

Jean de Jullienne (1686–1766), a great lover of art and the director of the Gobelins works, became a loyal friend to Watteau after having met him during the last years of his life, probably through Pierre Crozat (1665–1740), the financier and collector who also was a patron of Watteau. In order to further the renown of his friend, Jullienne commissioned some of the best printmakers (Cochin, Tardieu, Audran, Aveline, Cars, and Lépicié, among others) to reproduce in etchings the master's drawings and paintings. The drawings were the first to be reproduced in a collection entitled *Figures de differents caracteres, de paysages, & d'etudes, dessinées d'après nature par Antoine Watteau,* published in two volumes in 1726 and 1728.

The *Mercure de France* announced in 1734 that a second collection of Watteau's work was forthcoming, this time with reproductions of his paintings.[1] The collection *L'oeuvre d'Antoine Watteau, Peintre du Roy . . . gravé d'après ses tableaux et desseins originaux* came out the following year in two huge volumes. Ten of the one hundred copies were set aside for the use of Louis XV (r. 1715–74). The *Figures de differents caracteres* and *L'oeuvre gravé* together came to be known as the *Recueil Jullienne.*

Pierre Aveline's etching after the last great painting completed by Watteau, *L'enseigne de Gersaint* (Schloss Charlottenburg, Berlin), is one of eight double-page prints at the end of the first volume of *L'oeuvre gravé*. The composition has been reversed by the etching process. Besides the double-page prints, volume one of the Gulbenkian *L'oeuvre gravé* contains a title page, forty-nine single-page prints, and front and back leaves. It is bound in leather stamped with gold.

When he returned to Paris from London in 1721, moving in with his friend the art dealer Edme-François Gersaint, Watteau decided to paint a signboard for Gersaint's shop, Au Grand Monarque, on the Pont Notre-Dame. According to Gersaint, Watteau finished the work in eight days, even though his much diminished health allowed him to work only in the mornings. During the two weeks it was exhibited, the public flocked to admire it.[2] *L'enseigne de Gersaint (Gersaint's Shopsign)* presents the interior of a shop as if seen from the street with the facade removed. The shop's walls are covered with paintings by different artists displaying a variety of subjects. On one side, a portrait of Louis XIV is being placed in a crate, a mirror is being moved, a client is entering and being greeted by another man; on the other side, a couple is examining an oval painting, she absorbed in the landscape, he lingering over some female nudes, while another group of clients is admiring a mirror being shown to them by an employee. Aveline's mastery of etching allowed him to capture the pictorial qualities of the painting, especially Watteau's changing hues of fabrics, his modeling of shapes, and, above all, the idyllic atmosphere that always permeates the works of this artist.

M F

1. The prospectus is reprinted in Émile Dacier, Jacques Hérold, and Albert Vuaflart, *Jean de Jullienne et les graveurs de Watteau au XVIIIe siècle* (Paris, 1921–29), vol. 2, pp. 40–42.

2. Edme-François Gersaint, *Abrégé de la vie d'Antoine Watteau*, in *Catalogue raisonné des diverses curiosités du Cabinet de Feu M. Quentin de Lorangère* (sale March 2, 1744), pp. 172–88, reprinted in Pierre Rosenberg, ed., *Vies anciennes de Watteau* (Paris, 1984), p. 37.

EX COLL.
The Hermitage, Saint Petersburg [Leningrad], until 1930; bought from Paul Graupe, Berlin, on March 31, 1932, through Goldschmidt

48

FRANCESCO GUARDI
(Italian, Venetian, 1712–1793)

REGATTA ON THE
GRAND CANAL

ca. 1775
Oil on canvas
61 × 91 cm (24 × 35⅞ in.)
Inv. no. 391

The painting was inspired by Canaletto, who had in turn been influenced by Luca Carlevaris. Canaletto's *Regatta on the Grand Canal* (Collection of Her Majesty Queen Elizabeth II), a work of the early 1730s, was engraved by Antonio Visentini (1688–1782) for publication in 1735; a second, definitive edition of the set to which the print belongs dates from 1742 and circulated widely.[1] Guardi's perspective is deeper than Canaletto's and his horizon line is lower, which together have the effect of doubling the immense expanse of the silvery sky. Canaletto's Venetian architecture is geometrically precise. Guardi, whose style is freer, excels in suggesting the moist atmosphere bathed in light. His livelier handling extends to the rendering of the many small, gesticulating figures.

Guardi paints the Grand Canal looking toward the Rialto Bridge, as if seen from a window of Ca' Foscari with, at left, the *macchina della regatta,* a temporary structure erected upon a floating barge where prizes were presented to the winners of the races. The awnings, hangings draped over the balconies, and vessels decked with branches, effigies of marine deities, and fluttering standards all impart gaiety and a sense of gentle motion in accord with rococo taste. The competitors, single gondoliers in light craft, enter the picture space at the lower right corner; the viewer is invited to join the spectators in the foreground. Guardi has adapted many of Canaletto's boats and figures, probably from Visentini's print.

This Grand Canal scene may be from the mid-1770s. Two variants, one slightly larger (whereabouts unknown) and one smaller (Frick Art Reference Library, New York), are recorded.[2] There are also several related drawings, including a compositional study (British Museum, London) and a free transcription of Canaletto's *macchina* with the figures and boats in the near and middle distance (Kupferstichkabinett, Berlin).[3]

L S

1. J. G. Links, *Views of Venice by Canaletto Engraved by Antonio Visentini* (New York, 1971), pp. 3, 8, fig. 9, and pp. 40 and 41, illus.

2. Antonio Morassi, *Guardi: Antonio e Francesco Guardi* (Venice, 1973), vol. 2, figs. 327–28.

3. Vittorio Moschini, *Francesco Guardi* (Milan, 1952), n.p., no. 144, illus., and J. Byam Shaw, *The Drawings of Francesco Guardi* (London, 1951), p. 68, no. 39, illus.

BIBLIOGRAPHY
Morassi, Antonio. *Guardi: Antonio e Francesco Guardi.* Venice, 1973, vol. 1, pp. 199, 202, 366–67, no. 299, vol. 2, fig. 326.

EX COLL.
Robert Dundas Haldane-Duncan, first earl of Camperdown (d. 1859); Adam Haldane-Duncan, second earl of Camperdown (1859–d. 1867); his daughter, Lady Julia Duncan, Baroness Abercromby (1867–d. after 1915); her cousin, Georgiana Wilhelmina Mercer-Henderson, countess of Buckinghamshire (until 1919; bought through Christie's, London, March 11, 1919)

Opposite: Detail, cat. no. 48

49

FRANCESCO GUARDI
(Italian, Venetian, 1712–1793)

THE FEAST OF THE ASCENSION
IN PIAZZA SAN MARCO

ca. 1775
Oil on canvas
61 × 91 cm (24 × 35⅞ in.)
Inv. no. 390

1. Jacob Bean and William Griswold,
 *18th Century Italian Drawings in The
 Metropolitan Museum of Art* (New
 York, 1990), p. 136, no. 123, illus.

2. Dario Succi, *Da Carlevarijs ai Tiepolo:
 Incisori veneti e friulani del settecento*,
 exh. cat., Museo Correr (Venice,
 1983), p. 348, no. 447, illus.

3. Vittorio Moschini, *Francesco Guardi*
 (Milan, 1952), n.p., fig. 143.

BIBLIOGRAPHY
 Morassi, Antonio. *Guardi: Antonio
 e Francesco Guardi.* Venice, 1973,
 vol. 1, pp. 187–89, 361–62, no. 277,
 vol. 2, fig. 307.

EX COLL.
 Robert Dundas Haldane-Duncan,
 first earl of Camperdown (d. 1859);
 Adam Haldane-Duncan, second
 earl of Camperdown (1859–d. 1867);
 his daughter, Lady Julia Duncan,
 Baroness Abercromby (1867–d. after
 1915); her cousin, Georgiana Wilhel-
 mina Mercer-Henderson, countess
 of Buckinghamshire (until 1919;
 bought through Christie's, London,
 March 11, 1919)

One of Francesco Guardi's master-
pieces, *The Feast of the Ascension in
Piazza San Marco* shows the piazza
decorated for Venice's principal festi-
val, the Festa della Sensa, which falls
on May 7. On this date, in or about
A.D. 1000, Doge Pietro Orseolo II set
sail to conquer the Dalmatian pirates
and guarantee Venetian control of the
Adriatic. His victory was commemo-
rated by a splendid annual ceremony:
the doge sailed out through the Lido
port for a service of thanksgiving and
afterward cast into the waves a propi-
tiatory ring symbolic of Venice's marriage to the sea. Both Canaletto and Guardi painted the
ceremony, but Guardi alone depicted the celebration in the piazza. The picture shows the tempo-
rary curtained arcades, illuminated by oil lamps, that were set up to shelter booths where the
finest Venetian goods were offered for sale during the fifteen days of the festival. Behind are
the Procuratie Vecchie, the clock tower, the basilica, the bell tower, the Palazzo Ducale, and the
Procuratie Nuove. The painting is a pendant to catalogue number 48.

Guardi captures the theatrical atmosphere of the festival. The composition develops from the
foreground. The palette is heightened with touches of bright color, while the magnificent
vista is enlivened by the movements and gestures of elegant silhouettes defined by tremulous
brushstrokes. These figures, marvelously integrated into the setting, transmit a feverish gaiety
and excitement.

A date of about 1775 has been proposed. In the summer of 1776 the Venetian Senate chose
the architect Bernardino Maccaruzzi (d. 1798) to design for the following year an elaborate
elliptical wooden structure that could be easily assembled and dismantled in the Piazza San
Marco and thus reused in the future. Guardi later made a painting (Kunsthistorisches Museum,
Vienna) of this structure as seen from the east, looking toward the church of San Geminiano.
A drawing (The Metropolitan Museum of Art) of the same view with slight differences in
the staffage has been attributed to both Francesco Guardi and his son Giacomo (1764–1835).[1]
Francesco's painting was engraved by Antonio Sandi (1733–1817).[2] A preparatory drawing
for *The Feast of the Ascension in Piazza San Marco* is in the British Museum, London.[3] A smaller
version of the painting also belongs to the Gulbenkian Museum. L S

Opposite: Detail, cat. no. 49

50

THOMAS
GAINSBOROUGH
(British, 1727–1788)

MRS. LOWNDES-STONE

ca. 1775
Oil on canvas
232 × 153 cm (91³⁄₈ × 60¹⁄₄ in.)
Inv. no. 429

Thomas Gainsborough was already one of Georgian England's leading artists by the time he left Bath to settle permanently in London in 1774. This charming portrait was almost certainly painted in the following year to celebrate the marriage—on July 15, 1775—of Elizabeth Garth, daughter of Richard Garth of Morden, Surrey, and her cousin William Lowndes-Stone, of Astwood and North Crawley, Buckinghamshire, and of Baldwyn Brightwell, Oxfordshire. The composition adheres in a general way to the elegant full-length portrait type that had been introduced into England in the 1630s by Charles I's court painter, Anthony van Dyck (1599–1641). Van Dyck's influence on English portraiture was long-standing, and Gainsborough admired him deeply.

Elizabeth Lowndes-Stone wears an informal salmon-colored silk dress and a transparent gauze shawl trimmed with gold fringe. Accompanied by her spaniel, she emerges from a walk in the wooded landscape in the background. She is presented standing quite naturally in an imaginary setting that was doubtless painted in the artist's London studio. This portrait may exemplify Gainsborough's vaunted ability to take a likeness: despite the picture's grand sophisticated style, the painter captures his model's youth, gentle beauty, and captivating freshness. The canvas also exhibits the spontaneity characteristic of the painter's best work. The breadth, rhythm, and liveliness of the brushwork; the transparent coloring; and a sense of tranquil motion are typical of his style as he approached the height of his career as a fashionable portraitist. While it is more delicate in handling, Mrs. Lowndes-Stone's portrait is typologically similar to the marriage portrait *Caroline Alicia, Lady Briscoe* (Iveagh Bequest, Kenwood, London), which is dated 1776 on the reverse.

L S

BIBLIOGRAPHY
European Paintings from the Gulbenkian Collection. Exh. cat., National Gallery of Art. Washington, D.C., 1950, p. 34, no. 12 (text by Fern Rusk Shapley), and p. 35, illus.

Waterhouse, Ellis. *Gainsborough.* London, 1958, pp. 26, 79, no. 459.

EX COLL.
By descent to Mrs. Lowndes-Stone-Norton (by 1880–d. 1882); Baron Alfred Charles de Rothschild, London (about 1895–d. 1918); by descent to Almina, countess of Carnarvon (from 1918); bought from Duveen, London, on November 15, 1923

18 TH-CENTURY
DECORATIVE ARTS

51

CHARLES CRESSENT
(French, 1685–1768)

MEDAL CABINET
(ONE OF A PAIR)

Paris, ca. 1750
Oak with inlaid white quebracho,
amaranth, boxwood, and ebony;
engraved gilt bronze mounts
191 × 143 × 52 cm
(75¼ × 56¼ × 20½ in.)
Inv. no. 2368A

After an apprenticeship as a cabinetmaker and joiner, Charles Cressent completed his training by attending sculpture classes at the Académie de Saint Luc. Although his clients included both French and foreign nobility, it was in the service of Philippe II, duc d'Orléans and regent from 1715 to 1723, that he developed his talent to the full. The hallmark of Cressent's work, which is never signed, is its great stylistic unity. He is the most representative cabinetmaker of the Régence style.

The medal cabinet is an item of furniture that emerged with the increase in numismatic collections at the end of the fifteenth century. It developed further in the later part of the eighteenth century, alongside the fashion for collecting that was born of French aristocrats' passion for so-called curiosities. An impressive work, one that Cressent himself considered "worthy of a place in the home of those who most esteem curiosities,"[1] the present cabinet consists of two sections. The upper part is in the form of an armoire with double doors, housing two sets of narrow numbered drawers equipped with brass "windows" for labeling. The base is a table

Detail, cat. no. 51

109

with a drawer running its entire width; the top of the table pulls out to hold cases of medals. The principal decoration is in the upper section: an exquisite bronze mount in which three *putti* work a coin press; below them hang two medals, one displaying the bust of Louis XV (r. 1715–74) and another with facing likenesses of the dauphin and his wife Marie-Josèphe de Saxe. These replicate the obverse and reverse of a Louis XV medal struck in 1747 to celebrate the dauphin's second marriage. The mount's marquetry frame is trimmed by a bronze fillet with curling acanthus and shell-like ornaments, topped by a bow suspending flowers. Flanking the frame are medals of twelve Roman emperors, grouped in pairs.

The elephant that decorates the table drawer, as if supporting the weight of all of Roman antiquity, is especially noteworthy. The cabinet's legs, clad in engraved gilt bronze, end in claw feet and have busts of ancient warriors as finishing touches. I P C

1. Cressent sales catalogue, January 15–March 15, 1757, nos. 145–46, translated from Pierre Verlet, *Objets d'art français de la Collection Calouste Gulbenkian* (Lisbon, 1969), n.p.

BIBLIOGRAPHY

Coutinho, Maria Isabel Pereira. *O mobiliário francês do século XVIII na Colecção Calouste Gulbenkian.* Lisbon, 1999, cat. 3.

Levallois, Pierre, and Gaston d'Angelis, eds. *Les ébénistes du XVIIIe siècle français.* Paris, 1963, p. 47.

Pradère, Alexandre. *French Furniture Makers: The Art of the Ébéniste from Louis XIV to the Revolution.* London, 1989, p. 128, colorpl.

Verlet, Pierre. *Objets d'art français de la Collection Calouste Gulbenkian.* Lisbon, 1969, n.p., no. 3, colorpl. and illus.

EX COLL.

M. de Selle (until 1761; sale, 1761, no. 147); count de Stazensky; Baron Nathaniel de Rothschild, Vienna; Baron Alphonse de Rothschild, Paris (until 1948; bought from him through Rosenberg & Stiebel, New York, on March 24, 1948)

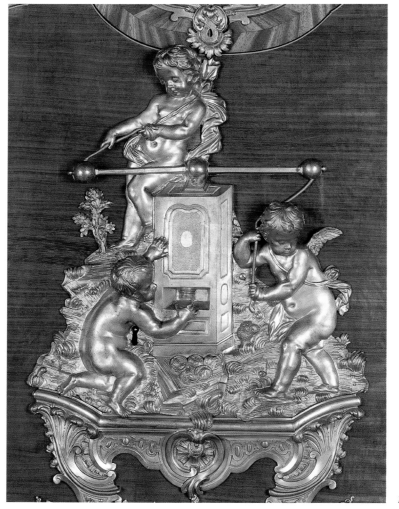

Detail, cat. no. 51

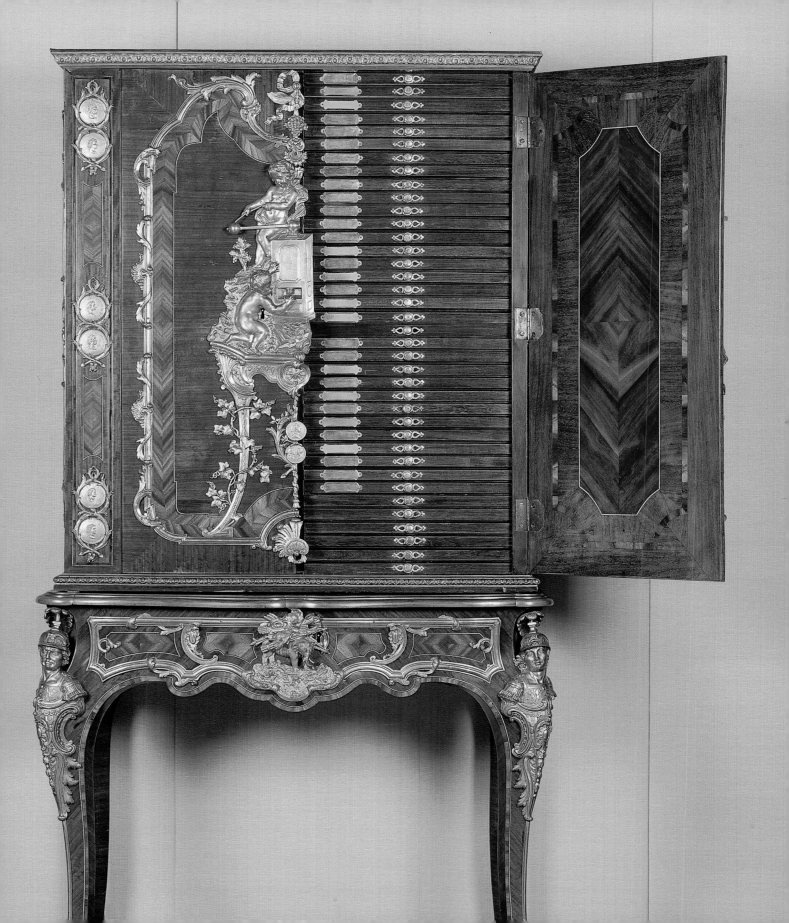

52

EWER WITH COVER

French (Paris), 1734–35
Jasper and gold
H. 33.5 cm (33¼ in.)

Marks:
Griffin's head
(Paris charge mark for gold,
1732–38); crowned S
(Paris warden's mark, 1734–35);
illegible mark

Inv. no. 2379

In the eighteenth century, vessels of rock crystal, Chinese porcelain, and lapis lazuli and other hard stones were especially esteemed for their decorative aspect and often designated as "curiosities" or "picturesque objects." The practice of mounting valuable objects in precious metals goes back, however, to the Renaissance.

The form of this ewer is extremely simple. Its pear-shaped body is separated from the high neck by a smooth collar and sits on a short truncated-cone base. Only the slightly recurved handle has a trilobate cut where it meets the shoulder. The purity of form and the incomparable texture of the blood-colored jasper from which this piece was carved, coupled with its antiquity (apparently, it is medieval), perhaps led to the decision to enhance it with an exquisite mounting in gold in the purest *rocaille* (or, to use the terminology of the time, *pittoresque*) style.

The design for this mount appears in an engraving by A. Bouchet after François Boucher in the latter artist's *Livre de vases*, published in Paris by Gabriel Huquier about 1738. It has recently been argued, however, that a variant drawing by Boucher's own hand was the likely model.[1] The garlands of laurel leaves and the spiral motifs that wrap around the neck are absent in the engraving after Boucher. Yet the lid is conspicuously similar, as are the motifs on the handle and foot. The lid is topped by a boy lying on a base whose rockery, flowers, shell-like forms, and spirals are combined in an extremely animated helicoidal motif. On the upper part of the handle, a goat raises itself on its front legs, while its extended tail unfolds in a spiral that echoes the shape of the handle. The foot mount is decorated with acanthus and spirals.

The absence of a maker's mark prompted the conjecture that this piece could have come only from the ateliers of the Louvre, which led in turn to its attribution to a member of the Germain family, probably Thomas.[2] This is not, however, a well-grounded attribution stylistically. Even so, the quality of the work, coupled with the perfection of the chasing, demonstrates that the mounts were made by one of the leading goldsmiths of the period. That the mounts on this ewer were worked in gold, when for this type of piece silver or gilt bronze would normally have been used, indicates a commission from an important personage, perhaps even a member of the royal family.

I P C

1. Alicia M. Priore, "François Boucher's Designs for Vases and Mounts," *Studies in the Decorative Arts* 3, no. 2 (Spring–Summer 1996), pp. 4–5, 17, fig. 12, 19, 25–28, figs. 28a–d, 49, nn. 53–56; see also pp. 28–29, figs. 24a–b.

2. Germain Bapst, *Études sur l'orfèvrerie française au XVIIIe siècle: Les Germain, orfèvres-sculpteurs du roy*. Paris, 1887, pp. 172–73, 215–16.

BIBLIOGRAPHY
Helft, Jacques, ed. *Les grands orfèvres de Louis XIII à Charles X*. Paris, 1965, p. 140 and p. 141, colorpl. 2.

Verlet, Pierre. *Objets d'art français de la Collection Calouste Gulbenkian*. Lisbon, 1969, n.p., no. 10, colorpl. and illus.

EX COLL.
Duke of Hamilton (until 1882; his sale, Christie's, London, June 24–26, 1882, no. 488, to S. Wertheimer); Baron Charles de Rothschild, Frankfurt; by descent to his daughter (by 1911); Baron Henri de Rothschild (bought from him on July 16, 1943)

53
ANTOINE-SÉBASTIEN DURAND

(French, master 1740, recorded 1785)

DISH COVER FROM THE PENTHIÈVRE-ORLÉANS SERVICE

Paris, 1754–55
Repoussé and engraved silver
28 × 58 × 45 cm (11 × 22⅞ ×
17¾ in.), 9.35 kg

Marks:
Crowned fleur-de-lis,
two *grains de remède*, ASD, device
a heart (maker's mark);
crowned A with palm and laurel
branches (Paris charge mark for
large silver pieces, 1750–56);
crowned O (Paris warden's
mark, 1754–55)

Coat of arms:
Orléans, applied after 1821
by Louis-Philippe (1773–1850),
then duc d'Orléans,
later king of the French

Inv. no. 2381

During the reign of Louis XV (1715–74), the art of the table developed in France almost to a science. The shapes of pieces became extraordinarily diversified and their functions, as well as the rituals involving their use, were strictly fixed. In the *service à la française*, the foods were placed on the table in containers artfully arranged in such a way that each diner could serve himself.

Many of the pieces used in the successive courses of a meal were decorated with elements that alluded to their contents. Such is the case with this *cloche*, or dish cover—called at the time a *cloche à la matelote*—which is crowned by a fabulous still life of fish, shellfish, and fishing symbols intertwined on a bed of algae. This sculptural composition, noteworthy not only for its originality, daring, and magnificent architectural sense but also for the perfection of its execution, attests to the consummate skill of the master silversmith Antoine-Sébastien Durand. The compartmented base is decorated with aquatic motifs on an engraved ground, framed by spirals, swirls, and festoons. In the central panel, a boy holds a shield, supported by two dolphins, that encloses the Orléans coat of arms surrounded by the orders of the Saint-Esprit and Saint-Louis and surmounted by a prince's crown. The commission for this coat of arms was given to the silversmiths J.-B.-C. and Charles-Nicolas Odiot by the duc d'Orléans prior to his ascension to the throne in 1830.

The *cloche* is part of the so-called Penthièvre-Orléans Service, whose history is well known but very complex: the earliest pieces, by Thomas Germain, were formerly thought to have been commissioned by the comte de Toulouse, illegitimate son of Louis XIV (r. 1643–1715) and Madame de Montespan, but it now appears they were ordered by a naturalized Englishman, Henry Janssen. The pieces made for Janssen were acquired after his death by the comte d'Eu, who added several fabulous pieces, among them the Gulbenkian *cloche*. The service was inherited by the duc de Penthièvre and then by his daughter, Louise-Marie-Adélaïde de Bourbon, wife of Louis-Philippe-Joseph d'Orléans (1747–1793), known as Philippe Égalité, who was guillotined. The widowed duchesse d'Orléans was able to reclaim a large part of her tableware, which had been confiscated; it passed by inheritance to her son Louis-Philippe, duc d'Orléans and future king of the French (r. 1830–48), who added his coat of arms. I P C

BIBLIOGRAPHY

Boiron, Stéphane. "The Origins of the Penthièvre-Orléans Service." In *Royal French Silver: The Property of George Ortiz,* Sotheby's New York, November 13, 1996, pp. 38–52.

Ferreira, Maria Teresa Gomes. "L'argenterie Gulbenkian." *Connaissance des arts,* December 1970, pp. 106–16.

Helft, Jacques, ed. *Les grands orfèvres de Louis XIII à Charles X.* Paris, 1965, pp. 154–55, no. 1, illus.

Phillips, Phoebe, ed. *Le grand livre de l'objet d'art.* Geneva, 1975, vol. 2, p. 32.

Verlet, Pierre. *Objets d'art français de la Collection Calouste Gulbenkian.* Lisbon, 1969, n.p., no. 12, colorpl. and illus.

Versailles et les tables royales en Europe. Exh. cat., Châteaux de Versailles et de Trianon. Paris, 1993, cited in no. 68.

EX COLL.

Louis-Charles de Bourbon, comte d'Eu (d. 1775); by descent to Louis-Jean de Bourbon, duc de Penthièvre (d. 1793); by descent to his daughter, Louise-Marie-Adélaïde de Bourbon, duchesse d'Orléans (d. 1821); by descent to her son Louis-Philippe, duc d'Orléans, later Louis-Philippe I (d. 1850); by descent to the duc de Vendôme (d. 1931); comtesse de Béhague, Paris; bought from Kleinberger, Paris, on July 17, 1950

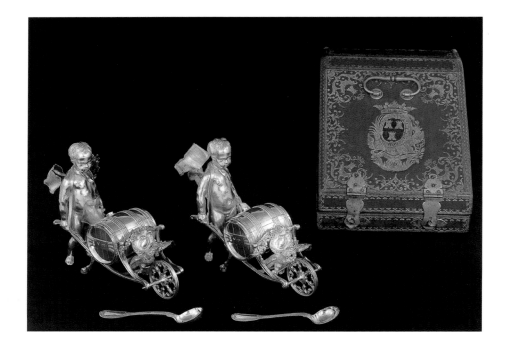

54

ANTOINE-SÉBASTIEN DURAND
(French, master 1740, recorded 1785)

PAIR OF MUSTARD BARRELS

Paris, 1751–52
Silver
Each mustard barrel:
17.4 × 8.5 × 23 cm
(6⅞ × 3⅜ × 9 in.), 1.3 kg;
spoons: 12.7 cm (5 in.) and 13 cm (5⅛ in.),
34 g and 37 g
Inv. no. 287A,B

Marks:
Crowned fleur-de-lis,
two *grains de remède*, ASD,
device a heart (maker's mark);
crowned A with palm and
laurel branches (Paris charge
mark for large silver pieces
1750–56); crowned K (Paris
warden's mark, 1750–51)

Inscribed:
DU Nº 199

BIBLIOGRAPHY
Ferreira, Maria Teresa Gomes. "L'argenterie Gulbenkian." *Connaissance des arts*, December 1970, pp. 106–16.

Helft, Jacques, ed. *Les grands orfèvres de Louis XIII à Charles X*. Paris, 1965, p. 150, colorpl. 1, and p. 151.

Verlet, Pierre. *Objets d'art français de la Collection Calouste Gulbenkian*. Lisbon, 1969, n.p., no. 11, colorpl. and illus.

EX COLL.
Jeanne-Antoinette Poisson Le Normant d'Étoiles, marquise de Pompadour (d. 1764); comte de Vergennes; bought from Duveen, Paris, on November 24, 1919

Receptacles for seasonings such as mustard, pepper, and cinnamon, or salt, oil, and vinegar, were at first integrated into a single large piece, the *surtout*, that was placed at the center of the table and also held candelabra. Over time, the *surtout* was separated into its component parts and, by the eighteenth century, retained only its decorative aspect. The candelabra were removed first, followed by other pieces, large and small, intended for the various seasonings. These containers came to have an important place at the French table, where they remained throughout the meal, accompanying the diverse courses. As they became freestanding, they evolved into elaborate entities whose decorative aspect sometimes overshadowed the utilitarian one. Children in the form of cupids and *putti* became a recurring theme, intimately linked to the *rocaille* style. We find them, individually or in groups, engaged in a variety of tasks or simply playing, in practically every artistic manifestation of the period. Madame de Pompadour (1721–1764) was a great enthusiast of this genre in which, among others, the sculptor Étienne-Maurice Falconet (1716–1791) specialized; he was her protégé and head of the sculpture workshop of the royal porcelain factory at Sèvres.

This pair of mustard barrels exemplifies the small, highly decorative vessels, whose utilitarian function is clearly secondary, that enhanced the tables of royalty and important members of the court and also illustrates the period's attraction to infantile charms. Executed by the master silversmith Antoine-Sébastien Durand for Madame de Pompadour, the pieces take the form of two small porters who, with a look of concentration, transport barrels in handcarts. Surmounted by a floral crown and supported by spread eagles, a shield at the front of each cart was intended to be engraved with a coat of arms. The barrels, the upper part of which can be opened, were designed to hold mustard and are each equipped with a spoon. The entire interior is gilded to avoid tarnish of the silver from contact with the seasoning. The two small marching figures are clad in drapery and carry on their shoulders quivers of arrows in allusion to Cupid, the god of love. The front wheel of each cart is movable, and both the

boys' feet and those of the cart rest on rolling spheres, facilitating their movement on the table. These are true gems of eighteenth-century French silversmithing.

The Gulbenkian mustard barrels preserve their original case, in embossed red morocco decorated with gilding. The work of the famous bookbinder Antoine Padeloup, the case bears the coat of arms of Madame de Pompadour.

IPC

Inscribed and dated:
FAIT.PAR.F.T.GERMAIN.
SCULPr.ORFre.DU.ROY
AUX GALLERIES.DU LOUVRE.
A PARIS 1762.

Marks:
Crowned fleur-de-lis, two *grains de remède*, FTG, device a fleece (maker's mark); crowned A (Paris charge mark for large silver pieces, 1756–62); crowned X (Paris warden's mark, 1761–62, on bases); crowned Y (Paris warden's mark, 1762–63, on bowls); small cow (Paris discharge mark for gold and small silver for export, 1765[?]–75); unidentified Russian mark

Coat of arms engraved on underside of bases: Miatliev

55

FRANÇOIS-THOMAS GERMAIN
(French, 1726–1791, master 1748)

PAIR OF SALTCELLARS

Paris, 1762
Silver
A: 21.5 × 27.2 × 17.3 cm (8½ × 10¾ × 6⅞ in.), 3.2 kg;
B: 20 × 28 × 17.5 cm (7⅞ × 11 × 6⅞ in.), 3.5 kg
Inv. no. 1091A,B

Like the mustard barrels that Durand executed for Madame de Pompadour (cat. no. 54), these saltcellars are stellar examples of decorative pieces intended for presenting seasonings at the table in whose conception children figure prominently. Here, the two sculptural groups illustrate stages in the extraction of salt as practiced in the Franche-Comté. Deposits of rock salt were one of the principal riches of the Franche-Comté, whose annexation by Louis XIV in 1678

BIBLIOGRAPHY

Bapst, Germain. *Études sur l'orfèvre-rie française au XVIIIe siècle: Les Germain, orfèvres-sculpteurs du roy.* Paris, 1887, pp. 134–35.

Perrin, Christiane. *François Thomas Germain orfèvre des rois.* Saint-Rémy-en-l'Eau, 1993, p. 99, illus., and p. 100.

EX COLL.

Elizabeth I, empress of Russia (d. 1762); Prince Soltikov; Alexander III, emperor of Russia (d. 1894); Russian imperial family (1894–1917); The Hermitage, Saint Petersburg [Leningrad] (1917–30); bought from the Antikvariat, Moscow, on March 16, 1930

was a source of pride for France. Salt from mines most frequently occurs in an aqueous solution. The brine is pumped to the surface, and the salt is extracted through evaporation of the brine.

On one of the saltcellars a boy standing next to a bucket works a pump from which brine pours into a vat placed over a furnace that another child stokes with wood. There is also a second, smaller vat and, on the ground, small logs and the lid of a basket. Three vats rest over fires on the other saltcellar. One boy stands next to a double faucet and probably originally held a small spoon in his upraised hand. The second boy, seated, holds in his left hand a pitcher with whose contents he appears to fill a cylindrical container at his feet. Small logs are scattered about. The vats serve as compartments for the salt. Both pieces sit on oval bases with spiral feet.

These small sculptural pieces were exquisitely fashioned by the great silversmith Germain. The boys' expressions—somewhere between concentrated and amused—the anatomical detail of the juvenile bodies, the movement in the hair, and the painstaking details are the work of a real master.

The saltcellars, like the centerpiece in this exhibition (cat. no. 57), were commissioned by Empress Elizabeth I of Russia (r. 1741–62). The presence of the engraved coat of arms of the Miatliev family suggests that the saltcellars also belonged to Prince Soltikov to whom they would have been given by Elizabeth I. They were made part of the Russian imperial collections by Emperor Alexander III (r. 1881–94). In his 1907 inventory of the Russian imperial gold and silver, Baron de Foelkersam cited the saltcellars as part of the so-called Soltikov Service.

I P C

Inscribed and dated:
FAIT.PAR.F.T.GERMAIN.SCULPr.
ORFre. DU ROY AUX GALLERIES.
DU LOUVRE.A PARIS 1761;
N° 482 Du N° 41–27m–3°–62,
on the stand; *N° 470/Du*
N° 40–49m–2°–1', on the tureen;
painted in red lacquer: *7211*,
on the stand, tureen, and cover

Marks:
crowned fleur-de-lis, two *grains de remède*, FTG, device a fleece (maker's mark); crowned A with a laurel branch (Paris charge mark for large silver pieces, 1762–68); crowned S (Paris warden's mark, 1758–59, on cover); crowned V (Paris warden's mark, 1760–61, on tureen stand); small cow (Paris discharge mark for gold and small silver for export, 1765[?]–75)

Coat of arms:
imperial Russian

56

FRANÇOIS-THOMAS GERMAIN
(French, 1726–1791, master 1748)

TUREEN AND STAND (ONE OF A PAIR)

Paris, 1758–61
Silver gilt, cast, repoussé, and engraved
36 (tureen) × 43 (stand) × 59 cm (14⅛ × 16⅞ × 23¼ in.), 10.39 kg
Inv. no. 1086B

Empress Elizabeth I of Russia (r. 1741–62) commissioned numerous works from France during the reign of Louis XV (1715–74). Her commissions included one to François-Thomas Germain for a large silver service known as the Paris Service, which was delivered beginning in 1761. Executed in *rocaille* style, this service evokes both the pomp of the Russian court and the magnificence of French silverwork of the period.

The present silver-gilt tureen is one of eight from this service and one of two in the Gulbenkian collection. The oval tureen rests on four spiral legs and displays on each face the Russian imperial coat of arms: topped by the imperial crown, a large double-headed eagle, its wings spread, grasps in its claws the scepter and the globe, while a shield on its breast represents the

struggle between Saint George and the dragon. At the sides of this heraldic emblem hang garlands of laurel leaves and berries that issue from the drapery that two small fauns hold in their outstretched arms. The figures are framed by large acanthus and shell-like forms that scroll from the edges of the cover to the tureen's feet, where they twist into a spiral. The surface of the wave-shaped, slightly concave cover features radial gadrooning with shell-like forms at the ends and, in the center, a sculptural group. The enchanting scene is very much in keeping with *rocaille* taste. On a small elevation on which fruit and flowers are scattered, a small boy is stretched out on the ground trying desperately to hold on to a dog's leash and prevent it from getting too near a nest of eggs from which baby birds are hatching. A little girl seated beside him holds a bird in both hands, protecting it from the dog. The oval stand is framed with acanthus and spiral motifs, whose movement suggests the undulation of waves and which continue into the feet. The surface is covered by radial gadrooning.

In these monumental pieces, Germain makes use of a 1757 tureen model for a service that was executed for King José I of Portugal. I P C

BIBLIOGRAPHY

Bapst, Germain. *Études sur l'orfèvrerie français au XVIIIe siècle: Les Germain, orfèvres-sculpteurs du roy.* Paris, 1887, p. 134.

Ferreira, Maria Teresa Gomes. "L'argenterie Gulbenkian." *Connaissance des arts,* December 1970, pp. 106–16.

Perrin, Christiane. *François Thomas Germain orfèvre des rois.* Saint-Rémy-en-l'Eau, 1993, p. 212 and p. 214, illus.

Verlet, Pierre. *Objets d'art français de la Collection Calouste Gulbenkian.* Lisbon, 1969, n.p., no. 13, colorpl. and illus.

Versailles et les tables royales en Europe. Exh. cat., Châteaux de Versailles et de Trianon. Paris, 1993, no. 203.

57

FRANÇOIS-THOMAS GERMAIN

(French, 1726–1791, master 1748)

CENTERPIECE

Paris, 1762–66
Cast and engraved silver
A: 53 × 90 × 67 cm
(20⅞ × 35⅜ × 26⅜ in.), 36.6 kg
B: 40 × 41.5 × 36 cm
(15¾ × 16⅜ × 14⅛ in.), 9.14 kg
C: 40 × 41 × 35 cm
(15¾ × 16⅛ × 13¾ in.), 8.5 kg

Inscribed and dated:
FAIT.PAR.F.T. GERMAIN.
SCULPr.ORFre.
DU.ROY AUX GALLERIES.DU
LOUVRE.A PARIS 1766.

Marks:
crowned fleur-de-lis, two *grains
de remède,* FTG, device a fleece
(maker's mark); crowned A with
a laurel branch (Paris charge
mark for large silver pieces,
1762–68); crowned X
(Paris warden's mark, 1761–62);
crowned Z (Paris warden's mark
1763–64); small cow (Paris
discharge mark for gold and
small silver for export,
1765[?]–75); unidentified
Russian mark

Coat of arms engraved on
underside of bases: Miatliev

Inv. no. 1085A,B,C

During the eighteenth century the *surtout*—the large stand placed at the center of the table that combined receptacles for seasonings—became a purely ornamental piece. There is no utilitarian aspect to the present ensemble, which was commissioned by Empress Elizabeth I of Russia (r. 1741–62) from the Parisian silversmith François-Thomas Germain in 1760 as a gift to her uncle General Soltikov.

The base of the central piece is decorated with spirals and embellished by two mascarons. Gamboling on a platform that abounds in *rocaille* motifs, with rocks, algae, and sea-foam, are two children who represent Bacchus and Cupid. Bacchus, his head crowned with vines and grapes, sits on a wineskin, raising a cup in his right hand. With his left hand he appears to push Cupid, who sports wings and has fallen onto a skin. On the ground next to Cupid lie his bow and quiver with arrows. At the feet of Bacchus, a thyrsus decorated with a ribbon rests among wineskins and bunches of grapes.

On the smaller flanking pieces, two little girls seated on platforms supported by spiral bases represent allegorically the Birth of Comedy and the Awakening of Love. The first girl, in a sleigh-bell headdress, plays castanets; a small tambourine and a theatrical mask lie on wineskins and scattered bunches of grapes. The second, with flowers in her hair, watches a pair of doves perched on a rose bough and brings her index finger to her lips as if asking for silence.

Children, whose representation was a quintessential feature of French art during the eighteenth century, are magnificently captured in these veritable sculptures in silver executed after models that are so fine as to remind one of those by the sculptor Étienne-Maurice Falconet (1716–1791).

This centerpiece was completed only in 1766, after the death of the empress Elizabeth. Like many other pieces in the so-called Soltikov Service (see cat. no. 55), it passed to the Miatliev family. It was later acquired by Emperor Alexander III (r. 1881–94) and added to the Russian imperial collections. The ensemble is cited in Baron de Foelkersam's 1907 inventory of the gold and silver pieces in the Russian imperial palaces. I P C

Above: Detail, cat. no. 57, central piece

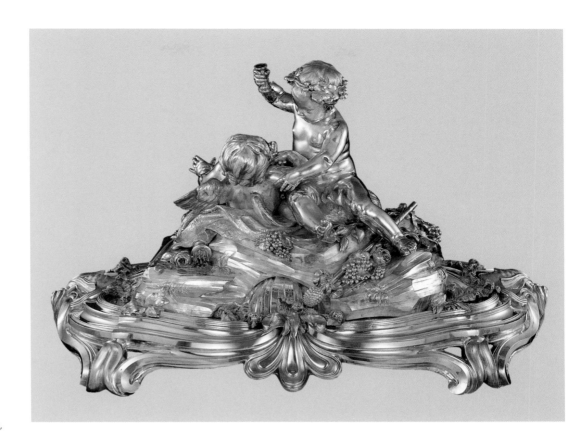

BIBLIOGRAPHY

Bapst, Germain. *Études sur l'orfèvrerie français au XVIIIe siècle: Les Germain, orfèvres-sculpteurs du roy.* Paris, 1887, p. 131.

Helft, Jacques, ed. *Les grands orfèvres de Louis XIII à Charles X.* Paris, 1965, pp. 186–87, no. 2, illus.

Mabille, Gérard. "Les surtouts de table dans l'art français du 18e." *L'estampille,* October 1980, pp. 62–73.

Perrin, Christiane. *François Thomas Germain orfèvre des rois.* Saint-Rémy-en-l'Eau, 1993, pp. 100–102, illus., and p. 197.

Verlet, Pierre. *Objets d'art français de la Collection Calouste Gulbenkian.* Lisbon, 1969, n.p., no. 14, colorpls. and illus.

Versailles et les tables royales en Europe. Exh. cat., Châteaux de Versailles et de Trianon. Paris, 1993, no. 204.

EX COLL.

Prince Soltikov; Alexander III, emperor of Russia (d. 1894); Russian imperial family (1894–1917); The Hermitage, Saint Petersburg [Leningrad] (1917–30); bought from the Antikvariat, Moscow, on March 16, 1930

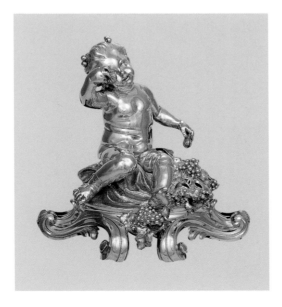

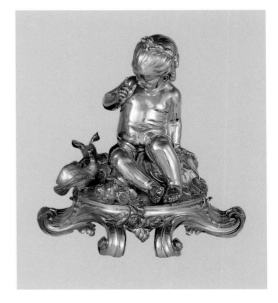

58
Panel

**after a
Design by Philippe de
Lasalle, from the
Palace of King Stanislas
Leszczynski in Nancy**

French (Lyon), ca. 1760–65
Silk with chenille
85 × 69 cm (33½ × 27⅛ in.)
Inv. no. 201

During the reign of Louis XIV (1643–1715), the various silk manufactories at Lyon were reorganized and rationalized according to an ordinance published by Colbert in 1667. This initiative was to have a great impact on French textiles, continuing the tradition previously fostered by Italian weavers living in France.

The work of Philippe de Lasalle (1723–1804) exemplifies silk production at Lyon in the eighteenth century. A student of Boucher, Lasalle was an exceptional artist who guided his creations from the initial design sketch to the final movement of the weaver's shuttle. His name became inseparable from that of Lyon and from the success of La Grande Fabrique, as the city was known at the time. Countless important fabrics are attributed to Lasalle, but though he rose to *maîtrise* in 1749, his name does not appear among those to whom commissions were awarded by the royal *garde-meuble*. This omission might be explained by deliveries having been made through other suppliers. We do know that Lasalle worked for the prince de Condé and for Catherine II of Russia.

This lampas fragment is brocaded with polychrome silk and chenille on a cream ground. The floral decoration amid drapery secured by cords and tassels is a composition typical of the reign of Louis XV (1715–74). (Floral motifs, though differently treated in various periods, were the favored textile decoration in eighteenth-century France.) Refined fabrics such as this were an integral part of aristocratic settings, often lining entire rooms or covering partitions, fireplace screens, and seat furniture. The present fragment comes from a textile that decorated the palace in Nancy that housed Louis XV's father-in-law, Stanislas Leszczynski, the exiled king of Poland (1677–1766; r. 1704–9, 1733–35).

Another fragment of this textile is in the collection of the Maison Prelle, Lyon. The Musée Historique des Tissus, Lyon, owns two fragments, including one from the matching border.

M F P L

Bibliography

Arizzoli-Clémentel, Pierre. *Soieries de Lyon: Commandes royales au XVIIIe s. (1730–1800)*. Exh. cat., Musée Historique des Tissus. Lyon, 1988, pp. 57–61, 113, nos. 8–9, illus.

———. *The Textile Museum, Lyons*. Paris, 1990, p. 75, colorpl.

Ex coll.

Stanislas Leszczynski (d. 1766); Besselièvre (until 1912; Besselièvre sale, Drouot, Paris, December 16–17, 1912, no. 163, bought through Stora)

59

Two Panels

AFTER A
DESIGN BY JACQUES GONDOUIN,
FROM THE CABINET DE LA REINE AT VERSAILLES

French (Lyon), 1779
Silk with chenille
Each panel: 230 × 46 cm (90½ × 18⅛ in.)
Inv. no. 1401A,B

Together with floral motifs, which dominated silk production in Lyon during the eighteenth century, a taste for arabesques reemerged about 1760. In the drawings of Jacques Gondouin (1737–1818), the king's architect, the arabesque acquired great lightness and elegance. Those qualities are evident in the present textile, which was conceived by Gondouin for Marie-Antoinette and executed in the workshops of Jean Charton. (Charton, chief manufacturer of the royal *garde-meuble* for more than forty years, had achieved the *maîtrise* in 1733.) The textile was intended for Marie-Antoinette's *cabinet intérieur* at Versailles. In 1778 and 1779, Gondouin provided colored drawings of a "Lyon furnishing for the Queen's Cabinet at Versailles," specifically, a "design for six medallions" then being produced on Charton's looms.[1] Of the seven models of medallions with trophies that were woven separately and applied to the main silk, three are represented on the Gulbenkian panels: the tambourine and panpipe, the bagpipe, and the quiver. These panels may come from wall hangings or curtains in the queen's bedchamber or from a supply held in reserve.

In the refined decoration of the silk, arabesque-style intertwined boughs and garlands of flowers are bound by bows and ribbons (motifs that were very much to Marie-Antoinette's taste), creating a frame for the medallions. This silk is also represented at Versailles.

M F P L

1. Pierre Verlet, *Objets d'art français de la Collection Calouste Gulbenkian* (Lisbon, 1969), n.p., no. 19, colorpl. and illus.

BIBLIOGRAPHY
Arizzoli-Clémentel, Pierre. *Soieries de Lyon: Commandes royales au XVIIIe s. (1730–1800).* Exh. cat., Musée Historique des Tissus. Lyon, 1988, pp. 54, 56–57, 116–17, no. 24, and p. 41, colorpl. 24.

EX COLL.
Marie-Antoinette (d. 1793); Sir John Murray Scott (d. 1912); bought from Desmond, London, on November 14, 1918

60

PANEL

FROM
LOUIS XVI's APARTMENTS
AT SAINT-CLOUD

French (Lyon), 1786
Silk
84 × 71 cm (33⅛ × 28 in.)
Inv. no. 1448A

This fragment has been identified with the "brocaded furnishing of *gros de Naples* of the arabesque type with nuanced tones on a white background" that is described in the inventory of the Palais de Saint-Cloud carried out in 1789.[1] That silk was delivered by Marie-Olivier Desfarges in 1786 and was intended for the rooms of Louis XVI's summer residence in Saint-Cloud.

Desfarges, who attained his *maîtrise* in 1774, was apparently the descendant of a family of silk workers in Lyon, though not himself the son of a "master," as were many French master artisans of the ancien régime. He received various commissions from the royal *garde-meuble*, a sign of the esteem in which his work was held; among them was the pattern for the rooms of the Palais de Saint-Cloud. If the textile after a design by Philippe de Lasalle (cat. no. 58) illustrates the taste of the reign of Louis XV (1715–74), this textile, with its balanced composition of large boughs of flowers, arabesques, cords, ribbons, and pearls, exemplifies the preferences of the reign of Louis XVI (1774–92). Roses, ribbons, and pearls frequently decorated furnishings and textiles destined for the royal house, notably for the rooms of Marie-Antoinette.

This textile, not sold during the revolutionary period, decorated the rooms of Napoleon I in the Tuileries early in the Empire.[2] Along with a second, identical fragment, the present panel was mounted on a fireplace screen (made of modern wood) when acquired by Calouste Gulbenkian. A larger fragment in the Mobilier National, Paris, preserves a complete repeat of the pattern. A screen covered with this textile is in the Musée du Louvre, Paris. M F P L

1. Pierre Verlet, *Objets d'art français de la Collection Calouste Gulbenkian* (Lisbon, 1969), n.p., no. 18, illus., and p. 46, colorpl. 43.

2. Pierre Arizzoli-Clémentel, *Soieries de Lyon: Commandes royales au XVIIIe s. (1730–1800)*, exh. cat., Musée Historique des Tissus (Lyon, 1988), pp. 68, 121, nos. 42–44, illus.

EX COLL.
 Louis XVI (d. 1793); Besselièvre (until 1912; Besselièvre sale, Drouot, Paris, December 16–17, 1912, no. 164, bought through Stora)

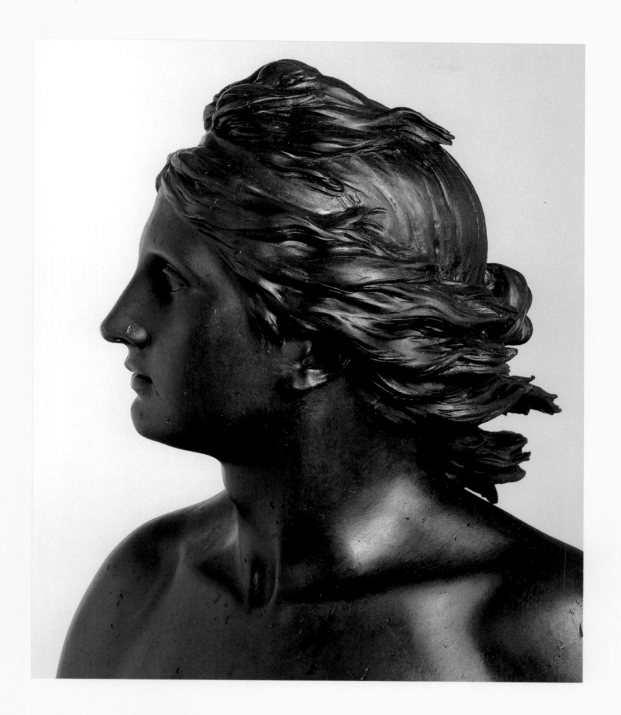

FRENCH SCULPTURE

61

JEAN-ANTOINE HOUDON

(French, 1741–1828)

APOLLO

Paris, 1790
Bronze
213 × 89 × 93 cm
(83⅞ × 35 × 36⅝ in.)

Inscribed and dated on base:
*HOUDON F. 1790. / POUR
JN. GIRARDOT DE MARIGNY,
NEGOCIANT A PARIS*

Inv. no. 552

BIBLIOGRAPHY
Arnason, H. H. *The Sculptures of Houdon*, London, 1975, pp. 92–93, fig. 185, pls. 122–23.

Figueiredo, Maria Rosa. *A escultura francesa*. Vol. 1 of *Catálogo de escultura européia*. Lisbon, 1992, pp. 96–99, no. 18, illus.

Ex COLL.
Jean Girardot de Marigny, Paris (from 1790); Feuchère (sale, 1824, no. 13; sale, 1829, no. 40); E. du Sommerard (1883); Léopold Goldschmidt (from 1883); his heirs, comtesse de Pastré and Comte Jean de Pastré (bought from them on January 30, 1927)

On September 24, 1788, the *Journal de Paris* carried an announcement that a statue of Apollo cast by Houdon earlier that month would be put on public view by the artist for six days, beginning on September 29, from four to six in the afternoon. A number of circumstances conspired to make the showing a significant event. Houdon was not only one of the most prolific sculptors of his time but also one of the most highly esteemed. His *Diana* (cast in plaster in 1776 and carved in marble in 1780) had provoked great debate in artistic circles and was prevented from being exhibited at the Salon because of its purported impropriety. The *Diana* was met with enthusiasm by the public, however, and there were orders for replicas and reductions. In 1782, Houdon delivered to Jean Girardot de Marigny a bronze replica that the sculptor himself had cast, using a technique that he evolved personally and of which he was very proud. After Étienne-Maurice Falconet (1716–1791), Houdon was one of the first eighteenth-century sculptors to attempt the casting of his own work, constructing his own furnaces and training his workers.

Girardot de Marigny wished to possess a pendant for the *Diana* (the notion of pairing was quite common in the eighteenth century). Apollo, Diana's brother, was, of course, the ideal companion. Completed prior to 1783, the model for *Apollo*, which was included in the autograph list of Houdon's works of that year, had to wait to be cast until Houdon returned from America, where he had gone to begin the statue of George Washington for the Virginia statehouse. The *Apollo* is a sand cast, less exact than a lost-wax cast but easier to produce and with less risk of failure. Sand casting also offered the possibility of taking further casts from the same mold.

The expectations created by the notice in the *Journal de Paris*, however, were not met. The *Diana* had been truly innovative, confronting the French with a running naked goddess when they were accustomed to a static, idealized chaste divinity clad in a tunic. But the heroic nudity of the *Apollo* brought with it nothing especially new. This nude was perhaps too reminiscent of the *Apollo Belvedere*, which Houdon had seen in the Vatican during his years of study in Italy and from which he could not quite emancipate himself. Thus, in contrast to the *Diana*, which was widely reproduced, this is the only example of the *Apollo*. The idealistic head of the *Apollo*, however, of particular beauty with the hair flowing as if rippled by a breeze, was disseminated in the form of relief medallions.

M R F

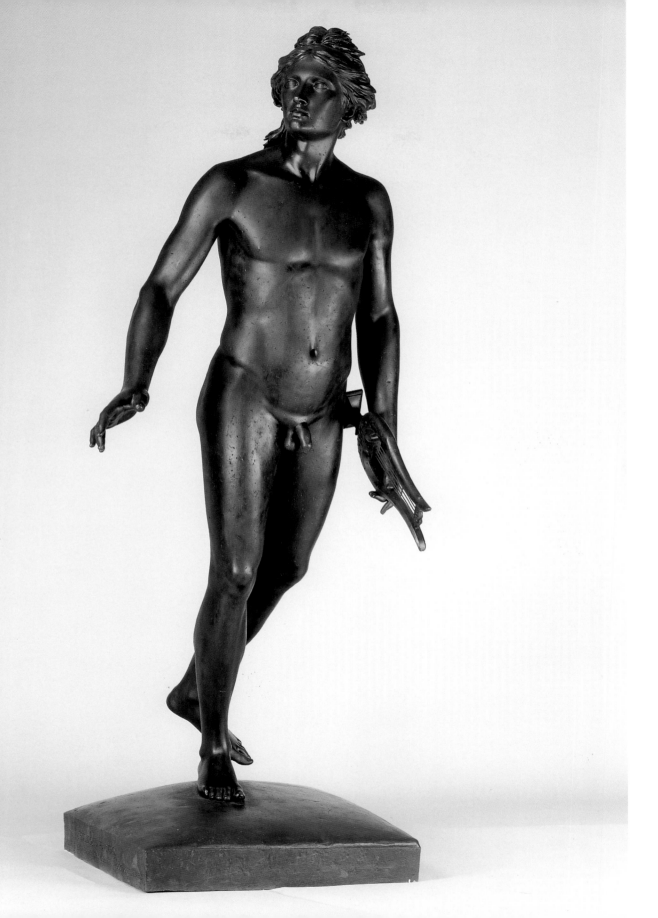

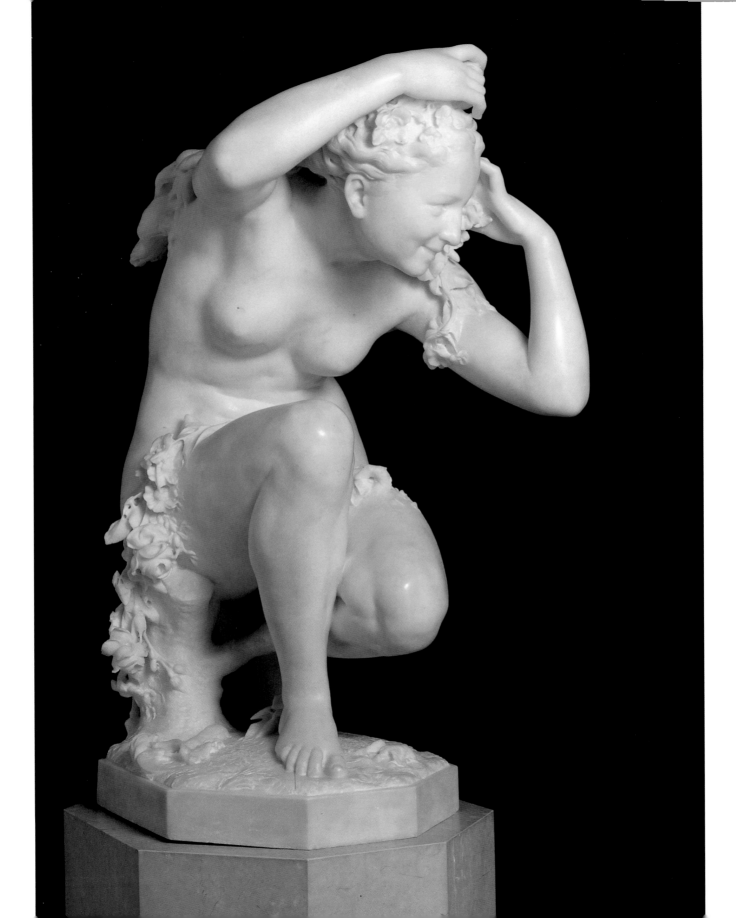

62

JEAN-BAPTISTE CARPEAUX

(French, 1827–1875)

CROUCHING FLORA

1873
Marble
97 × 65 × 60 cm
(38 ¼ × 25 ⅝ × 23 ⅝ in.)

Inscribed and dated on base:
J. Bte. Carpeaux London 1873.

Inv. no. 562

BIBLIOGRAPHY
Figueiredo, Maria Rosa. *A escultura francesa.* Vol. 1 of *Catálogo de escultura européia.* Lisbon, 1992, pp. 154–59, no. 40, illus.

EX COLL.
Henry James Turner, London (1873); E. Cronier (until 1905; his estate sale, Georges Petit, Paris, December 4–5, 1905, no. 121, bought through Graat)

Jean-Baptiste Carpeaux, leading exponent of the eclectic and neo-Baroque movement of the mid-nineteenth century in France, benefited greatly from the Second Empire's taste for decorative sculpture on the facades of its public edifices, a preference encouraged by the comte de Nieuwerkerke, superintendent of the fine arts and himself a sculptor. Carpeaux was the favorite sculptor of Napoleon III, who appreciated the liveliness, movement, abundance of forms, and sensual vigor of Carpeaux's creations, to the point of defending him to the architect Hector Lefuel during a series of misunderstandings that arose over Carpeaux's execution of the relief representing *The Triumph of Flora* for the southern facade of the Louvre. That commission, which also included the pediment of the Pavillon de Flore, as it came to be known, occupied Carpeaux from 1863 to 1866. The result that so displeased Lefuel—a composition in high relief with a circular movement—was influenced by Carpeaux's memories of the art of Flanders (he came from nearby Valenciennes) and especially by the Baroque qualities of Rubens. Four years later, Carpeaux returned to the subject of Flora, this time creating an isolated figure adorning her hair with flowers, whom he called Spring. The original plaster model, in the Musée du Petit Palais, Paris, dates from 1870, as does the oil study in the Musée des Beaux-Arts, Valenciennes.

In 1872 Carpeaux, in flight from the excesses of the Paris Commune, took refuge in London, where he established a workshop across from Regent's Park. There he executed this human-scale *Flora* in marble, commissioned by his principal London patron, Henry James Turner, heir to a paint factory. (Carpeaux also did portrait busts of Mr. and Mrs. Turner.)

In the creation of this smiling girl, Carpeaux was inspired by an ancient crouching Venus in the Uffizi Gallery, Florence, adapting her squatting position to achieve an interplay of superimposed planes that enlivens the sculpture. Numerous surviving studies of young women in various poses, however, attest that he also based this work on living models. The face and smile, as in the earlier work in high relief, are those of Anna Foucart, the daughter of Carpeaux's friend Jean-Baptiste Foucart.

Flora, the goddess of flowers and springtime and the wife of Zephyr, is imbued with a somewhat ambiguous symbolism. She represents joy, love, and youth, the vital exuberance that Carpeaux knew so well how to transmit. Flowers are messengers of love and symbolic of the beloved. Yet flowers, like youth and pleasure, are ephemeral. And, in certain cases, they symbolize lust. In his *De claris mulieribus,* Boccaccio described an unchaste Flora, a well-off Roman courtesan who placed her money at the disposal of the people so that games would be organized in her honor. In Boccaccio's version, the prostitute Flora shows off her flowers as symbols of the pleasures she can provide. Flora's sensual and erotic aspect did not escape Carpeaux and is hinted at in the girl's smile.

In the transfer to marble from the plaster model, the artist employed the pointing technique using compasses. The compass marks are still visible in the marble. M R F

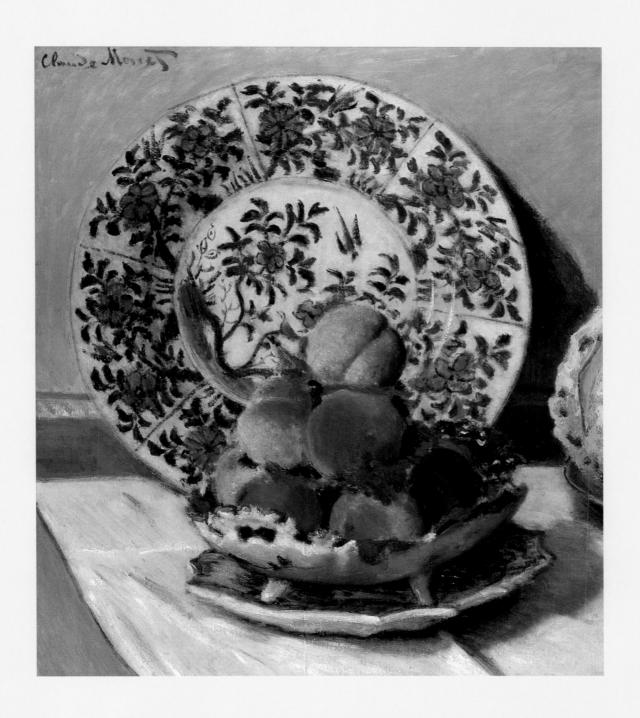

19TH-CENTURY PAINTING

63

JOSEPH MALLORD
WILLIAM TURNER
(British, 1775–1851)

THE WRECK OF A
TRANSPORT SHIP

ca. 1810
Oil on canvas
173 × 245 cm (68⅛ × 96½ in.)
Inv. no. 260

The painting is part of a series of major canvases dedicated to catastrophes and storms at sea completed by Turner between 1801 and 1810. The composition seems to derive from *The Shipwreck* of 1805 (Tate Gallery, London), though the conception here is more elaborate, expressed with greater narrative force and stylistic freedom.[1] The picture's structure, deliberately asymmetrical and chaotic, is organized around the diagonal masts and broken oars, juxtaposed against the curves of the swirling waters in tumult. The passengers and crew, insignificant in scale, are on the verge of being devoured by the maelstrom.

This work was traditionally associated with a marine disaster that occurred on December 22, 1810, and was therefore called *The Wreck of Minotaur . . . on the Haak Sands.* There are two studies for the composition, however, in the painter's "Shipwreck No. 1" sketchbook of about 1806. Moreover, the artist's accounts suggest that this is the canvas sold to the Honorable Charles Pelham, later first earl of Yarborough, on May 25, 1810, a date seven months prior to the sinking of the *Minotaur.*

The Wreck of a Transport Ship is the product of the artist's visionary temperament and extreme sensitivity to nature. Turner not only absorbed the legacy of Dutch maritime painting but also reflected the obsessive concern and fascination with shipwrecks of a people dependent upon the sea.

L S

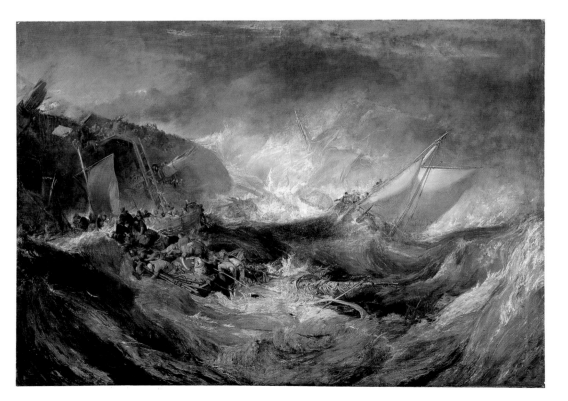

1. Martin Butlin and Evelyn Joll, *The Paintings of J.M.W. Turner,* rev. ed. (New Haven and London, 1984), vol. 2, colorpl. 64.

BIBLIOGRAPHY
Butlin, Martin, and Evelyn Joll. *The Paintings of J.M.W. Turner.* Rev. ed. New Haven and London, 1984, vol. 1, pp. 128–29, no. 210, vol. 2, colorpl. 213.

EX COLL.
Bought from the artist by Hon. Charles Pelham, later first earl of Yarborough (1810–d. 1846); the earls of Yarborough (1846–75); Charles Alfred Worsley Pelham, fourth earl of Yarborough (1875–1920; bought from him on July 24, 1920, through Arthur Ruck, London)

Opposite: Detail, cat. no. 63

Eugène Lami studied first with Horace Vernet (1789–1863) and then with Antoine-Jean Gros (1771–1835). His early works are military paintings (Château de Versailles) and elegant lithographs that bear witness to Parisian society during the reign of Louis-Philippe (1830–48). Lami exhibited regularly at the Salon between 1824 and 1878. He became known above all for his watercolors and in 1879 was among the founders of the Société des Aquarellistes Français.

Lami, who had visited London in 1826–27, followed Louis-Philippe into exile in England in 1848. He remained there until 1852 and enjoyed considerable success at the court of Queen Victoria. The present painting, a romantic depiction of an English garden, is unusual in the artist's oeuvre and must date from about 1850. The landscape evokes French eighteenth-century tradition, as can be seen from the affinities between its composition and the work of Fragonard (see cat. no. 44). Lami's conception of the scene is quite formal, differing from the interpretations of landscape by his contemporaries Jean-Baptiste-Camille Corot (1796–1875) and Théodore Rousseau (1812–1867).

Nature in Lami's painting is serene, molded by man, balanced and harmonious. It is minutely described. The figures are a reminder of his taste for worldly society and his interest in describing the pleasures of daily life. L S

BIBLIOGRAPHY
Lemoisne, P[aul].-André. *Eugène Lami, 1800–1890.* Paris, 1912.

———. *L'oeuvre d'Eugène Lami (1800–1890): Lithographies—dessins—aquarelles—peintures. Essai d'un catalogue raisonné.* Paris, 1914.

EX COLL.
G. V. (until 1927; G. V. sale, Paris, May 29, 1927, no. 30, bought through Graat)

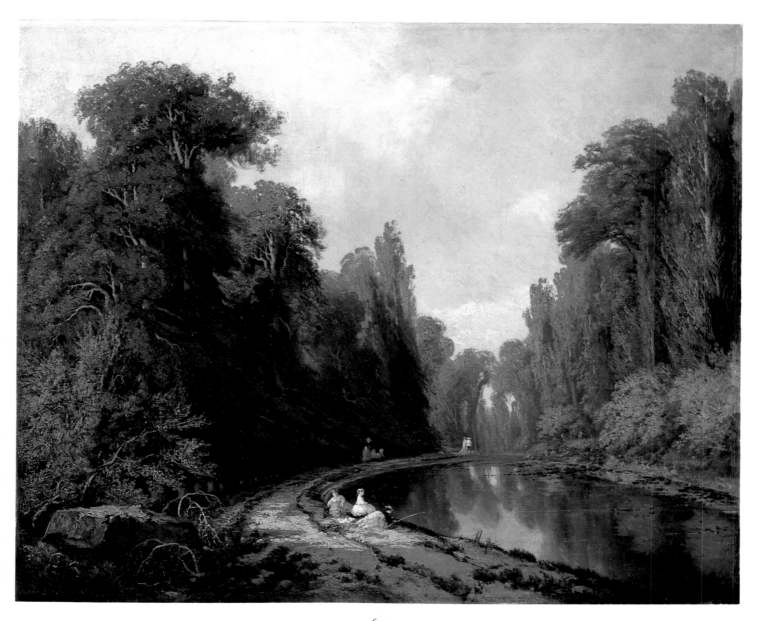

64

EUGÈNE-LOUIS LAMI
(French, 1800–1890)

LANDSCAPE IN A PARK

ca. 1850
Oil on canvas
54 × 64 cm (21¼ × 25¼ in.)
Inv. no. 258

65

ÉDOUARD MANET
(French, 1832–1883)

BOY BLOWING BUBBLES

1867
Oil on canvas
100 × 81 cm (39³⁄₈ × 31⁷⁄₈ in.)

Signed lower right:
Manet

Inv. no. 2361

1. *Manet, 1832–1883*, exh. cat., The Metropolitan Museum of Art (New York, 1983), pp. 271–72, no. 103, illus.

2. Ibid., p. 47, colorpl. 2, p. 77, colorpl. 14, p. 291, colorpl. 109, and p. 330, colorpl. 127.

3. Pierre Rosenberg, *Chardin, 1699–1779*, exh. cat., Cleveland Museum of Art (Cleveland, 1979), p. 204, illus., and pp. 205–7, no. 59.

BIBLIOGRAPHY
Manet, 1832–1883. Exh. cat., The Metropolitan Museum of Art. New York, 1983, pp. 268–70, no. 102, colorpl. 102.

Rouart, Denis, and Daniel Wildenstein. *Édouard Manet: Catalogue raisonné*, vol. 1, Lausanne and Paris, 1975, pp. 122–23, no. 129, illus.

EX COLL.
Albert (1872–d. 1889) and Henri Hecht (1872–d. 1891), Paris; by descent to M. and Mme Emmanuel Pontremoli, Paris (until 1916); Bernheim-Jeune, Paris (1916–18); Durand-Ruel, Paris and New York (1918–19); Adolf Lewisohn, New York (1919–d. 1938; his estate, from 1938; bought through André Weil, New York, in November 1943

The model for this painting is Léon-Édouard Koëlla, known as Leenhoff (1852–1927), the illegitimate son of Suzanne Leenhoff (1830–1906), whom Manet married in 1863. As Suzanne Leenhoff and Manet had known each other since the early 1850s and had lived quietly together for a number of years prior to their marriage, it is possible that the boy was the painter's natural son. According to Léon's much later testimony, he posed for the work at age fifteen in September 1867, in the atelier on Rue Guyot. The etching that Manet made after the painting probably dates from 1868.[1] It was not published until 1890, after the artist's death. Léon Leenhoff figures for a number of years in Manet's work. He appears, for example, in *Spanish Cavaliers* of 1859 (Musée des Beaux-Arts, Lyon), *Boy with a Sword* of 1861 (The Metropolitan Museum of Art), *The Luncheon in the Studio* of 1868 (Neue Pinakothek, Bayerische Staatsgemäldesammlungen, Munich), and *Interior at Arachon* of 1871 (Sterling and Francine Clark Art Institute, Williamstown, Mass.).[2]

The *vanitas* theme that marked the ephemerality of life, symbolized by the soap bubbles, here receives an interpretation freed from the moral content it had earlier carried. A traditional seventeenth-century Dutch interpretation, *Blowing Bubbles* (Musée du Louvre, Paris) by Willem van Mieris (1662–1741), may have influenced Manet. A connection has also been drawn between this painting and the more sentimental *Soap Bubbles,* 1859, by Thomas Couture (The Metropolitan Museum of Art). Manet's stone sill and dark background, as well as the sobriety of his shapes and the simplicity of his composition, seem, however, to recall Jean-Siméon Chardin's *Soap Bubbles* (National Gallery of Art, Washington, D.C.) from about 1745, which Manet might have seen at the April 11, 1867, Laurent Laperlier sale in Paris, a few months before composing his own version.[3] It is also possible that the painting constitutes a reflection by the artist upon the immortality of art. Manet moves from allegory toward an affirmation of his powers of observation. Freed of sentiment, *Boy Blowing Bubbles* engages the eye. The work inhabits a universe of impressions where pure painting is the essential pictorial value. L S

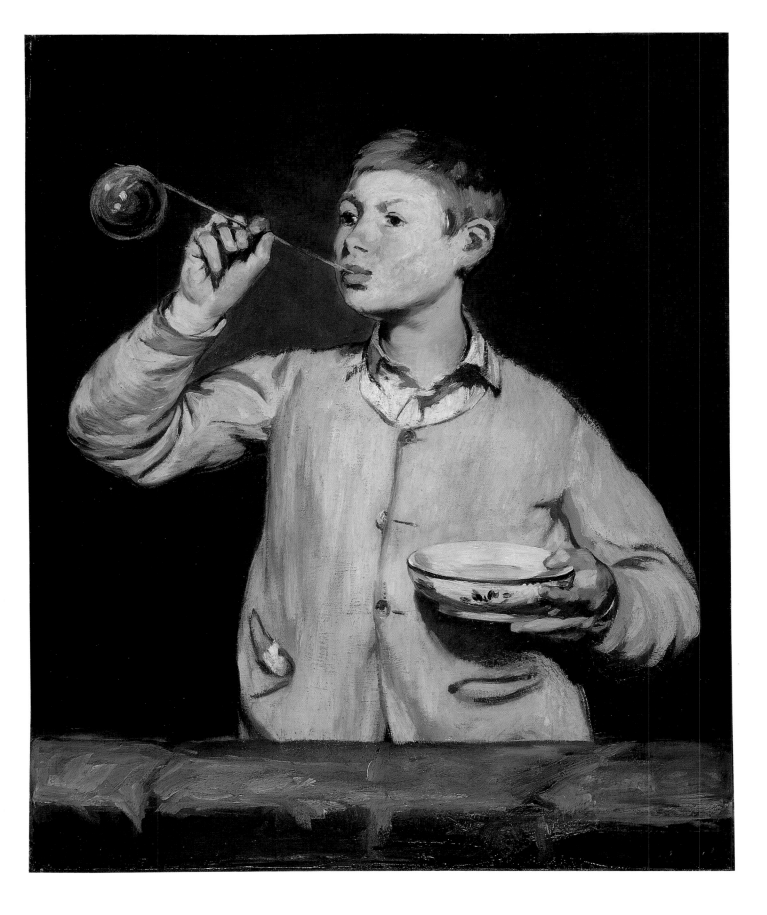

66

EDGAR DEGAS
(French, 1834–1917)

HENRI MICHEL-LÉVY

ca. 1878
Oil on canvas
40 × 28 cm (15¾ × 11 in.)

Signed lower left:
Degas

Inv. no. 420

1. *Catalogue des tableaux anciens . . . composant la Collection H. Michel-Lévy,* sale cat., Paris, Galerie Georges Petit, May 12–13, 1919. For a painting and five drawings by Watteau from Michel-Lévy's collection, see Margaret Morgan Grasselli and Pierre Rosenberg, *Watteau, 1684–1721,* exh. cat., National Gallery of Art (Washington, D.C., 1984), pp. 158, 203–4, 206, 219, 325–28. Michel-Lévy also owned a Corot now belonging to the Metropolitan Museum (Alice Cooney Frelinghuysen et al., *Splendid Legacy: The Havemeyer Collection,* exh. cat., The Metropolitan Museum of Art [New York, 1993], p. 308, no. 104).

2. Theodore Reff, "The Pictures within Degas's Pictures," *Metropolitan Museum Journal* 1 (1968), p. 153, fig. 34.

3. Ibid., p. 153.

BIBLIOGRAPHY
Reff, Theodore. "The Pictures within Degas's Pictures." *Metropolitan Museum Journal* 1 (1968), pp. 127, 150–54, 165, fig. 33.

EX COLL.
Henri Michel-Lévy; Boussod Valadon, Paris; Sir George A. Drummond, Montreal (d. 1910; his estate, from 1910; his sale, Christie's, London, June 26–27, 1919, no. 27, as *The Artist in His Studio,* bought through Colnaghi)

The sitter for this portrait of an artist in his atelier has been identified erroneously as Cézanne and as Degas himself. The present identification is supported by information the painter provided for the catalogue of the fourth Impressionist exhibition of 1879: listed as *Portrait d'un peintre dans son atelier,* the canvas is cited as from the collection of *Mr. H. M.-L.* Although included in the catalogue, it is not mentioned in any contemporary review and probably was not exhibited. The painting dates from about 1878 and returns to the subject of the studio, a theme the artist had explored some ten years earlier in his portrait *James Tissot* (The Metropolitan Museum of Art). Degas depicts the painter Henri Michel-Lévy (1844–1914), who first exhibited at the Salon of 1868. A student of Félix-Joseph Barrias (1822–1907) and Antoine Vollon (1833–1900), Michel-Lévy was acquainted also with Manet and Monet but declined Monet's invitation to participate in the first Impressionist exhibition in 1874. All indications are that Degas and Michel-Lévy met about 1867 in Barrias's atelier. The painters exchanged portraits of each other, and Degas was later displeased to learn of Michel-Lévy's sale of Degas's work for a high price. Nothing is known of the fate of Michel-Lévy's portrait of Degas.

In the portrait of Michel-Lévy, the painting depicted on the right is a modern *fête galante.* Works by Watteau, Boucher, and Fragonard were included in the posthumous sale of Michel-Lévy's collection, attesting to his enthusiasm for eighteenth-century French art.[1] The work shown on the left is similar to a picture Michel-Lévy exhibited at the Salon of 1879, entitled *The Regattas* (present whereabouts unknown).[2] The mannequin on the floor, which appears to turn its back on the artist, echoes the even more remote figure in the painting to the artist's right, which has been called "an imitation of an imitation of reality."[3]

In this complex, disturbing composition, the solitary, even embittered painter looks out from an unsettling off-center vantage point. Degas seems to reflect on the relationship between truth and illusion, and on art and those who create it. Degas reveals himself a lucid, pitiless, and pessimistic observer of daily life.

L S

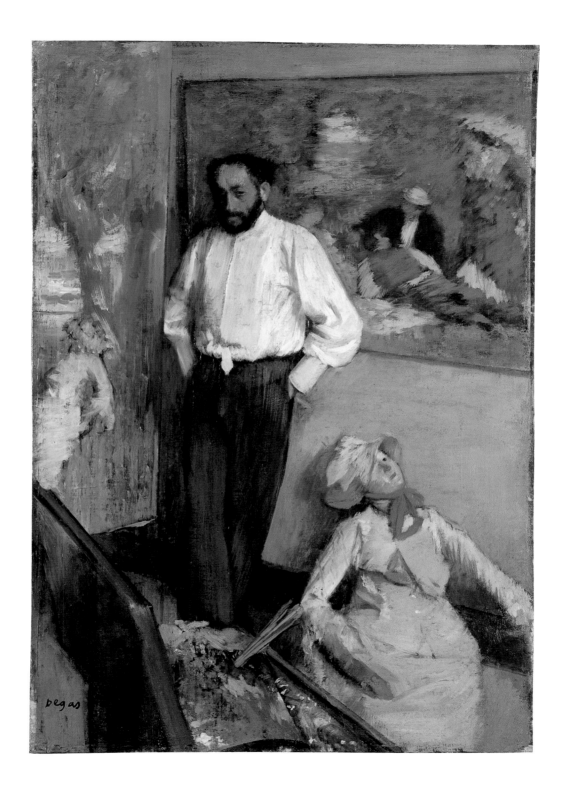

This painting is one of four compositions by Fantin-Latour depicting two female figures in an indoor setting and a meditative atmosphere in a format derived from seventeenth-century prototypes. Fantin's first work of this type is *The Two Sisters* of 1859 (Saint Louis Art Museum), a portrait of his sisters Nathalie and Marie Fantin-Latour.[1] The other two works in the series are *Reading* (Musée des Beaux-Arts, Lyon) from 1877 and *The Drawing Lesson* (Musées Royaux des Beaux-Arts, Brussels) from 1879.[2] Marie, the painter's sister, is also depicted reading in two portraits from the early 1860s (that of 1861, in the Musée d'Orsay, Paris, and that of 1863, in the Musée des Beaux-Arts, Tournai).

On the left is the austere figure of Victoria Dubourg, the future wife of the artist and herself a painter. (The two became acquainted at the Louvre in 1866, and were married six years after the completion of this work. In the Musée d'Orsay, there is a portrait of Victoria, also reading, from 1873. A more informal and spontaneous portrait of her by Edgar Degas is in the Toledo Museum of Art.) On the right is the enigmatic Charlotte Dubourg, Victoria's sister, an important figure in other works by the artist as well, where she appears both alone and with others. The most impressive of Fantin's portraits of Charlotte Dubourg is perhaps the one painted in 1882 that is now in the Musée d'Orsay.[3]

One of the most disturbing aspects of this double portrait is the psychological isolation of the Dubourg sisters both from each other and from the painter. The contrast between the light and dark areas accentuates the solitude of the figures. It has been suggested that there was an understanding between Charlotte Dubourg and the artist, since Charlotte was the only model Fantin ever depicted staring directly at the viewer, as he did in *The Dubourg Family* of 1878 (Musée d'Orsay).[4]

L S

1. *Fantin-Latour*, exh. cat., National Gallery of Canada (Ottawa, 1983), p. 94, no. 20, illus.

2. Ibid., colorpl. p. 47 (*The Drawing Lesson*).

3. Ibid., colorpl. p. 51.

4. Ibid., p. 250, no. 90, illus.

BIBLIOGRAPHY
 Fantin-Latour. Exh. cat., National Gallery of Canada. Ottawa, 1983, pp. 14, 16, 145–46, no. 45 (text by Michel Hoog), illus.

EX COLL.
 Charles E. Haviland, Paris (by 1906–17); Durand-Ruel, Bernheim Jeune, Georges Bernheim, Hessel, and Georges Petit, Paris (1917); bought from Georges Petit, Paris, in December 1917

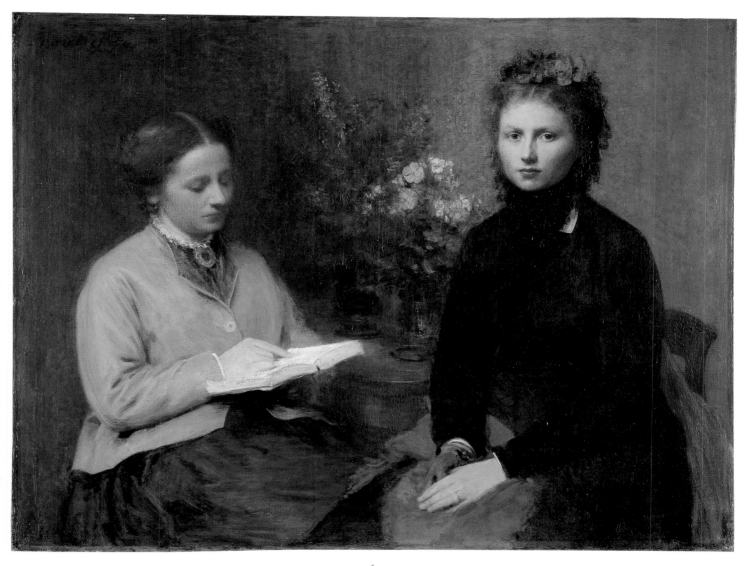

67

HENRI FANTIN-LATOUR
(French, 1836–1904)

READING

1870
Oil on canvas
95 × 123 cm (37 3/8 × 48 3/8 in.)

Signed and dated lower left:
Fantin 70

Inv. no. 257

Judging from the date Durand-Ruel purchased it from the artist—September 30, 1872—this work was completed in the same year as the celebrated *Impression, soleil levant* (Musée Marmottan, Paris), while Monet was living in Argenteuil. He painted a number of still lifes in the early 1870s, and returned to them about 1878. *The Tea Service* (private collection, France), which is probably of the same date as *Still Life with Melon* and is the same size, was acquired by Durand-Ruel in November 1872.[1] The maturity and creativity demonstrated by these two works set them apart from still lifes painted by Monet some ten years before, such as *Still Life with Pheasant* (Musée des Beaux-Arts, Rouen) of about 1861.

Monet worked indoors during periods of inclement weather. *Still Life with Melon* was painted in late summer, to judge by the fruit piled up on the Chinese blue-and-white porcelain dishes that he collected (they are a type of porcelain made for the European market from the early eighteenth century on). The artist adopts a raised point of view for this composition, disregarding conventional perspective. The color juxtapositions confer a sense of the volume and texture of the objects depicted and reveal a concern for transmitting not only the impression of light but also the weight of matter.

In *Still Life with Melon* the forms may be read as dissociated from their meaning, following the practice of Édouard Manet (see cat. no. 65). Inanimate objects are thereby transformed into pretexts for a purely pictorial exercise. Monet and Pierre-Auguste Renoir (1841–1919) nonetheless approach still life in a bourgeois spirit, evoking an atmosphere of domestic intimacy.

L S

1. *Hommage à Claude Monet (1840– 1926)*, exh. cat., Galeries Nationales du Grand Palais (Paris, 1980), p. 138, no. 44, illus.

BIBLIOGRAPHY

Hommage à Claude Monet (1840– 1926). Exh. cat., Galeries Nationales du Grand Palais. Paris, 1980, p. 138, no. 44b, and p. 137, illus.

Wildenstein, Daniel. *Claude Monet: Biographie et catalogue raisonné* (Lausanne and Paris, 1974), vol. 1, pp. 218–19, no. 245, illus.

———. *Monet: Catalogue Raisonné/ Werkverzeichnis*. Cologne, 1996, vol. 2, p. 107, no. 245, colorpl.

EX COLL.

Durand-Ruel, Paris (1872); Hiltbrunner, Paris; Durand-Ruel, Paris (1882); Charles Cotinaud, Périgueux (until 1903); Durand-Ruel, Paris (1903); Georges Hoentschel, Paris (1903); Galeries Barbazanges (1924); bought from Knoedler, London, on April 25, 1924

68

CLAUDE MONET
(French, 1840–1926)

STILL LIFE WITH MELON

ca. 1872
Oil on canvas
53 × 73 cm (20⅞ × 28¾ in.)

Signed upper left:
Claude Monet

Inv. no. 450

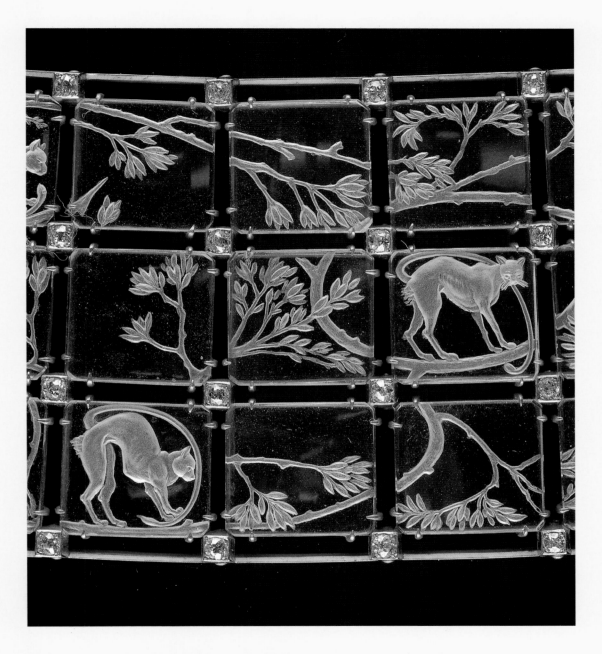

Lacquer, Lalique,
and
Modern Bindings

69

JITOKUSAI GYOKUZAN
THREE-CASE INRŌ

Japanese, late 18th century
Lacquer and mother-of-pearl
9 × 6.5 × 3 cm (3½ × 2½ × 1⅛ in.)

Signed on base:
Jitokusai Gyokuzan

Inv. no. 1329

EX COLL.
Sir Trevor Lawrence, London (until
1916; his estate sale, Christie's,
London, December 4, 1916, no. 118,
bought through Coureau)

Because Japanese apparel did not have pockets, objects of everyday use were carried in pouches hung from the belt. The *inrō,* imported from China and known in Japan from the sixteenth century, took on the form familiar to us today in the seventeenth. Originally intended to hold the bearer's ink and seal, the *inrō* came to be used as a receptacle for medicinal powders and herbs. Hanging from the wide sash worn by Japanese men, the cases of the *inrō* were linked by a cord whose ends were inserted first into an *ojime,* a bead that acted as a tightener, and then into a *netsuke,* which functioned as a button and allowed the user to fasten the *inrō* to the sash.

Lacquer was the material most often used, along with mother-of-pearl, ivory, or silver, as well as less precious materials such as colored glass, eggshell, or ceramics. The manufacture entailed difficulties both formally (the *inrō* was usually made up of superimposed compartments whose perfect fit assured impermeability) and decoratively: the motif had to be continuous, and the separation between the cases imperceptible. Only the most dexterous artists dedicated themselves to *inrō,* which are often signed. *Inrō* were frequently presented as gifts on festive occasions. Their use spread rapidly, especially among the upper classes, reaching its apogee in the eighteenth century.

The surface of the present example is overlaid with plates of mother-of-pearl atop which a viper coils. The viper, in engraved brown-and-black lacquer, is executed in relief with great realism. Its eye is a small glass bead over gold leaf, while gold leaf applied along the edges of the lacquer imitates glistening scales. The inside tops are decorated in the *mokumenuri* technique, imitating wood grain, and the interior is completely gilded. The artist's signature, on the base, is in low relief within a rectangular cartouche.

I P C

70

HARA YOYUSAI
(1772–1845)

FOUR-CASE INRŌ

Japanese, 18th–19th century
Lacquer, mother-of-pearl,
and ivory
7.5 × 5.5 × 2.5 cm (3 × 2⅛ × 1 in.)

Signed on base:
Yoyusai

Inv. no. 1364

EX COLL.
Norie, 1900; Sir Trevor Lawrence,
London (until 1916; his estate sale,
Christie's, London, December 4, 1916,
no. 572, bought through Coureau)

On this *inrō,* a squirrel hangs from a vine with leaves, tendrils, and a bunch of grapes against a smooth, red lacquer ground. The grapes are mother-of-pearl and some of the leaves are green-tinged ivory. Gold powder and gold leaf are used for the remaining leaves, as well as for the branches and tendrils. The squirrel is in relief, achieved by use of the *sabi-age-takamakie* technique (lacquer agglutinated with powder of burnt clay). Inside the *inrō,* the *nashiji* (lacquer sprinkled with small pieces of gold leaf) technique is employed. The artist's signature appears on the base in gold letters.

Both the present example and catalogue number 69 lacked the *netsuke* and *ojime* when acquired by Calouste Gulbenkian.

I P C

71

SUZURIBAKO

Japanese, 19th century
Lacquer
4.3 × 24 × 22 cm (1¾ × 9½ × 8⅝ in.)
Inv. no. 1350

Calligraphy is practiced throughout East Asia. In Japan this highly esteemed art was favored not only by artists and calligraphers but also by the upper classes, including women. The tools and materials—brushes, spatulas, inks, stamps, paper—were stored in a variety of boxes and other receptacles. Usually executed in lacquer, these writing boxes, like cases for toiletries, the tea ceremony, or incense, were obligatory components in the trousseaus of the daughters of the nobility or military elite. The *suzuribako* contained a hard stone, sometimes jade, with a cavity for preparation of the ink, and a water dropper. The ink, in the form of a cake, was ground in a small quantity on the stone, with water, to reach the desired consistency. Additional tools were housed in other compartments. Both the interior and the exterior of the box were meticulously decorated in a variety of techniques.

The present example, in black lacquer, is decorated using the *takamakie* (lacquer with relief decoration in sprinkled gold) and *sumie togidashie* (lacquer sprinkled with camellia charcoal and silver powder, then polished) techniques. Superimposed on the outside cover are a folding screen displaying a grove of trees and an owl sitting on a branch; a screen decorated with a hawk, its wings spread, chained to the perch on which it rests; and a lacquered clothes rack from which hang robes, an *inrō* (see cat. nos. 69, 70), and two small pouches. Shown on the inside of the cover are two cases for the game of shell matching (*kaioke*) and a papier-mâché toy dog (*inuhariko*) executed in the *togidashie* (lacquer sprinkled with metallic powder) technique on a ground of black lacquer sprinkled with large pieces of gold leaf (the *yasuriko* technique). The interior of the box is divided into compartments, with the stone in the middle and the water dropper above.

IPC

EX COLL.
Sir Trevor Lawrence, London (until 1916; his estate sale, Christie's, London, November 6, 1916, no. 324, bought through Coureau)

72

RENÉ LALIQUE
(French, 1860–1945)

SERPENTS BROOCH

ca. 1898–99
Gold and enamel
21 × 14.3 cm (8 ¼ × 5 ⅝ in.)

Signed upper right edge:
LALIQUE

Marks:
goldsmith's stamp and hallmark

Inv. no. 1216

Another example of the Serpents brooch was first displayed by Lalique at the 1900 Exposition Universelle in Paris.[1] (Its whereabouts today are unknown.) This surprising work encapsulates the prodigious imagination, technical mastery, total command of materials, and perfection of execution that made Lalique the creator of the modern jewel, if not the greatest jeweler of his time.

The Gulbenkian pin may have been executed by Lalique as a variation of the first one, without the rows of baroque pearls described by contemporary viewers of the pin shown in Paris in 1900. Reptiles, especially serpents, are among the countless animal motifs that occur in Lalique's work, whether in jewelry, glass (see cat. no. 78), bronze, or ivory. This motif, heavily charged with symbolism, may be linked to the combination of opposites—the beautiful and the horrific, the divine and the demonic—that is associated in the artist's oeuvre with the figure of woman.

The brooch, made of engraved and enameled cast gold, is composed of a knot of nine serpents. From the tangled mass, the central serpent raises itself in a position of attack, its underside decorated in light blue opalescent enamel. The dorsal sides of all the serpents are enameled in a deep green with semicircles in black and shades of green on the eight hanging serpents. The serpents' heads, too, are in vitreous enamel. Rings of enameled gold adorned with tiny serpents' heads, also with jaws widespread, occur at the joints, concealing the structural details of the piece. Lalique always sought to decorate the reverse of his work as meticulously as he did the front.

M F P L

1. Pol Neveux, "René Lalique," *Art et décoration* 8 (November 1900), pp. 17 and 135, illus.

BIBLIOGRAPHY
Barten, Sigrid. *René Lalique: Schmuck und Objets d'Art, 1890–1910. Monographie und Werkkatalog.* Munich, 1977, p. 392, no. 947, illus.

Brunhammer, Yvonne, ed. *The Jewels of Lalique.* Exh. cat., Cooper-Hewitt National Design Museum. New York, 1998, pp. 58–59, fig. 8, colorpl.

Ferreira, Maria Teresa Gomes. *Lalique: Jóias.* Lisbon, 1997, pp. 25, 240, colorpls., and p. 241.

René Lalique—bijoux, verre. Exh. cat., Musée des Arts Décoratifs. Paris, 1991, p. 19, colorpl.

EX COLL.
Bought from René Lalique in February 1908

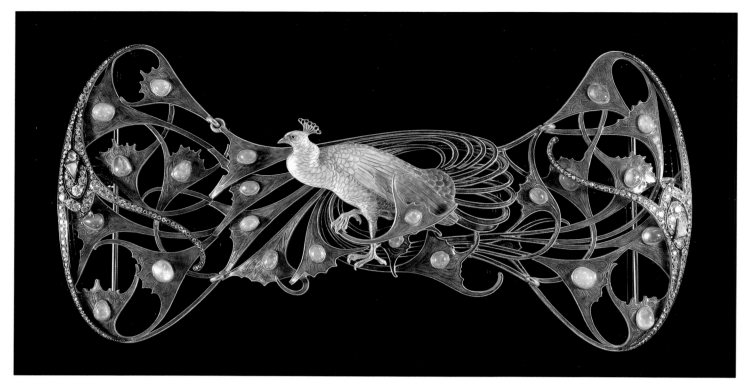

73

RENÉ LALIQUE
(French, 1860–1945)

PEACOCK BROOCH

ca. 1898–1900
Gold, enamel, opals,
and diamonds
9.2 × 19 cm (3 ⅝ × 7 ½ in.)

Signed center lower edge:
LALIQUE

Inv. no. 1134

BIBLIOGRAPHY
Barten, Sigrid. *René Lalique: Schmuck
und Objets d'Art, 1890–1910. Mono-
graphie und Werkkatalog.* Munich,
1977, p. 401, no. 988, illus.
Becker, Vivienne. *The Jewellery of
René Lalique: A Goldsmith's Company
Exhibition, 28 May to 24 July 1987.*
London, 1987, p. 43, no. 17, and
pp. 44–45, colorpl.
Ferreira, Maria Teresa Gomes.
Lalique: Jóias. Lisbon, 1997, p. 93
and pp. 92, 94–95, colorpls.
René Lalique—bijoux, verre. Exh. cat.,
Musée des Arts Décoratifs. Paris,
1991, pp. 42–43, colorpl.

EX COLL.
Bought from René Lalique on
May 11, 1900

In the bestiary represented by the work of René Lalique, the peacock is the creature most emblematic of the spirit of Art Nouveau. The peacock appears frequently in fin de siècle poetry and painting (the walls of Whistler's exquisite Peacock Room in the Freer Gallery, Washington, D.C., are a symphony of blue and gold), and it became a leitmotif in Lalique's work, whether alone in all its splendor, as here, or paired. This brooch, Lalique's first representation of the peacock, was exhibited with enormous success at the 1900 Exposition Universelle in Paris.

The peacock is made of opalescent enameled gold in hues of blue and green that imitate the bird's feathers, dotted with small oval cabochon opals. The opal, a gem to which malevolent effects were attributed, was rehabilitated by Lalique, who made steady use of it in his jewelry, especially from 1898 to 1903. The sinuous movement of the tail feathers that wind around the bird's body, which is turned to the left, is enhanced by a mirror composition of diamonds at left and right.

This large openwork pin is perfectly adapted to the style of the time. The rounded bust of a lady of fashion projecting above the wasplike waist created by a corset was an ideal support for oversize brooches, accompanied by long strings of pearls and the famous "dog collars," or chokers (see cat. nos. 75 and 77), that graced the necks of elegant women of the era.

Catalogue number 74 shows the artist's preparatory drawing for this piece. M F P L

74

RENÉ LALIQUE
(French, 1860–1945)

DRAWING FOR THE
PEACOCK BROOCH

ca. 1898–1900
Pencil, india ink, and
gouache on paper
21.7 × 28.1 cm (8½ × 11⅛ in.)
Inv. no. 2471

Lalique drew from an early age and in his childhood spent hours tramping through fields and recording birds, insects, flowers, trees, and scenery. The love of nature that permeated the artist's oeuvre was shared by his friend Calouste Gulbenkian. There are a great number of preparatory drawings by Lalique for his jewelry, many of which until recently were in the possession of his family. Consummate artist that he was, Lalique painstakingly drew the pieces that he would later execute; his drawings can therefore be considered, as Roger Marx called them in 1899, the artist's "book of fact."[1] The majority date from 1895 to 1905, the period of his greatest creativity in jewelry. Calouste Gulbenkian acquired twenty-odd drawings for the pieces of jewelry that he collected, as well as drawings for jewelry in other collections or whose whereabouts or execution is unknown. The drawing, though quite similar to the jewel (cat. no. 73), lacks the rows of tiny diamonds that in the finished piece mark the final flourishes of the tail.

M F P L

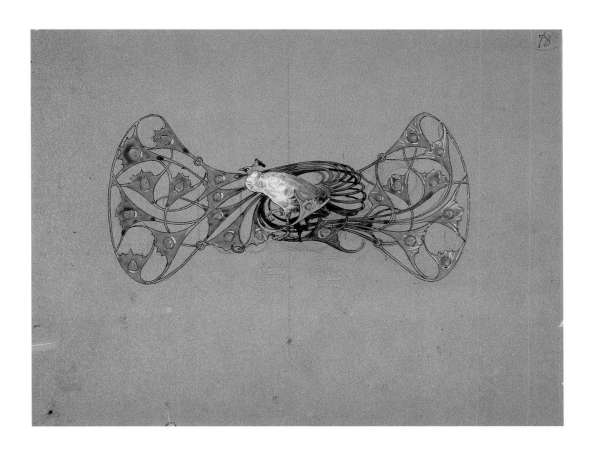

1. Roger Marx, "René Lalique," *Art et décoration* 6 (July 1899), p. 15.

BIBLIOGRAPHY
Ferreira, Maria Teresa Gomes. *Lalique: Jóias.* Lisbon, 1997, p. 287, colorpl.

EX COLL.
Bought from Lalique

75

RENÉ LALIQUE
(French, 1860–1945)

PLAQUE FOR THE
EAGLES AND PINES CHOKER

ca. 1899–1901
Gold, opal, and enamel
5.3 × 10.6 cm (2⅛ × 4⅛ in.)

Signed center lower edge:
LALIQUE

Inv. no. 1151

Lalique chose animal and vegetal motifs for the jewel of this choker, whose most spectacular element is the enormous rectangular cabochon opal at its center. The entangled pine branches with their needles enameled in green and the pinecones in gold all but hide two facing eagles with curved beaks enameled in dark blue. These birds were one of Lalique's favorite motifs and appear on a variety of pieces. At the sides of the jewel are gold fasteners to hold the rows of pearls that were to complete the choker. On the underside of the jewel are plant motifs painstakingly executed in cast gold and engraved.

Catalogue number 76 shows the artist's preparatory drawing for this piece. M F P L

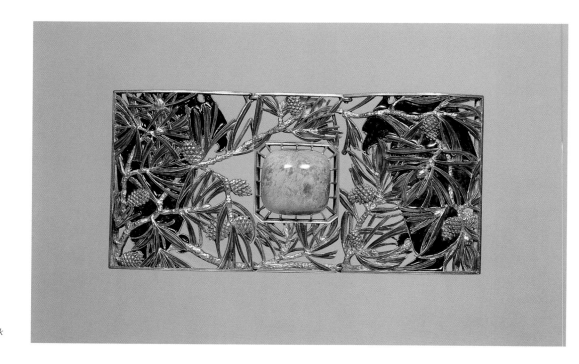

BIBLIOGRAPHY
Barten, Sigrid. *René Lalique: Schmuck und Objets d'Art, 1890–1910. Monographie und Werkkatalog.* Munich, 1977, pp. 230–31, no. 282, illus.

Becker, Vivienne. *The Jewellery of René Lalique: A Goldsmith's Company Exhibition, 28 May to 24 July 1987.* London, 1987, p. 149, no. 150, colorpl.

Ferreira, Maria Teresa Gomes. *Lalique: Jóias.* Lisbon, 1997, p. 126, colorpls., and p. 127.

René Lalique—bijoux, verre. Exh. cat., Musée des Arts Décoratifs. Paris, 1991, p. 62, colorpl.

EX COLL.
Bought from René Lalique in July 1901

76

RENÉ LALIQUE
(French, 1860–1945)

DRAWING FOR THE
EAGLES AND PINES PLAQUE

ca. 1899–1901
Pencil, india ink, and
gouache on paper
21.8 × 28 cm (8⅝ × 11⅛ in.)
Inv. no. 2468

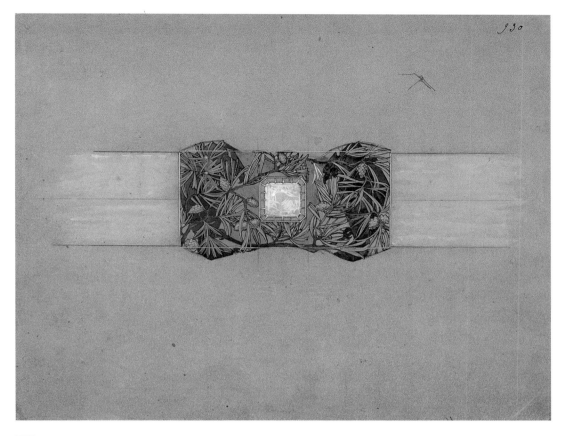

This preparatory drawing for catalogue number 75 shows that Lalique contemplated using a different stone, perhaps rock crystal, in the center of the piece, as well as extending the eagles beyond the borders of the jewel. In order to distinguish better the contours of the birds among the branches of the pine trees, the artist added a reddish background, which highlights the detail. The jewel's supports are suggested in white. In general, the preliminary drawings for Lalique's jewelry were executed on paper of a brownish ocher shade. M F P L

BIBLIOGRAPHY
Ferreira, Maria Teresa Gomes.
Lalique: Jóias. Lisbon, 1997, p. 284, colorpl.

EX COLL.
Bought from Lalique

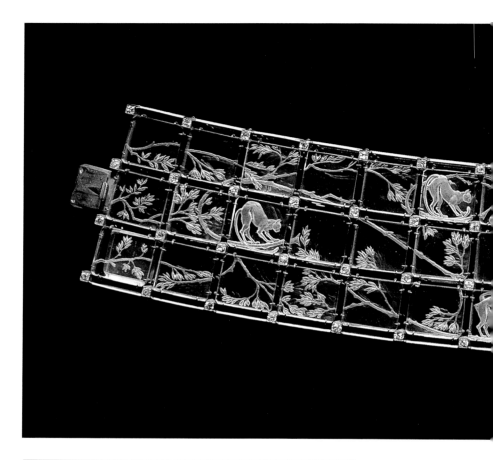

77

RENÉ LALIQUE
(French, 1860–1945)

CATS CHOKER

ca. 1906–8
Rock crystal, gold, and diamonds
5.4 × 33.8 cm (2⅛ × 13¾ in.)

Signed upper edge next to clasp:
LALIQUE

Marks:
goldsmith's stamp and hallmark

Inv. no. 1255

Chokers or the jewels of chokers worn with as many as fifteen rows of pearls adorned the necks of ladies of the Belle Epoque, whose hair was normally piled high and held by elaborate horn combs decorated with enamel and stones. Fashion dictated dressing with as many jewels as possible, and chokers were an essential element in the toilette of elegant women. Lalique's most spectacular jewels, of grand dimensions and with novel and daring themes and decoration, were worn by the great actresses of the time, notably Sarah Bernhardt, who may have introduced the artist to Calouste Gulbenkian, and others such as Liane de Pougy. Certain more enlightened aristocratic ladies—the

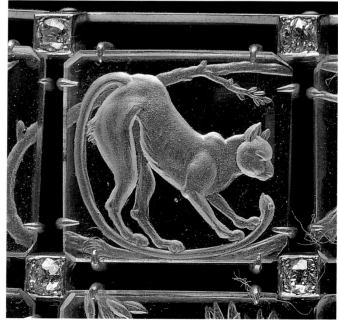

Detail, cat. no. 77

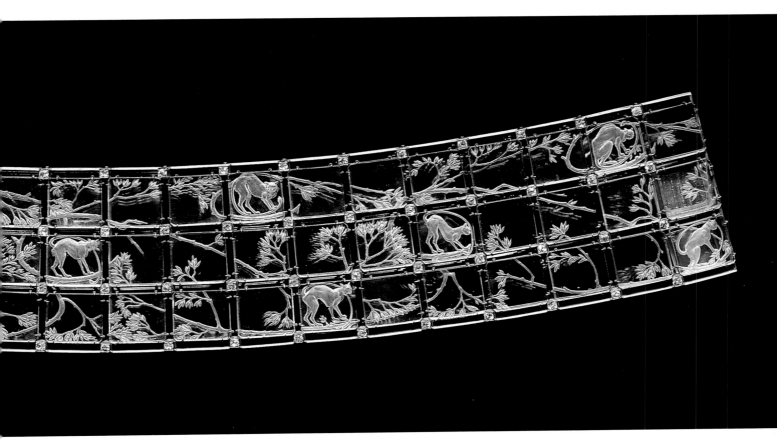

comtesse de Béarn and the marchesa di Arconati-Visconti—also dared to enhance their toilettes with the jewels of Lalique.

The Cats choker is among the artist's most refined pieces in the Gulbenkian collection, for despite its apparent sobriety it represents a prodigious combination of artistry and technique. A series of small engraved rock-crystal squares, alternately decorated with cats and foliage, are linked by a gold mesh. The joints that allow the squares to flex are concealed by small diamonds, and the top and bottom of the choker have a gold border enameled in white. This piece revels in the play of light and effects of transparency that interested the artist throughout his career, especially after he incorporated glass into his jewelry. (The rock crystal used here is a material extremely difficult to manipulate.) The dominant lines of the choker are rectilinear, far from the sinuous Art Nouveau elements that once characterized the artist's style (see cat. no. 73).

M F P L

BIBLIOGRAPHY
Barten, Sigrid. *René Lalique: Schmuck und Objets d'Art, 1890–1910. Monographie und Werkkatalog.* Munich, 1977, p. 238, no. 313, illus.

Ferreira, Maria Teresa Gomes. *Lalique: Jóias.* Lisbon, 1997, p. 257 and pp. 256, 258–59, colorpls.

René Lalique—bijoux, verre. Exh. cat., Musée des Arts Décoratifs. Paris, 1991, pp. 64–65, colorpl.

EX COLL.
Bought from René Lalique on April 8, 1920

Lalique, the great innovator in the art of jewelry at the end of the nineteenth century, is known above all for his superb artistry in glass. His passion for this material was foreshadowed by the recurrence in his jewelry of enamels, whose chemical composition is identical to that of glass and with which he achieved exquisite tonalities, as well as by the use of glass itself in many of his works.

In 1902, Lalique moved to a new home on the banks of the Seine at Cours la Reine (today Cours Albert 1er), where he created a workshop and set aside space for entertaining clients and displaying his work. He also embarked on a change in career as he experimented more and more with glass, a material he mastered no less than the precious, semiprecious, and ordinary materials he had already used so successfully in his jewelry. In glass he discovered the ideal material with which to interpret his favorite motifs of flora and fauna. The full transition from jewelry maker to glass artist occurred about 1909, when Lalique executed works in molded blown glass and molded pressed glass. Several of Lalique's molded-glass pieces and pieces blown in molds by the lost-wax method are in the Gulbenkian collection.

Items such as the sugar bowl seen here constitute an earlier stage in Lalique's work, dating from about 1898 and related to his deep knowledge of the goldsmith's work. In a difficult manufacturing process, glass is blown into hollow bronze or silver structures. Objects made by this method are relatively rare. The present piece has a hollow cast-silver mounting; the silver is patinated, intended to be dark. Serpents, a recurrent motif in Lalique's work (see cat. no. 72), cover the amber blown glass of the body of the bowl. Opposite the coiled serpent that forms the handle, a pair of serpents leap from the bowl in a posture of attack, their mouths agape. Another serpent, its body raised in readiness to attack, serves as the lid of the sugar bowl.

M F P L

BIBLIOGRAPHY

Barten, Sigrid. *René Lalique: Schmuck und Objets d'Art, 1890–1910. Monographie und Werkkatalog*. Munich, 1977, p. 543, no. 1700, illus.

Brunhammer, Yvonne, ed. *The Jewels of Lalique*. Exh. cat., Cooper-Hewitt National Design Museum. New York, 1998, p. 43, cat. 177, colorpl.

René Lalique—bijoux, verre. Exh. cat., Musée des Arts Décoratifs. Paris, 1991, p. 108, colorpl.

EX COLL.

Bought from René Lalique in 1902

78

RENÉ LALIQUE
(French, 1860–1945)

SERPENTS SUGAR BOWL

ca. 1897–1900
Silver and glass
22 × 29 cm (8⅝ × 11⅜ in.), diam. 17.6 cm (6⅞ in.)

Signed edge of base:
LALIQUE

Inv. no. 1162

Front inside cover

79

L'ÉVANGILE
DE L'ENFANCE DE NOTRE SEIGNEUR JÉSUS CHRIST
SELON SAINT PIERRE,
MISE EN FRANÇAIS PAR CATULLE MENDÈS,
D'APRÈS LE MANUSCRIT DE L'ABBAYE DE SAINT-WOLFGANG

French (Paris), Colin & Cie, n.d. [1896]
Printed book on Japan paper
with gold-stamped leather covers by Charles Meunier
and illustrations by Carlos Schwabe
32.6 × 25.3 (12⅞ × 10 in.)

Stamped on inside cover in gold lower right:
Ch MEUNIER. 97

Inv. no. L. M. 64

The decorative language replete with symbolic references employed by the binder Charles Meunier (1865–1940) and the illustrator Carlos Schwabe (1866–1926) in the present work marks it as an exemplar of Art Nouveau style. *L'Évangile* was printed in an edition of 150 copies of which the Gulbenkian volume is number 26.

The binding of *L'Évangile,* like many of Meunier's bindings, is even more interesting for the floral ornamentation on the inside covers than for that on the outside. Here, the front inside cover features an elegant floral composition of irises with passionflowers whose gilded stems are a lively counterpoint to the darker colors of the blossoms, leaves, and buds. On the back inside cover is a more restrained arrangement of lilies and passionflowers. Both compositions are framed by a border with thorns, a suitable reference to the crown worn by Christ during His Passion.

L'Évangile was one of the first works illustrated by Schwabe to earn him public recognition; it had been published serially in the *Revue illustrée* between 1891 and 1894. Schwabe's originality is apparent in the delicate arrangements of flowers and dreamy, sensual figures that express not the content of the text but the artist's response. In a harmonious blending of words and images, undulating curved lines and interlaced geometric arabesques predominate.

Meunier and Schwabe also collaborated on an edition of Charles Baudelaire's *Les fleurs du mal,* the book with which Meunier made his debut as a publisher, in 1900. M F

BIBLIOGRAPHY
 de Herdt, Anne, et al. *Carlos Schwabe, 1866–1926.* Exh. cat., Cabinet des Dessins du Musée d'Art et d'Histoire. Geneva, 1987, cat. 52.

 Le livre, objet d'art: Collection Calouste Gulbenkian. France, XIXe–XXe siècles. Exh. cat., Centre Culturelle Calouste Gulbenkian, Paris. Lisbon, 1997, pp. 72–73, colorpls.

EX COLL.
 Vicomte de La Croix-Laval [ex-libris]; bought at Sotheby's, London, July 1, 1920, no. 116, through Gudenian

The decoration of bookbindings was revolutionized in the second half of the nineteenth century by Henri Marius-Michel (1846–1925). His motifs, inspired by natural flora as well as by the content of the book to be bound, were chosen to attract the attention and stimulate the imagination of the reader. The present binding is illustrative of the new principles. Its beauty is the result of a close collaboration between Georges Canape (1864–1940) and the designer, Adolphe Giraldon (b. 1855).

The majority of bindings designed by Giraldon are inspired by the text, in this case, by the bucolic atmosphere of Virgil's pastoral poems. The decoration is applied to green morocco around a small central motif made of inlaid pieces of morocco of various shades. Rustic nature is evoked by the pinecones at the four corners that alternate with clusters of ivy leaves at the sides of the binding. The concentric circles stamped in gold are both manifestations of the turn-of-the-century Art Nouveau aesthetic and premonitions of Art Deco.

Giraldon dedicated three years to the illustration of *Les Églogues*. He prepared watercolors that were then engraved in wood by Florian. Each narrative scene is set in an idyllic landscape surrounded by an ornamental frame-work. Giraldon was also responsible for the book's typographic design. Lyon silk embellished with branches of white flowers against a pale green ground adorns the inside covers and flyleaves.

Les Églogues, with a preface by Émile Gebhart, was published in 1906 in an edition of 301 copies (the present volume is number 55). So great was the book's success that Giraldon was asked to design bindings for other copies in the edition as well. The Gulbenkian Museum also owns a copy (number 138) of *Les Églogues* with a Giraldon binding executed by Henri Noulhac (1866–1931) in 1920. M F

BIBLIOGRAPHY
Carteret, L. *Le trésor du bibliophile: Livres illustrés modernes, 1875 à 1945*. Paris, 1948, vol. 4, p. 403.
Le livre, objet d'art: Collection Calouste Gulbenkian. France, XIXe–XXe siècles. Exh. cat., Centre Culturelle Calouste Gulbenkian, Paris. Lisbon, 1997, pp. 110–11, colorpls.

EX COLL.
Henry Hirsch [ex-libris]; C.L. [Christian Lazard?] (until 1939; C.L. sale, Paris, June 13, 1939, no. 32)

80

VIRGILE
LES ÉGLOGUES

French (Paris),
Plon-Nourrit & Cie, 1906;
binding, 1920
Printed book on Japan paper with
gold-stamped leather covers by
Georges Canape, after a design
by Adolphe Giraldon
33.5 × 23 cm (13¼ × 9 in.)

Stamped on back cover in gold:
Giraldon Del., lower left center;
CANAPE R.D. 1920,
lower right center

Inv. no. L. M. 444

Selected Bibliography

The Calouste Gulbenkian Foundation publishes extensively, primarily in Portuguese. The following titles are among the most important publications on Calouste Gulbenkian and the Calouste Gulbenkian Museum.

Assam, Maria Helena. *Colecção Calouste Gulbenkian: Arte egípcia.* Lisbon, 1991.

Catalogue. 2nd ed., rev. and enl. Lisbon, 1989.

Costa, Maria Helena Soares, and Maria Luísa Sampaio. *Pintura.* Lisbon, 1998.

Coutinho, Maria Isabel Pereira. *O mobiliário francês do século XVIII na Colecção Calouste Gulbenkian.* Lisbon, 1999.

Ettinghausen, Richard. *Persian Art: Calouste Gulbenkian Collection.* Lisbon, 1972.

European Paintings from the Gulbenkian Collection. Exh. cat., National Gallery of Art. Washington, D.C., 1950 (text by Fern Rusk Shapley).

Ferreira, Maria Teresa Gomes. *Lalique: Jóias.* Lisbon, 1997.

Ferreira, Maria Teresa Gomes, and Maria Isabel Pereira Coutinho. *Colecção Calouste Gulbenkian: Medalhas do renascimento.* Lisbon, 1979.

Figueiredo, Maria Rosa. *A escultura francesa.* Vol. 1 of *Catálogo de escultura européia.* Lisbon, 1992.

Galleries of Paintings: Guide. Lisbon, 1998.

Lalique Gallery. Lisbon, 1997.

Le livre, objet d'art: Collection Calouste Gulbenkian. France, XIXe–XXe siècles. Exh. cat., Centre Culturelle Calouste Gulbenkian, Paris. Lisbon, 1997.

Marrow, James H. *As Horas de Margarida de Cleves / The Hours of Margaret of Cleves.* Lisbon, 1995.

Mota, Maria Manuela. *Louças seljúcidas.* Lisbon, 1988.

Muraro, Michelangelo. *Os Guardi da Colecção C. Gulbenkian.* Lisbon, 1993.

Museu Calouste Gulbenkian: Guide. Lisbon, 1997.

Oriental Islamic Art: Collection of the Calouste Gulbenkian Foundation / L'art de l'orient islamique: Collection de la Fondation Calouste Gulbenkian. Exh. cat., Museu Nacional de Arte Antiga. Lisbon, 1963 (text by Ernst Kühnel and Basil Gray).

Perdigão, José de Azeredo. *Calouste Gulbenkian Collector.* Lisbon, 1969.

Ribeiro, Maria Queiroz. *Louças Iznik / Iznik Pottery.* Lisbon, 1996.

Tecidos de Colecção Calouste Gulbenkian. Lisbon, 1978.

Verlet, Pierre. *Objets d'art français de la Collection Calouste Gulbenkian.* Lisbon, 1969.